Compliments of
Chicagohoodz

**Compliments of Chicagohoodz:
Chicago Street Gang Art & Culture**

All content copyright ©2019 James O'Connor and Damen Corrado

ISBN 978-1-62731-065-9

Feral House
1240 W. Sims Way
Suite 124
Port Townsend, WA 98368
10 9 8 7 6 5 4 3 2 1

design by designSimple

Printed in South Korea

Compliments of Chicagohoodz
Chicago Street Gang Art & Culture

**James O'Connor, AKA Jinx &
Damen Corrado, AKA Mr. C**

Acknowledgements

This collection was acquired with the help of many individuals who traded, sold, or just plain donated to us. All in all, you will note the thousands of names. Some of you will remember a nickname, but you won't be able to put a face to it. Some of you will have fond memories, while others will have memories you wish to forget. Thank you all for your contributions—and enjoy the ride.

Archival image credits: Esquires: Al B; Taylor St. map, Counts roster and patch designs: Franco; Rampants and Spartans: Dick Dolej; Ridgeway Lords: Billy M; Royal Cavaliers: Mondo; Kents: Player; Counts: Benny and Spanky; Greasers: Chicago History Museum; C-Note$: the Curley collection; Howard Street Greasers: Duster; Lady Party People: Vandal; Lady 2-2: Two-Two Boys; Latinettes: Spanky; PBC and Latin Disciples: Joe S; GBO/YBO: Chicano and Joe S; Kool Gang: Beto; Latin Hoods: Alex R; Night Crew: Night Crew; Royals: Clown, Todd, Jake, Duster, Telly, Beto; PBC: Jeff K; Satan Disciples: Dee Dee; Ambrose, Racine Boys and Latin Kings: Beto; Party People: Lil' Frank; Two-Six: Joe H; Cobras: original DM Cobra; Lovers: Sting; OAs: Chicano and Joe S; Popes: Jake and Chicano; Gents: Joe S; Gaylords: Joker; Jousters: Kenny; Stoned Freaks: Keith; Noble Knights: Capone; 12th Street Players: TPN; Uptown Rebels: Jack; Deuces: Mr. Big, Ted M and Sting; Nike Boys: Telly.

The authors would also like to sincerely thank the following: Andre W, Al B, Apache, Arthur M, Babe / Patrick, Bear, Benny, Bill, Bill Hillman, Bill K, Billy M, Billious, Bob from Knitting Mills, Chava, Chicano, Chino, Chivo, Christina Ward, Chuy, Corkey, Dana Collins, David Ayala, David Q, Dee Dee and Rick, Diane, Dick D, Don Cuba, Duster, Eddy, Emilio, Frank Franco, Frank from Hegwisch, Frank Tinoco, George Ferguson, Ghost / Keith, Goofy, Harvey, Jack Q, Jack Walls, Jake, J-Dog, Jeff Kaiser, Jeremy Kart, John Hagedorn, Jose, Jose VL, Juan S, Kapone, Keith R, Kenny M, the Lazy Gent, Lorin from Galewood Park, Mario, Mark Torre, Mike Medrano, Mike R, Mr. Big, Negro, neighbor Nancy, original Latin King, Paul K, Pete S, Pete Tinoco, Polaco, Reuben Q. (Sr. and Jr.), Rocker, Roger R, Shoe, the Spanish Seagents, Spanky, Spidey, Spinn, Spook, SS / Skoombading, Sting, Teddy M, Telly, Tim Lanners, Todd

Compliments of Chicagohoodz: Chicago Street Gang Art & Culture

> Danny RIP Don C.
>
> Steve W. Mikey P. Pete T.
>
> Alex R. Adam P.

/ Bombsquad, Todd S, Tootsie, Steve Weiser, Stooge, Telly, Vandal, Vicky Q, Will, the YMCA intervention workers—and all of Chicago's hoods.

Much love and appreciation goes out to Robert N. Taylor for his generous contributions of text and research material ("per aspera ad astra"); to a champion and true gent, Anthony Haden-Guest, for his longstanding support and invitation to "The Last Party" in 2015; to our good friends Bruce Benderson and Mark Cassidy for their invaluable editorial input; to Keith Campbell for his excellent visual contributions; and to Judy Rosenberg for all her encouragement.

A tremendous word of thanks is due to Bill Smith, Dave Shulman, Mitch Handsone and the entire team at designSimple, for their initial interest in this project, and for rising to its challenge with enthusiasm and an impeccable design sensibility. They have our eternal gratitude for going far above and beyond the call of duty.

This book is dedicated to Adam Parfrey—the leader of the pack—for your independent nature, for blazing the trail and showing the way, and for believing in and guiding this project; and to Jessica for forging ahead with the mission. Thank you to Christina, Laura, Meg, and all at Feral House for defending the free flow of unpopular ideas and challenging information. Adam Lives.

RIP to all of those who have passed on. This book is not a glorification of violence. Its purposes are purely historical and cultural.

RIP card designed by Keith Campbell. Selected and edited by Damen Corrado.

Table of Contents

```
FOREWORD by Anthony Haden-Guest /////////////////////////////  10
INTRODUCTION ////////////////////////////////////////////////  14
PREFACE by James "Jinx" O'Connor ////////////////////////////  42
1. "OLD SCHOOL" /////////////////////////////////////////////  58
2. ROYALS: "NO PITY IN SIMON CITY" //////////////////////////  120
3. FOLKS: "ALL IS ONE" //////////////////////////////////////  156
```

4. GAYLORDS: "GOD FORGIVES, GAYLORDS DON'T" ///////////////// **214**

5. PEOPLE: "ALL IS WELL" /////////////////////////////// **256**

6. DEUCES: "KILL OR BE KILLED" /////////////////////// **324**

7. PARTY CREWS: "WE DON'T DIE; WE JUST GET HIGH" //////////// **344**

KEY TO GANG ABBREVIATIONS ///////////////////////////// **368**

MAPS OF GANG TERRITORIES //////////////////////////// **370**

Foreword
by Anthony Haden-Guest

New Yorkers are not pushy—hell no—but when it comes to the culture that blossomed on the streets and in the clubs, the citizens of the Empire State do like it to be known that their city rules. They do not, for instance, necessarily react favorably to the information that flamboyantly over-the-top public sex was on the menu in San Francisco long before Plato's Retreat was a glitter in anybody's eye, that there was a hardcore punk scene in Los Angeles, and that tagging arguably began in Philadelphia. And for New Yorkers it is a given that street art is a New York phenomenon which has gone gloriously global.

Certainly there's much truth to this. The signage which first grabbed public attention on New York subway cars and was certified by Charlie Ahearn's 1981 movie *Wild Style*, has become a durable element of the pictorial vocabulary on streets worldwide. You could likewise make the case that it has been this firm New York grip that explains why the wholly different pictorial vocabulary, forms of lettering and baroque cultural practices that developed in the street culture of Chicago, despite their hypnotic intensity, remain—to steal a phrase from that culture—an Insane Unknown.

The New York/Chicago difference is organic. There was already a strong gang culture in Chicago in the '50s and '60s, and photographs of street graffiti there date from at least the early '60s, well before the New York phenomenon, but it wasn't just a difference of timing. From the get-go the New York graffitisti epitomized the culture caught by Tom Wolfe in his August 23, 1976, *New York* magazine cover, *The "Me" Decade*, because their motivation was to get Me, Me, Me up on as many surfaces, and in as many far-flung places as he or she—there was an occasional she—could reach.

In Chicago, though, writing graffiti was not an assertion of individual will and need, but a gang thing, a turf marker, a declaration that we are here, and if you're a rival, you'd better not be. Not that the street gangs in Chicago had all chosen a culture of control and violence. The gangs, which were often known less aggressively as "clubs," often began as athletic associations, car clubs, and, from the '80s on, as "party crews," formed to do just that, to party. One club had begun as a softball team; another, Orquesta Albany, as a salsa band. But, yes, there were burglary rings and omnipresent narcotics; the credibility of a gang depended upon its ability to protect its turf, and both the softball team and the salsa band had gone to the dark side.

Compliments of Chicagohoodz: Chicago Street Gang Art & Culture

Street culture in New York has known violence. Indeed, the death of Michael Stewart after his arrest for marking up the wall of the 14th Street subway station wall in 1983 has become a historic reference point. In Chicago, though, assassination was a regular fact of life and its street culture reflected this, as can be seen in the gang names, with its hectic mix of old-world titles and present-day brutality, and as can also be seen in that uniquely Chicagoan form of street literature: compliment cards.

These began as a parodic borrowing from the business cards which are routinely handed out at any get-together of Chicago's business culture. They were sometimes handwritten but usually printed, in which case their format is the identical white oblong, but the messaging has been borrowed from the invitations to dances and the like thrown by the aspirational youth groups of yesteryear known as social athletic clubs. In the hands of the gangbangers the cards crackle with inventive wordplay, including the names of the club handing out the card, and listing gang members.

A card will sometimes include ominous and/or jocular sayings like *Clubs That Are Doomed* and *Sworn to Fun/Loyal to None*, and, as the gangs' control of printing technology developed, there would be images, initially generic, such as skulls, daggers, top hats and hearts, but some of which seem peculiar to Chicago street culture, such as Playboy bunnies, sometimes with the ear bent, pairs of dice, poker hands, devilish pitchforks, broken stars and the hand language used by the deaf.

And then there are the antiquated martial and feudal images, such as knight's casques with plumes, the two-headed eagles holding scepters, and plump crowns, sometimes upside down as a death threat. Because these cards were weapons too, of course, wielded in "card wars."

Jinx O'Connor, a Chicagoan who has been looking at the gangs up close since his late adolescence, and who put together most of the material you will see here, observes, "They would draw disrespectful images. Like maybe a Gaylord would have an image of a guy in a Ku Klux Klan outfit,

holding a Simon City Royals' Playboy bunny in a noose. They would make a stack of fifty or a hundred or whatever, and they would bundle 'em up with a rubber band and go over to the rival gang's neighborhood and throw it onto their corner. Or if they knew where this rival lived they would throw it in front of their house." Like so much else, the use of compliment cards has been more or less wiped out by the Internet, and they have ascended into the afterlife of collectibles.

Gangland wear—the sweaters, the patches—was similarly customized. A Royals patch featured two black dice, a crossed scepter and machine gun, and a black Playboy bunny emerging from an upside-down blue top hat. The Insane Unknowns had one featuring a hooded man holding a rifle and crossed sabres. And these items were prized. The wearables had the significance of uniforms, the compliment cards were ritualistic, bombastic. But nothing had the significance of the art that signified a gang's terrain: the murals on their walls.

The images used in these murals can be naturalistic, but they often channel old-school comic books. These devils and red-eyed bunnies are powerful, devoid of cutesy charm, and the language and lettering that presents them is integral and key—the "Dukes," the "Knights," the "Kings," the gleeful usage of archaic words like "Thee," never uttered in the United States, except perhaps by cults—and while they crop up elsewhere, they certainly seem to have become more rooted in Chicago than anyplace else. It's a highly specific look, faux-Medieval, bringing Mötorhead album covers to mind, the logo of newspapers such as *The New York Times*, and the texts that accompanied Hollywood movies about, say, King Arthur and the Knights of the Round Table, movies of the sort that were still current back in the '50s, the era that saw the birth of the Chicago gangs that were the ancestors to those that made these murals.

How important were these murals to the life of a Chicago gang? Well, they don't just function as works of art, but like the statuary of Imperial Rome, they also imprint images of power and control. Jinx vividly remembers seeing a mural that had been painted by the Cullerton Deuces: "As you get closer to the actual corner they are claiming, you see an elaborate emblem they have painted, a 'crest' so to speak," he told me. "That particular piece, which was done very well and which took them time to do, would be a sacred emblem that they would guard 24 hours. And if a gang had come in and crossed something out, they would feel that it was necessary to remedy this, to fix that, so that people would know that this was still the Deuces' neighborhood. But if that tag that got crossed out had sat there for a period of time, it would have been seen that the gang that runs this neighborhood is now getting weak. So therefore, another gang will continue to tag that wall with *their* emblem. And that is the precursor to them taking over the neighborhood. If they were able to cross it out or splash it, well, that's the ultimate disrespect. And that is going to cause somebody to die." •

Compliments of Chicagohoodz: Chicago Street Gang Art & Culture

The Aces were from the Italian Grant Works neighborhood in Cicero. They wore black and silver jackets and were more of a gang than a social athletic club ("SAC"). They fought often, and with bats and chains at that. Dice and playing cards accent games of chance and the gambler's lifestyle, and thus mesh with the playboy image so prevalent amongst Chicago gangs. Courtesy of the Chicago History Museum.

Compliments of Chicagohoodz: Chicago Street Gang Art & Culture

Introduction

Complimentary Colors

FOUNDED BY FRENCH-HAITIAN TRADER Jean Baptiste Point Du Sable in the late 18th century, and incorporated in 1837, Chicago rapidly established itself upon the shore of Lake Michigan as the metropolis of the Midwest, the nation's "Second City," and a booming industrial hub of both commerce and crime. Cubs v. Sox rivalry notwithstanding, Chicago's three "sides"—North, South, and West—were traditionally united by working-class, blue-collar values, and defined throughout the 20th century by three primary racial or ethnic groups: white, black and Hispanic, all drawn by the promise of work in its steel mills and slaughterhouses.

Chicago has always been a city of neighborhoods, often named after the local park or parish. As European immigrants rushed to take advantage of the city's growing industry in the late 19th and early 20th centuries, they created communities reflecting their hometowns. These neighborhoods were dominated by certain ethnic groups, be they Irish, Germans, Poles, Greeks or Swedes—everyone had their own little enclave, and they rarely accepted outsiders. In those days, there was no mixing of ethnicities. Strangers were not trusted, and although some were feared, most were detested. There was a hierarchy among the Europeans, with different nationalities believing they were better than others. White Americans who descended from the colonists looked down on the Italians and Irish, believing them no better than "the blacks," and treating them as such. The Italians and Irish in turn looked down on the Greeks, whom they viewed as barely European.

The story of Chicago's street gangs begins with these migrants. Soon after their arrival in the city, tribes of youths almost naturally formed their own gangs (widely known as "clubs"), or joined already established ones. Within every neighborhood lay a collection of young hoodlums, ready to defend their turf at any cost. They called themselves by many names, but most reflected the neighborhoods they lived in, the corners they hung out on, or, more often than not, their heritage. In the beginning—almost without exception—these clubs were predominantly ethnic, restricting membership to

those of similar ancestry who lived in the same 'hood.

The Irish joined "social athletic clubs" (SACs) that engaged in electoral fraud on behalf of the Cook County Democratic Party. Young future mayor Richard J. Daley's Hamburg Club was one such gang. Neighborhood peer groups of delinquent Italian youth like the 42 Gang and Taylor Street Dukes gradually evolved into, or became farm teams for, the Chicago Mob (the "Outfit"). Cook County Commissioner Frank Ragen's "Colts" had a hand in both ballot-stuffing and bootlegging. By the mid-20th century, the city's Irish and Italian demographics had both institutionalized—into city machine-style political and organized criminal enterprises, respectively.

When a new youth movement arose in the post-World War II years, the descendants of these European immigrants would form "greaser" gangs throughout the city—bands of working-class juvenile delinquents and automotive enthusiasts with slicked-back hair and leather jackets. Although the term originated as a put-down for both Italians and Mexicans—in reference to mechanical labor as well as ethnic stereotypes—by the 1960s and 1970s it would become the banner under which white gangs like the Gaylords, Popes, and Jousters would resist black and Hispanic migration.

Urban African Americans had initially migrated north during World War I. This "great migration" was restricted by real estate "covenants" to a narrow strip on the South Side called the "Black Belt," directly east of the Irish bulwark of Bridgeport. There they were met with the same discrimination they had fled from in the South. During the summer of 1919, the stoning and drowning death of 17-year-old Eugene Williams at a South Side beach led to a conflict between the Hamburg Club and Ragen's Colts on the one hand, and black residents on the other. This climaxed in a riot which left 38 dead and hundreds wounded.

Around World War II, another migration of rural blacks from the South commenced, and to accommodate the influx, public housing complexes were developed. High-rise modernist projects such as Stateway Gardens, the Robert Taylor Homes and Cabrini-Green kept concentrations of poor blacks segregated from the rest of the city. These structures were purposefully allowed to deteriorate and become crime-ridden through policies that were designed to break up families and to ensure there wasn't enough money to properly maintain the buildings. Additionally, the police and emergency services would refuse to patrol or answer emergency calls, thereby emboldening criminals.

By 1960 the first modern black gangs had formed: the Vice Lords in North Lawndale, Blackstone Rangers in Woodlawn, and the Disciples in Englewood. These three groups would all expand into highly organized "super gangs" through mergers and hostile takeovers, and make ill-fated attempts to reinvent themselves as community organizations. They would also become the dominant gang forces on the South and West Sides, founding the Folks and People gang alliances in the late 1970s.

During the 1960s, as the growing black population spilled over to the West Side neighborhoods of North Lawndale, Garfield Park and Austin, the Caucasian exodus to the suburbs known as "white

Top to bottom:

At the peak of compliment cards, white supremacist groups would hit the public schools in an attempt to recruit. Their calling cards got added to the mix; this one was defaced by Kaos from the Cullerton Deuces.

Right before the Cabrini-Green housing complex was torn down in the 2000s. A series of high-rise towers erected just blocks away from the affluent Gold Coast and Magnificent Mile, these buildings obtained nationwide notoriety for the violence and gang rivalries responsible for the deaths of many, including seven-year-old Dantrell Davis, caught in the crossfire in 1992. The Gangster Disciples were the dominant gang, but the Mickey Cobras controlled individual buildings.

flight" advanced. Nothing sells, or increases violence, more than fear. Capitalizing on that fear were the "panic peddlers": real estate agents who purchased housing cheaply from scared whites, then flipped it back to blacks at a profit. Their white neighbors would then move further northwest—and eventually out of the city itself. The civil rights and Black Power movements further inflamed racial tension, and the lines began to be drawn.

Chicago businesses first recruited from the border towns of Mexico in the early 1900s as cheap labor for the railroads, and then again in the 1940s in order to fill the positions left by those who had gone to fight in WWII. As Americanized Mexicans came to the West and South Sides in the late 1950s to work in the railroad industry, their children formed gangs like the Ambrose, Counts, Spartans, and Rampants—most often in response to resentment toward the new residents by the local youth. These Mexican gangs would in turn antagonize and rob migrant workers called braceros, or "brazers"—unassimilated Mexican immigrants in cowboy hats, who invested their life savings into jewelry.

Concentrations of Puerto Ricans migrated to Chicago in the late 1950s and early 1960s, creating communities and gangs of their own, eventually making Humboldt Park on the North Side their homeland. There, the fearsome Latin Kings began as a civil rights organization to resist discrimination, mostly from working-class whites in pre-existing gangs. During the 1970s, Puerto Rican gangs the Latin Disciples, Spanish Cobras, Imperial Gangsters, and Latin Eagles would bind together in a tightly knit front called the United Latino Organization (ULO), to combat the remnants of the 1950s greasers—now mobilized into a coalition named the United Fighting Organization (UFO), designed to halt the rapid spread of Hispanic migration northward.

But perhaps "the most dangerous and lawless elements of Chicago's fast-growing migrant population" constituted its "hillbilly problem," according to the *Chicago Tribune* in 1957. These southern Appalachian laborers' most familiar settlement was in Uptown, yet this demographic scattered throughout the city, to become one of the most denigrated yet enduring elements of Chicago's ethnic tapestry.

As demographics shifted and neighborhoods changed, the poorest whites weren't able to run when everyone bailed out. They often ended up getting along and joining clubs with their new neighbors. The Esquires, formerly of Pilsen, are a great example of a mixed-race gang, largely comprised of Mexicans and Italians. All that mattered to them was whether you were from the neighborhood, not your race. The Esquires called it quits in the early 1970s, just as deindustrialization began to uproot factories, decimating the work force that made up their ranks. Additionally, as the jobs left, the former industrial working class slid into poverty and increasingly turned to drugs. Many Jr. Esquires became addicts, effectively leaving the gang life for the life of the needle. Those gangs who were still driven by race or territory found themselves a cause, while others saw new economic opportunities.

White flight, the decline of manufacturing, and drug abuse all played a part in the eventual fall of Chicago's white ethnic population and its gangs. Already

FIRST ANNUAL DANCE

GIVEN BY

ALTROCKS S.A.C.

SAT., FEBRUARY 19, 1949

KUBAL'S BALLROOM

31st ST. and CENTRAL PARK AVE.

MUSIC BY

KAY BLAKE'S ORCHESTRA

ENTREE 8:30 P. M. ADMISSION 75c Tax Incl.

Compliments of Chicagohoodz: Chicago Street Gang Art & Culture

Club cards from 1920s Cicero. Many athletic clubs ("AC")—also known as "social athletic clubs" (SAC)—were just as they proclaimed, but gangs from that era, like those involved in the 1919 riot, also referred to themselves as such. Their aesthetic carried over to the gangs of the 1950s and beyond.

in decline by the mid-1980s, they, as well as gang alliances along racial lines, were on the way out by the 1990s. Although they still exist in pockets and suburban outposts, what remains of the city's working-class white youth are now more likely to join traditionally Latin gangs.

As gentrification spreads to low-rent neighborhoods once occupied by working-class or poor of all races, all of Chicago's hoods now face a new threat, as real estate seizes upon opportunities to snatch up property and increase rents in areas attractive to transient tech workers and the so-called "creative class" currently transforming all major American cities into characterless yuppie havens.

Footnote: Although Mexicans and Puerto Ricans were united by language, genuine animosity existed between them as well. Puerto Ricans would brick Mexicans driving through Humboldt Park on Cinco de Mayo; Mexicans disliked Puerto Ricans because they acted "too black."

A Manual of Chicago Style

IT'S NO WONDER THAT A TEENAGER would want to be the cool kid in any neighborhood, and therefore seek a cool group to associate with, whether it be a sports team or a musical group—and a neighborhood social club or "gang" is no different. With this comes the attempt to draw attention to your group with the creation of various types of advertisements. While the local high school may have the school paper, bulletin boards, and pep rallies to promote their team and display disdain toward a rival, the local street gang used murals, sweaters, and calling cards. And like the high school sports team, they adopted rallying cries and slogans, as well as images that reflected their name. Commonly called "emblems," these logos would often resemble medieval coats of arms.

COMPLIMENT CARDS

"Compliment cards," as they were once referred to, likely evolved out of invitations to dances or socials thrown by youth-led social athletic clubs or SACs (as gangs were termed in the 1960s), with the names of the club and its president printed on them:

> *"When we had dances, we would put up posters with the venue's name on it that was hosting the dance, and started putting the clubs' names on there, like 'Almighty Spartans, Death Before Dishonor, Annual Dance' and shit like that. One of the guys worked for a printing company."*
> —Bear, Spartans member and founder of the Jr. Ambrose

Members would come up with a potential design and see if other members liked it. Some gangs were a little more strict, and their designs needed approval before being printed—often in the high school or neighborhood print shop, where one would flip through a design book and pick the style, font, and card stock they liked. Available options included marble chip or 3-D effects, anything to make your card stand out or above. Older cards feature stock images for restaurants or gentlemen's clubs, like top hats, gloves

Top to bottom:

Gang branches are typically named after the street or intersection that runs through it, the park or school in which it congregates, or the suburb within which it operates.

Serving as both nom de guerre and nom de plume, gang nicknames are acquired naturally due to physical characteristics, personality traits, or habitual behavior. They also serve to protect anonymity in criminal organizations, gang members periodically changing them up to stay one step ahead of the law. For example, Danny "Ramos," an Insane Unknown turned Cullerton Deuce, was known over the years as "Lil Kent," "Mr. Cortez," and finally "Kaos."

Older cards from the early days were more about promoting your own club than disrespecting others. It is believed the Centaurs were from the South Side. Their cards are over 50 years old.

Compliments of Chicagohoodz: Chicago Street Gang Art & Culture

25

and cocktail glasses. Many used the crown, the cross, and the cane, as well as beer can or cigarette logos, to make their "crest." Like the Lowenbrau lion, these logos were usually derived from heraldic devices themselves. When the pitchfork came around, many gangs used it, just because it was devious and mean-looking.

Many clubs used the same symbols. Although some weren't official logos at first, gangs often made them official later on. Even if they got the idea from a card, the symbol was already there for them. As technology improved in the late 1970s, people were able to bring in their own handmade designs. One consideration was budget. If you were able to make them for free in high school print class, you had to be there anyway—why not make a print of it? Or even better, make five hundred?

Cards were passed among members and friends, and were used to meet chicks and invite people to the neighborhood for parties and recruitment. Some came with a space for the owner to personalize it with his signature. As with any business card, the member might sign it or underline his name and then say, "Just bring this and tell them so-and-so invited you." A little later, as they became more popular, people traded them like baseball cards, and they were often signed as they traveled from gang to gang. Once in circulation, you can see whose hands the cards have fallen into by the tags or signatures on the back.

Other times, a rival might get his hands on it and draw an offensive image or write a disrespectful slogan. A lot of gangs used to write "suck." Then "killer," and the use of "K" to stand for it, started in the early 1970s, when killing became the norm.

Some gangs created so many cards, they would compete and purposely try to disrespect their main rivals with the most offensive design possible. Some clubs would put a rubber band around a stack of 50 or so cards and throw them on the corner of an opponent. The Gaylords and Simon City Royals were known to do this often.

It's a small world, especially in the streets of Chicago. Gang members first get to know each other through family members from different parts of the city—often belonging to different, even rival clubs—and social functions like parties.

Then they meet at school and in the jails, where they are forced to rub elbows with members of other groups, rival or not. Prison is often where the biggest and most important decisions were made, because that's where the presidents are. Before the courts decided it was a good idea to separate the streets from the bosses, by putting them in supermax prisons and cutting off communication to the outside, this was where wars in the streets were ultimately decided.

Each card tells a story of its own: who the members were, which club they belonged to, its specific branch or section, its allies and foes, and its deceased. They came in various sizes and styles, some more elaborate than others, with a great deal of time and effort put into the designs. Prices varied, depending on the paper and quantity of cards made. Their market value today also depends on the organization: if it is active or extinct, which section or branch it's from, if it's rare, and who is on it. Cards with members who lost

Compliments of Chicagohoodz: Chicago Street Gang Art & Culture

27

their lives in action hold a lot of value and are the most sought-after. Compliment cards reached their peak in the late 1980s, only to decline in popularity soon after. The practice just seemed to taper off, and after a generation or two it became forgotten. Although still occasionally produced, they are not nearly as common as years ago.

SWEATERS AND PATCHES

Until sweaters became the standard uniform for white and Hispanic gangs in the late 1950s and early 1960s, they wore satin or poplin jackets displaying their insignia. Inspired by high school fraternity sweaters, it was not their price that made the gangs choose sweaters, as opposed to the letterman-style jackets with leather sleeves. Sweaters were more expensive, but they were easier to manipulate or customize with patches, chops and belts.

Bob from Knitting Mills recalls the discussion in the 1960s of what could be done to distinguish the gang sweaters from the high school ones, so people wouldn't confuse the two. Hence the chops—reminiscent of football jerseys—were used, rather than stripes or bars, and the belts came shortly thereafter.

There were only so many colors to choose from, so some would distinguish themselves with different styles—like the location of the chops on the shoulder or sleeve, or with stripes instead of chops. Because their schools didn't have those particular colors, the C-Notes and Gaylords were able to wear sweaters with stripes. Some took that even further, having the number of stripes determine members' rank.

"In those days, we as well as other gangs wore knit button-up sweaters, and on the right side was a club patch. In the case of the Dukes, it was the heraldic device taken from a Pall Mall cigarette package design with the wording modified. It was a proud day when our sweaters arrived from the millinery store that sold school sweaters and jerseys and such stuff. We raised the money for our sweaters by doing snow-shoveling or grass-cutting or one of various chores. We were always on the lookout for odd jobs to make a little money since our families had little money to spare."
—Robert N. Taylor, "neo-folk" artist, and former Taylor Street Duke

Sweaters came in two styles: "party" and "war." To someone who grew up on the South or West Side, all gang sweaters were called "party sweaters."

To others, a solid black sweater with belts was what was considered a party sweater. The idea may have once been that one was worn for battle and the other for a festive or formal setting. There probably were those that owned both, but realistically it would have been expensive for most members to buy two, so they would wear whichever they had.

There were a handful of knitting mills around Chicago, where guys would just bring in their patch designs and have them made. Some would create a design

Compliments of Chicagohoodz: Chicago Street Gang Art & Culture

Top: The practice of inverting and reversing a rival's emblem or initials can be traced back to high school pep rallies firing up their teams. Although allies, there was a period of resistance from the Stone Kents toward the Latin Kings, as the Kings moved in to occupy two of the main Kent sections in Little Village.

Above, left to right: Latin Counts with a Satan Disciples trophy; Orquesta Albany.

Top: Insane Campbell Boys from Campbell and Augusta were allied with the Cobras; the ones that didn't end up joining them joined the Insane Dragons. The Maniac Campbell Boys were associated with the Latin Disciples. They became two different gangs that ultimately ended up as rivals.

Clockwise from above: Latin King in an Arizona Sun Devils cap to disrespect the Satan Disciples; Two Ashland Vikings shirts—one a RIP memorial for a deceased member, the other displaying their intersection and eight-pointed star symbol; Compadres Del Soul hung around Richards Vocational High in the early 1970s, but didn't last too long.

Compliments of Chicagohoodz: Chicago Street Gang Art & Culture

Top: A mannequin in a Latin Disciples sweater that a Gang Crimes officer let me photograph. These confiscations would function as trophies for the police as well. Gang members view the CPD as the biggest gang in the city, and many cops act as such. Gang Crimes even conceived the "Insane Fish," a mock gang intended to annoy gangbangers and other police units alike.

Left: Maniac Latin Disciples.

Above: A patch copied by Frank Franco (a.k.a. "Squeaks") from an 18th Street club in Pilsen. Before gangs started drawing up paperwork known as "literature" (organizational rules, regulations and mission statements), the meanings attributed to colors were secondary. Newer gangs may have chosen colors for a particular reason at the outset. As black gangs had used pan-African colors in the 1960s, La Raza adopted the colors of the Mexican flag, while the Uptown Rebels took on those of the Confederacy.

from prison, send it in, and pick it up when they got out. Sweaters themselves were also available at many sporting goods stores and school supply shops. As the club sweater became a trend, these establishments capitalized on it and started carrying various colors and designs for gang members to choose from. Displaying patches and sweaters in windows and countertops turned out to be a bad idea, as the gangs became increasingly criminal in nature. A few shops became victims of burglary and even smash-and-grab-type theft; Collegiate's on Milwaukee was broken into all the time.

The practice of robbing a rival for their "flag" has been common between warring armies for as long as there have been uniforms. Stripping someone of their colors was the ultimate proof that you had taken their property as a war trophy—a display of strength and loyalty that has always been popular with gangs. As the violence continued to escalate, gangs resorted to shooting rivals for their sweaters. Many gang members were laid to rest with them, and to this day people will order sweaters to bury their departed in.

In early 1980s the CPD outlawed the wearing of gang sweaters in public. When they became illegal, gang members used other styles to advertise allegiance. During the hip-hop era, it was iron-on letters and fat shoelaces. Airbrushed T-shirts became popular in the late 1980s. The early 1990s brought about Starter jackets and hats that seemed to fit gangs' color schemes or emblems well. Bishops wore Texas Longhorns, Counts wore Bulls, Two-Six wore White Sox—not for the colors but because the combined "S" and "O" look like a bunny—L.A. Kings for the Kings, and the Noble Knights wore British Knights.

MURALS

Writing "your name was here" dates back to the Stone Age and has forever been evolving. The practice of street gangs marking territory is no different. When gangs and SACs got clubhouses, some of them would paint their emblems on the front. In the late 1950s, the Gaylords had a big "G" on the front of theirs.

In the 1970s, adding flair to larger and more elaborate emblems became popular. What was once a name on a wall done with a paint brush or roller, was now a full-blown advertisement, complete with the gang's colors, along with carefully drawn out letters and insignia.

Someone would sketch up an idea on paper and the most talented member—or even a neighborhood artist—would execute it. One well-known North Side graffiti artist was often hired by the Harrison Gents and other gangs to do their murals. Some gangs had members that were graffiti writers as well. A good artist in a gang takes pride in their work, and gang members also like to be known—as is displayed in many ways throughout this book.

> "I think I'd done 14 murals. The Latin Count mural from 16th and Loomis, I designed for them. I charged them $900 to paint it. In one day, I did it. I think it was 1980. I said, 'Lookit, I'll come here at 7 in the morning; if nobody's here, you lose your down payment. I want half down. I want a guy with a shotgun over here, and a guy with a .45 over there, because I know how the gang-

Compliments of Chicagohoodz: Chicago Street Gang Art & Culture

Top to bottom:

The Spanish Gangster Disciples on the South Side began as a prison "concept," the North Side branch becoming sanctioned later: "In prison, if you had a Latin guy that wasn't a member of any gang, but was a stand-up guy, everybody agreed that he would be a 'Spanish Gangster Disciple.' Some guys went home and branched out like that."—David Ayala, former Two-Six leader. SGDs off 88th and Commercial. The Counts were a main rival to the south. This may be a memorial to, or a wall by, "Larry." 1991.

Franco belonged to the Junior Latin Counts in the early 1960s, and was involved in finding clubhouses and throwing parties. Franco wanted to put a book out of his hand-drawn club emblems. The Chancellors were an 18th Street gang; it is unknown if they made it into the 1970s.

Clockwise from top left:

"Back in the early 1980s, everyone would party with us in the neighborhood before the wars started."—Vandal, Party People. A joint mural between La Raza and Party People in Pilsen. Historically, both mural painting and blackletter typeface hold a strong place within Mexican culture.

The Latin Kings at Whipple and Ainsley started in the early 1990s, about when I took this picture. On the left door is an inverted Cobra diamond and Royal "R" / cross; on the middle a backwards Imperial Gangster "IG." The right door has a Latin Lovers' "Universal" flipped.

A memorial wall for Ace from the Ambrose, shot by the Party People before a fight, when another Ambrose pulled a pistol. Deceased gang members will have "RIP" placed after their name in respect.

The Gaylords displaying a trophy sweater they more than likely robbed a rival for.

Compliments of Chicagohoodz: Chicago Street Gang Art & Culture

Compliments of Chicagohoodz: Chicago Street Gang Art & Culture

The Chicago gang "handstyle" (lettering or tagging technique) is essentially blackletter or "Old English" calligraphic script modified to be executed in a single-line with a marker, pen or spray can for quick hits. While L.A. gang graffiti had an Aztec flavor, with Xs and square lettering, and New York emulated outlaw motorcycle clubs with biker typeface, the distinctive Chicago gang style highlights medieval heraldry and gothic lettering, as seen in the gang crest. Within this approach, both regional and generational variations have evolved, but all gang taggers will painstakingly craft their letters in respect to this tradition, as readily seen in the definitive way the S curves, or the horizontal part of the L hooks. An artist in a gang will often develop a personal style that the gang then adopts as their own. This can be seen in the Noble Knights, Players, Counts, Gangsters, etc. The Gaylords can claim ownership of their squarish G, as well as lowercase A and O, and generally elongated lettering.

"The traditional emblematic method would be full-blown Old English in a bold outline with a wider font, and the body inside highlighted in both gang colors. For quicker, smaller tags, many would use a generic single-stroke Old English in one line. Your capital letters would still have the hooks that would come off the side on the descender. Or they would have that double line, but it wouldn't be the full treatment. It's a matter of time. They want to do it in a quick manner without getting shot in someone else's territory. Back in the 1990s, calligraphy kits were a standard thing you would get in any art store. They came with a sheet of paper that had about eight different specific Old English fonts, and little arrows showing the angle of the pen. For example, on the bottom of every upper-case Old English letter are elegant hooks on the bottom where the pen stroke carves to the left an swings upward to the right. Different artists have different abilities, and a personal style will emerge if a tagger wants an Old English effect but has limited artistic ability and time. These styles—even within a gang—varied from section to section, and from neighborhood to neighborhood. In any case, this regal lettering makes a statement on its own. There's a certain power in that font. It says, 'We mean business.'"—former Two-Six member

bangers are gonna come. If they cut through that viaduct, I want you to hit 'em.' So, I put up my scaffolds and put on my whites, and the cops were driving by and they didn't know what I was doing. I drew a new emblem for 'em."
—*Rufus*

Gangs are mostly about turf, so you would primarily find their emblems in their neighborhood, whereas graffiti artists were about "getting up" in as much of the city and suburbs as possible. Gangs would surround their territory with initials and symbols, and near the corner that they represent or the place where meetings would take place, there would be a mural displaying the gang's crest. Other pieces might include a "diss" toward an enemy, and then there are the murals done in memory of those who have passed on. Gangs would forever try to guard their walls, just like they would watch for a rival to come get his sweater or desecrated mascot hanging from a lamppost. It was always a practice to splash a rival's emblem, especially with paint in your own color, often in a baby food jar. Running up and drawing your gang's emblem over it is much bolder, since there's a good chance someone is posted up on a rooftop, doing coke all night while keeping an eye on that mural, hoping to catch someone defacing it. These taunts lure rivals into the 'hood, as one of the attractions of being a gang member is the adrenaline rush of taking excessive risks and proving yourself.

When the police started cracking down on gang activity in the 1980s, they implemented task forces and D.A.R.E. programs, reaching out for more community involvement. Departments started confiscating cards and sweaters, and cops were messing with anyone wearing gang colors. Public schools followed with dress codes of neutral colors (beige pants and white shirts were most common). Now aware of gang representation through various media, schools addressed it accordingly, as did the schools' print shops. At the same time, hip-hop culture made the practice of graffiti popular among youth beyond gangs. Chicago banned spray paint—mostly because of graffiti artists—and increased the penalty for it too. You now do time for any kind of graff, but cops would also threaten the gangs with heightened presence for gang tags.

The graffiti task force was created, and in 1993, Graffiti Blasters became part of Chicago's public works. Laws have continued to expand in order to curb graffiti over the years. The gang style has since evolved into a quick Old English outline, thrown up in seconds. They don't put the effort into it because in a day or two it will be a brown wall again.

African-American Gangs

AFRICAN-AMERICAN GANGS ARE represented in this book, but not covered in depth for a few reasons. Chicago was, and is, one of the most racially and ethnically segregated cities in the United States. Even the relationships developed that allowed exploration of various white and Latin gangs would not have permitted the same entry to black gangs and their neighborhoods.

Historically, black gangs have been the subject of much publicity over the

Top to bottom: A RIP memorial for a member of the Latin Souls; a Latin Counts crest by Rufus Linus, a Spartan who later became a professional artist. His work can be seen on business signs, as well as in Chicago schools.

years, and in many respects were far more advanced when it came to the business end of gangbanging. In the 1960s, 1970s, and early 1980s, organizations like the Vice Lords, Black P-Stones/El-Rukns and Gangster Disciples have made headlines, either by trying to create community programs via government grants, or through major racketeering cases and gun violence. These gangs were born as a reflection of a broken society, and therefore have created a mindset that this lifestyle is the only chance of survival. To many people in the most desperate of communities, gangs are a real and visible opportunity to rise above poverty, while others in Chicago have generations of business or political connections through family and friends.

Graffiti in black neighborhoods was more functional and less about style—more about marking territory than trying to make it fancy. An impressive mural would be done in a clubhouse or meeting place, but they just weren't caught up as much in the stereotypical Old English approach. Many of them were more focused on the business of making money through drug territory than anything else, whereas there was a certain amount of bravado involved for turf gangs engaged in the large-scale mural movement.

Wearing colors would have just been your clothing combination, as opposed to a particular uniform; you would not see a black guy in a sweater unless he belonged to a Latin or white gang. The beret was standard for the black gang member in early 1960s Chicago and New York City. The style spoke for a changing time, and it spilled over to other gangs and socially conscious groups as well in the following years. Disciples wore blue berets; Stones wore red—those were their gang identifiers. The Warlords and Latin Kings wore them as well. When the Black Panthers and Young Lords started to wear berets, they became more of a revolutionary item. In Pilsen there were the revolutionary Brown Berets, while racist South Side kids started the White Berets, adopting them in response to the Panthers. Even the crime-fighting group the Guardian Angels fell into it too, donning red berets at the tail end of the trend. Rags and bandannas were worn as well, by both blacks and whites, in the early days.

Vice Lords and Black Souls cards have been seen, but black gangs were somewhat socially separated and just didn't compete as much for flair and flash. Nonetheless, the iconography of these gangs shaped the entire visual language of the city landscape. The creation of the Folks and People gang alliances in 1978 are credited to the Vice Lords, Black P-Stones, and Black Gangster Disciples—along with the omnipresent pitchfork, five and six-pointed stars, and right vs. left identification scheme seen in much of the work contained herein.

Compliments of Chicagohoodz: Chicago Street Gang Art & Culture

Top to bottom:

A lot near Kostner and Madison in Garfield Park on the West Side, a.k.a. "Ghost Town." After Willie Lloyd's release from prison in 1992, there was an upsurge in Unknown Vice Lord (UVL) graffiti. "GTP" = Ghost Town Posse.

4 Corner Hustlers and their associates the Unknown Vice Lords in the K-Town area off Kostner and Chicago, 1989. This may have been the name of the section, to reflect an image of insanity. The 4CH and VLs' relationship was on-and-off.

"Doom Room" may have been the name of a "violation" (gang-imposed beating punishment) room for the Travelling Vice Lords, or simply used as a warning to trespassers. Harrison and California area.

A view from the south side of the "L" (elevated) tracks looking northwest toward Washtenaw one block before 21st Street. Two Cullerton Deuces murals on the rooftop for the passing train to see. When riding around Chicago, graffiti was everywhere and there was no mistaking where you were.

Preface by Jinx

I GOT INTERESTED IN STREET GANGS early on as a kid. I grew up in the near western suburbs of Chicago, about five miles west of city limits in the town of Riverside. This sheltered island of middle- and upper-class residents was surrounded by blue-collar towns like Brookfield, Lyons, North Riverside, Cicero and the city of Berwyn.

A lot of popular movies and books of the time period like *West Side Story* and *The Outsiders* had captured my attention, as well as some of my new neighbors in grade school talking about gangs from their old neighborhoods. I saw it as romanticized camaraderie, a brotherhood of people who think alike and would back each other up.

After I started high school in 1979, a family moved in a few blocks away from me. They had a couple kids my age; one was named David. He had the same appetite for partying as my friends and I did, and so we became friends quickly. He was Puerto Rican and Mexican, which made him a little darker than most kids at our school. For that reason, he was tested often by the local tough guys and always won. He was a real badass but never acted like one. He never had anything bad to say about anyone and never started trouble.

Dave came from an area in Little Village known as "K-Town" because all the streets start with "K." His family moved out of the city because the Latin Kings were shooting out the windows of his house, and pouring gas around it in an attempt to burn them out. He took me and my friends back to his old neighborhood and showed us a couple big, elaborate murals painted by the two major gangs in K-Town. One was the Ridgeway Lords, an older gang that was still mostly white. Two-Six was the gang that Dave belonged to, and he showed us their mural: "a big Nestlé Quik-looking bunny" is how they described it, with dice on each side, one showing two dots and the other showing six. I'd seen some impressive graffiti from the "L" train, but hadn't seen an actual mural before.

Seeing that got me more interested in gang culture, so I would ask Dave about it and try to learn more. His older brother Reuben told me about an Imperial Gangster mural he had once seen that covered the whole back of a factory. It was in their colors of black and pink and was painted to resemble a compliment card. He said they had guys guarding it 24 hours.

Dave's mother worked very hard to try to get her children away from the

gangs. She made them throw away all their memorabilia, compliment cards, and beige-colored clothes. They knew I was interested in that stuff, so they gave me what they had left. Between Reuben and Dave's sister Vicky, I now had a stack of cards.

In the summers I got a job working for a lawyer's office, running envelopes around the Loop. I used to take the Burlington Northern commuter train downtown and, while riding east through the city, would daydream about life in Little Village, where I would see "Two-Six" painted, and East Pilsen, where I would see "Kool Gang" on the walls. Then I started taking the "L" from Cicero, which was a more colorful journey. There I'd see Two-Two Boys and Gangster Disciples tags. The train would begin to elevate above the rooftops, which I loved, and I would see graffiti from the Latin Kings, Stone Kents, Deuces, Royal Cavaliers, Satan Disciples, Future Boys of Hoyne, Tokers, Ambrose, Latin Counts, Bishops—pretty much in that order too. Then the train would travel east, and looking down on California Avenue, I would see "SKN" (Stone Kent Nation), or the Satan Disciples would have "KKK" painted on California, just north of the "L" stop, which stood for "King Kent Killers." Moving east, I would see "Deuces," then past the railroad tracks I saw "Royal Cavaliers" painted real big by Leavitt, and then more "Satan Disciples" passing Damen. On garages there was "Ambrose," and on rooftops, "Future Boys of Hoyne." And as the train turned around Wood Street, I'd see "Bishops," before it crossed another set of tracks and the neighborhood would change again.

In the late 1980s I joined a volunteer group that set me in the area of Ashland and Division; back then, that neighborhood was still pretty rough. I started to notice the different gangs around the area and the murals they did. I started taking pictures of them, but only when I came across them. I didn't think to look for them, until one of the guys from the program told me of a martial arts gym near Wrigley Field that a Gang Crimes officer owned, which had some photos on display. I went there and was taken aback by the photos of murals, some by gangs I'd never even heard of. I was fascinated—so much so that for the next 25 years, every moment of my spare time was spent driving around Chicago, trying to learn as much as I could about this subculture.

I decided to concentrate on taking pictures of murals, and one of the first places I went was back to Little Village. I rode my bicycle up 27th and found Ridgeway Boys graffiti. That was new to me. Rode around by the Party Gents by 25th. Most of the time, I drove. I went by the Spanish Cobras and found a R.I.P. wall for Loco, Lefty, Shadow, Coco, Face, New York, Tommy, and KC. The names were in a scroll, with an emphasis on the "SCN" for Shadow, Coco, and New York. The police didn't make a big deal about the memorial but made them fix the SCN part.

One day, I was taking a picture of the wall when a bunch of Cobras came to see what I was doing. I said I was writing a book. At the time, all I knew was that I wanted to share my interest through photographs. They had a white limousine and drove me around their neighborhood. This wasn't in my plans.

I would keep going back there to take pictures, but I was still a rookie with no

Top to bottom:

Sin in front of the Spanish Cobras' Artesian and Potomac wall. "I better not see this picture in a police station," the Cobras told me.

With the Cullerton Deuces.

idea what I was going to write. Then, as I drove around and started talking to more gang members, I had to gain their trust and convince them that I wasn't trying to get them in trouble with anyone—police, rivals, or even their own club. I promised no faces or real names without permission.

When I would go out there, there'd be a guy on almost every corner ready to sell me a bag. At that time, that was the only reason a white boy would be riding through those neighborhoods. That's what the cops thought too, and so my car and I were searched often. Once, some tactical officers drove up and snatched my camera. They asked me where I was from, then started bitching, "These guys have to live here. Get the fuck out of here—I don't want to see you again!" The Satan Disciples had a big emblem at 18th and California. I was in the middle of the street getting ready to take a picture of a guy in front of it, when I looked to my right to see the grille of a cop car. "What the fuck are you doing? This is the kind of thing we're trying to get rid of, and you're hyping these guys up!"

Eventually, I was more worried about cops than gangs. They'd see me coming out of an alley and put me against a car or have me sit on a curb while they tore my car apart, looking for drugs. They weren't too crazy about what I was doing.

I got a job at Loyola University and became friends with a guy named Pete. Just goofing around one day, I threw up the Two-Six bunny to him, and he threw it back. Finally I asked him, "You Two-Six?" He said, "No, Party People." I didn't know about them. I went out looking for murals one day, drove down 17th Street in Pilsen, came across a Party People emblem—and Pete was standing there in front of it. So I got to spend a lot of time with them.

I made it to other areas, like South Chicago to find the Latin Dragons, King Cobras, and Spanish Vice Lords; and East Chicago, Indiana, to find more Imperial Gangsters, Two-Six, and Latin Kings. I went to Waukegan and Milwaukee to find Insane Unknowns and Orquesta Albany; and to Joliet, Aurora, and Elgin to find Two-Six, Home Boys, Latin Disciples, and Deuces. I got so used to these areas that I'd pick a side of town and make a path. I once found myself around 21st and Washtenaw, where a couple of impressive Cullerton Deuce emblems were, so I got out and started taking pictures. A guy came out and asked what I was doing. He introduced himself as Danny, and later became a good friend.

Danny (a.k.a. "Kaos") introduced me to a few of the Deuces, but when I came around we didn't usually hang around them. I think he was keeping me from getting myself in trouble. I would go there a lot. I would pull my car up and usually see him with the guys. One night I got out of my car and one of them says, "Hey, look, someone's tagging the bridge."

The viaduct to the north was the dividing line between the Deuces and the Satan Disciples. Danny ran in and came out with a shotgun. I don't know much about guns, but the shells were solid brass or metal, with one slug, as opposed to the buckshot shells. He pointed it and fired—each shot sounded like two with the echo off the viaduct. BOOM-boom BOOM-boom BOOM-boom. I could see the fire flaring out of the barrel with each shot, followed by the jingling of shells hitting the street.

Compliments of Chicagohoodz: Chicago Street Gang Art & Culture

Top to bottom:

Danny with a rooftop mural, "Demon RIP" at far left. After Danny got out of County Jail the Deuces were at war with the Latin Kings. Demon was set up by a girl who knocked on his door. When he answered, a King shot him.

One of the very first pictures I ever took, in 1988 around Greenview and Pearson in the Noble Square neighborhood within West Town. This is the Ashland Vikings' motherland. In addition to the eight-point star, their symbols are a Viking helmet and a hatchet.

Compliments of Chicagohoodz: Chicago Street Gang Art & Culture

Opposite top: A Satan Disciples tag from their 51st and 42nd set, found in La Raza hood by 47th east of Ashland in Back of the Yards on the South Side.

Above: A Two-Six mural from their "Dark Side" section. "Originally the softball team had three dots. The heart, diamond and club—a lot of that stuff didn't actually have a meaning. It was just some decorative shit. Some of it did, like the T-Sword—the Two-Two Boys plagiarized that completely—the Ambrose spear or helmet, or the Disciples' pitchfork or heart with wings—anything with horns has meaning. There's official stuff, then there's decorative stuff. They might have given it a meaning later. I never was crazy about the bunny."—David Ayala, former Two-Six leader

Most modern gang drawings consist of renderings of their emblem, sometimes noting the section and members' names, along with taunts toward rivals and flipped images of their symbols. These are often executed on whatever paper is at hand. This Insane Deuces drawing achieves a rare level of abstraction in the density and stylization of its lettering.

Compliments of Chicagohoodz: Chicago Street Gang Art & Culture

"Pick up the shells," he told one of the guys. Danny ran in the house to stash the gun, and I ran into the little grocery store on the corner until the cops came and went.

The Deuces pretty much had about four square blocks and the "L" tracks that ran right over the alley between Cullerton and 21st Street. Driving through there, I've had a guy run up on my car ready to take a 2x4 to my windshield. I had a guy run up to the window and put a pistol to my head. I've parked and gotten out in the middle of a gun battle with the "BZZzzz, dink, BZZzz, BZZzz dink" of the bullets passing and hitting the cars parked around me as the shadows of the Latin Kings moved forward from Fairfield and the Deuces came from Washtenaw.

Danny had moved to a garden apartment. I was working nights when his number came across my pager. I called back and didn't get an answer. Tried again, but still nothing. A few days later, I still couldn't get through to him, when I got a call from a mutual friend who told me that Danny was killed. It was a reality check in a way. Witnessing so many shootings and then losing friends to gang life makes you realize how fragile life is in neighborhoods like that.

As I narrowed down what I wanted to write, my questions got better, but I would be nervous about asking the wrong one, and making someone think I was with law enforcement. I have gotten some negative response to talking to people I had just met on the street. Some guys just walked away from me; that happened more often. Some just said to fuck off. I tried to start asking the Spanish Cobras questions, but they weren't very receptive. Pete and the Party People were, but a lot of the time I just liked hanging around there and sort of forgot to ask questions. Hanging out with Danny was more of an experience, but then, like hanging with the Party People, I ended up making friends rather than asking questions. But through them I met Sting from the Insane Deuces, who introduced me to Chicano from the Orquesta Albany and a few others, so in the mid- to late 1990s, I started to really interview people.

I then interviewed an older gang member, who at one point in the interview asked if I wanted to fight, and when I was getting ready to leave, I thought his kids were gonna jump me. I interviewed Pete's cousin Lil' Frank, Hector ("Player") from the Stone Kents, Mr. Big from the Morgan Deuces, Spook and Jake from the Popes, Lenny from the Knights, Todd and Telly from the Royals, and many more. I met Spidey through the Marshall Square YMCA street intervention. And I met others who were willing to donate memorabilia.

In the mid-1990s, the internet was still new to me. I worked in a school that had recently gotten internet access, and when I was done with my work at night I would poke around on it. I came across a Chicago street gang website hosted by Angelfire with a couple images and drawings of gang emblems. But the website consisted of the same bits of misinformation I had seen in other documents over the years. By this time, I had accumulated hundreds of pictures and compliment cards over the previous decade and a half, and I thought I could put a website together with more current information and real photos. I reached out to a friend of a friend, who was studying at IIT and wanted to do a class project, so he took on the challenge of building my site. He was known as "A1,"

Top: Sent in to the Chicagohoodz P.O. box. The back of the old folks home at 21st and Albany was already a Latin Kings section, but was shared with the Stone Kents. That's how tight they were.

Bottom: Sometimes new compliment cards showed up on Chicagohoodz. All For One from Brookfield, Illinois did one in the mid-2000s. Although cards had faded out by then, the website inspired some newer clubs to keep with tradition. The internet was still new to the general public, and as the city's first major gang-related site that wasn't tied to the police, Chicagohoodz blew up. Some middle schools banned it because so many kids were going on it, and it brought old practices back to people's attention.

	B The Don		Vile13
~		All For One	
T	D~Rock		Flip
O	Slikk	Rob.P	
W	Smokky	J	Lukky
N	BigDaddy	Goody	Crybaby

Compliments of Chicagohoodz: Chicago Street Gang Art & Culture

Top: Uptown, 1990. Mongo on the left was an original Chicago Guardian Angel in 1981. Sharon was from Humboldt Park and started in '88. She was down to brawl with any of the guys. Iron Eagle on the right started in '88 as well; I saw him dish out some whoop-ass. The Guardian Angels have lost six members nationwide since 1979.

Bottom: This is probably the best picture I'd ever taken, 1990 or 1991. At the top left are the Party Gents, an old-school group from the original party crew days. Next to them are the Latin Kings of Avers. And on the garage below is a Villa Lobos emblem. That was 25th Street in Little Village.

and he was very good at what he did. I gave him the photos and information, he went over a few designs with me, and within a few months we had "Chicagohoodz.com" up and running in 1998.

"Hoodz" was a reference to both the neighborhoods as well as the "hoodlums" that claim these communities as their own. My interest was in both the people that settled these areas and the development of the teenage social clubs that drifted into deviancy. Another reason I put the site up was I still had more to learn, and I was hoping to gain the attention of older gang members in order to finish my book.

The first people to go on my message board were a Latin King, a police officer, and a concerned mother—which I thought was great, because here were three people from three different perspectives to voice their concerns with each other. This little community was pretty interesting. The conversations were pretty hostile, but within a month they were talking about football and wishing each other happy holidays—in between talking shit.

Letters were starting to come in and I was coming home to about 75 emails a night; it would take me at least an hour to address them all. The number of guests grew. I started getting emails telling me a few things I got wrong or the names of street corners I should add. I would jump in my car and drive out there to see if that was true. I couldn't post something on the website, only to find that it was some rival gang trying to get over. Before I knew it, I had almost every section in Chicago on the site. I would get emails from people thanking me for helping them avoid those corners, and from cops—either hating me, thanking me, or threatening me.

As the internet became broader and more popular, I added a chatroom. Soon, reunions started being formed on it between old friends who had lost contact after they moved out of the neighborhood. I was contacted by the History Channel's *Gangland* about using my photos for a few episodes, which I was happy to allow them to do.

In the meantime, my computer was starting to get hit with viruses, and webpages stopped working. A1 had moved on to more important school projects and didn't have time to help. A couple regulars decided to build their own sites, while others made sites dedicated to their own clubs. Eventually, Chicagohoodz went down.

After a few personal family tragedies, I decided to take some time off and focus on some other personal interests. But Sting kept on me about the book, and introduced me to SS who helped me get back on track. He in turn introduced me to a former Chicago resident and artist now residing in New York who was doing his own book on Chicago gangs.

As I gathered more material for the history book, I started to accumulate more cards and memorabilia, and thought this could be a book by itself. I stopped documenting gang graffiti in the mid-2000s, but I still go out to see what the neighborhoods look like. And I still like taking photos, not just of gang stuff, but of all kinds of things I find interesting.

Compliments of Chicagohoodz: Chicago Street Gang Art & Culture

JOIN THE CHICAGO GUARDIAN ANGELS

DARE TO CARE!

Let's work together in unity—all races, to bring peace and safety back to our neighborhoods.

CALL NOW — 24 HOURS

278-2406

A lot of police compared the Guardian Angels volunteer group to a street gang, but any altercations with gangs were in response to criminal activity. If we showed up in a neighborhood, it was because the residents invited us there. Aside from that, we would stay on the "L" trains to deter crime, defend the defenseless and act as a positive role model for kids.

Compliments of Chicagohoodz: Chicago Street Gang Art & Culture

Previous spread: The Playboys from West Town seated around a meeting table. In the early days, social agencies like the YMCA would have "street intervention workers" try to iron out inter-gang rivalries in order to prevent wars. The gang jackets as opposed to sweaters indicate the late 1950s / early 1960s. Note the Playboy emblem on the member far right.

Above: Judging by the knicker-clad youth, this image dates from the 1930s. Pool hall hangouts were synonymous with delinquency; even for adults they were known to attract a questionable crowd. Both photos courtesy of the Chicago History Museum.

Compliments of Chicagohoodz: Chicago Street Gang Art & Culture

chapter 1
"OLD SCHOOL"

FOR THE PURPOSES OF THIS BOOK, the term "old school" refers to any club whose heyday was prior to the institution of the Folk and People Nation gang alliances in 1978 (see Chapters 3 and 5). Some did continue into the 1980s, but for various reasons their presence was greatly diminished by then.

When comparing post-World War II 1950s "greaser"-era gangs to those of the late 1960s and beyond, the difference is stark. People tell stories of a day when they took pride in their neighborhoods—the same neighborhoods that are now by-passed while taking the expressways to their jobs downtown from the suburbs. They would tell tales of their club hosting dances in the local church basement or community center, or opening a clubhouse of their own, complete with a jukebox, pinball machine, and pool table. It was still common in the 1960s and 1970s for gangs to hold dances as a way to raise money. They also gave any musical groups within the gang an opportunity to perform. Gangs would compete with each other to see who could have the "best dance."

"Most of the fights that occurred with other white gangs found their focal point at various dances and sock hops held at parks and schools in the area. This was both a pecking-order game as well as concerning the girls who attended these dances. If a member of another group made a move toward one of the ladies we considered ours, there would be fighting as a result. I cannot today count the number of altercations that occurred by way of school dances. Dances of course were announced ahead of time, and if we heard that a particular group that we didn't like would be there, it was a focal point where we could attack them out of their known enclaves."
—Robert N. Taylor, former Taylor Street Duke

Although a deviant youth culture, most gangs had an element of respect for civilians, property, and each other, and like most teenagers and young adults,

were preoccupied with dating, racing cars, and playing sports. Of course, there were neighborhood turf rivalries, but delinquent behavior was on the level of drag racing and maybe an organized fistfight. While the stereotypical "rumble" did happen on occasion, most fights were one-on-one between the two disgruntled parties—usually over a girl.

Quite often, if there was a rumor of a gang fight scheduled, an anonymous telephone call would be made to a social worker or the police before anything would happen, and the rare involvement of firepower usually was limited to a .22-caliber converted car antenna known as a zip gun. Nobody was really trying to kill anyone.

> "In those days, guns were seldom used with the exception of homemade ones: zip guns, as they called them. They generally fired .20-caliber shots, and they were composed of a threaded rod or car antenna length that was set into a carved-out wood handle wrapped in electrical tape. Usually, we used heavy rubber bands to provide a force for the trigger, which was little more than a nail or a toy pistol hammer sharpened to a point. They were greatly inefficient, and you never quite knew where the bullet would land. They were smooth-bore and hence the shot was not as tight as you'd get from the spin of the bullet with a rifled bore. I recall shooting at another kid in a fight and aiming at his gut, but the bullet grazed his kneecap instead. They were almost as dangerous to the shooter as to the one being shot at."
> —Robert N. Taylor

Gangs of the 1950s and 1960s were for the most part what were often referred to as "social athletic clubs," and with a few exceptions, conducted themselves as such. And the competition, if it wasn't for the club that had the best sports team, was for the club that had the best clubhouse.

The style for the "tough guy" during that period was usually the greaser look, and a lot of the gangs fell into that category. White and Hispanic males dressed in the style left over from the 1950s: Converse Chuck Taylor All-Stars, creased khakis or blue jeans, and white T-shirts. They took pride in Stacy Adams shoes when going out looking good. As time progressed, greasers and gangs eventually became almost synonymous with each other, both representing the working class.

> "In the winter months, black leather Cabretta three-quarter-length coats were the most popular sign of status. Shoes were an important assortment. We all preferred shiny pointy-toed Cuban heels with two-inch heels for dress-up and steel-toed dockworker boots for roughing around in. They had the added capacity to do some real damage in kicking."
> —Robert N. Taylor

Until the mid- to late 1960s, drugs were sold by unaffiliated individuals and looked down upon by greasers and most gangs.

Compliments of Chicagohoodz: Chicago Street Gang Art & Culture

Top to bottom:

The Esquires were a Pilsen "social athletic club" that earned the respect of other social clubs and gangs. They played softball against other gangs from Pilsen, as well as other neighborhoods. Their saying was "We may lose the game, but we'll win the fight."

The Squires were a Pilsen club that hung around Pickard Elementary School on Cermak/21st Place for a while. Patch design by Franco.

"Both downers and uppers were very popular among the street gang members I knew. Yet despite the prevalence of these, beer, whiskey, and wine were probably the drugs most indulged in. Pot began to make its appearance among whites at the time I was about 18 years old or so. Not that it was totally unknown at the time. It just wasn't as readily available in the white community as it was the black community. Generally, we drank white port wine, flavored with Kool-Aid."

—Robert N. Taylor

Drugs were viewed by most as something losers did, until the drug culture became more mainstream in the hippie era. Eventually, the gangs started to figure out that the neighborhood drug dealer was making money and, realizing the power they already possessed in the community, knew that money could be used to fund themselves. This changed the nature of gang culture altogether.

By the late 1960s and early 1970s, drugs had started coming in, and jobs had started moving out. Whereas most gang members up until this point would retire soon after high school and get a job or start a career, those in the more depressed areas started to see the gang as a career opportunity, as did the organized crime figures of the 1920s and 1930s.

The Barons were a small North Side club from the Lathrop Homes public housing development in the mid- to late 1960s. Their colors were gray and maroon. They lasted through the late 1960s or early 1970s, when the dominant presence of the Insane Deuces eventually overwhelmed them, causing the Barons to either become Deuce or retire.

"SAC" stands for "social athletic club." They were neighborhood-based organizations that acted as exactly that: a club for socializing and playing softball or other sports. Some were more legitimate than others, such as the Naturals, Rocky Stars, West Side Royals, West Side Arrows, and Mits. Throughout the 1950s, 1960s, and early 1970s, social workers from organizations like the YMCA and Chicago Boys and Girls Clubs would try to help legitimize street gangs, in order to redirect their energy to more constructive activities, like organized sporting events and fundraisers.

Social athletic clubs were also a part of school culture, funded by the Chicago Public School system, until the mid-1970s. Mather, Sullivan, Von Steuben, and Roosevelt high schools all had SACs—and the girls had their own clubs, such as the Jesters and the ELs (Ever Lasting). They even had junior members, who were elementary school children from feeder pools to the local high schools. When funding was taken away, all those kids who used to play against each other in softball, with a fight here and there, soon found that idle hands are the Devil's workshop.

Recognizing that they could benefit from the legitimacy conferred by the title "SAC," gangs attached the moniker to their emblems and compliment cards. Legitimate social athletic clubs still exist today, like the Chi Ways in Pilsen, a club that consists of community residents, as well as former members of various neighborhood gangs.

Compliments of Chicagohoodz: Chicago Street Gang Art & Culture

Top row: All patch design drawings by Franco.

Middle row: Griffins patch design by Franco, early 1960s. The Griffins were started by their president, "Babe." Like Franco, he later became an Esquire.

Bottom row, middle: This ticket granted admittance to the Harrison Gents' sixth annual dance in their original 'hood. "They were mixed. They had this band called The Meditations. So they were sort of neutral, cos everybody liked them as a band."—Jack Walls, a.k.a. "Hi-Fi," former Morgan Deuce

"We didn't call ourselves gangs. We said 'club.' We didn't say, 'What gang are you in?' That was tacky, almost. We never used the word 'gang' (but we said 'gang-banging'). It was like a sign of respect: 'What club are you in?'
—Jack Walls, a.k.a. "Hi-Fi," former Morgan Deuce

"No one ever referred to themselves as gangs. They all used the term 'social athletic club.' Much of the structure and organization was modeled on La Cosa Nostra or the Mafia, which everyone venerated. In fact, the Dukes, as well as a few other gangs, were recruiting grounds for the Mafia... we had a pledge of loyalty to the group written on a piece of paper. As we recited it, the crumpled paper with the pledge in the palm of your hand was set ablaze. You had to bear the heat of the fire while you repeated the oath and not drop it until it had burned out."
—Robert N. Taylor

Taylor Street

The Near West Side area, directly west of Chicago's Loop, has historically been home to both European and Hispanic immigrants, as well as African Americans, with districts like Greektown and the ethnic Maxwell Street Market. Its Taylor Street neighborhood (a.k.a. "Little Italy") is famous for Mario's Italian Ice and a host of restaurants, but if you grew up in Chicago, it was one neighborhood you didn't venture into if you had no business there. One thing that made Taylor Street such a close-knit, even suspicious, community was the presence of the Outfit. This was the former residence of Al Capone's crew, and still part of his territory long after he'd gone.

Taylor Street was an epicenter of gang activity, and host to the Morgan Deuces, Artistics, Sharks, Vicounts, Jets, Gents, Majestics, Counts, Scorpions, Markings, Challengers, Jousters, Comets, Vikings, and others—most notably the Taylor Street Dukes.

Up to the 1960s, the Taylor Street Dukes were considered Chicago's premier white street gang. Reputed to have mob ties that originated in the Prohibition era, the Dukes were one of the few gangs bridging the eras of the tommy gun and the greaser. They also had a West Side chapter. Robert N. Taylor was a member of this branch during the 1960s:

"One day, a dark-complected fellow appeared in our midst. He had come as sort of an ambassador to bring a message to us that we were invited to join the gang that he represented or they would commence war on us. It was an ultimatum: Join us or fight us. This is basically how the street gangs recruited. At first, we were sort of ready to boot him in the ass and send him on his way, but he was a rather engaging person with a broad smile and seemed a likable person overall. We inquired what the name of his gang was. 'The Taylor Street

Compliments of Chicagohoodz: Chicago Street Gang Art & Culture

In the Near West Side you didn't cross boundaries. There was a public housing section for blacks; rowhouses for Latinos, bounded by Racine; another section where all the Italians lived. One passing through would have to give respect and/or belong to a reputable area gang. However, rather than serving a military function, this map simply documents the locations of various gangs situated in this area. Hand-drawn on graph paper by Franco in 1962.

Above: A Junior Latin Counts roster from the early 1960s. In the process of documenting the gangs of Taylor Steet and Pilsen, Franco also registered the Count's members, cataloging their nicknames and ranks within the gang, even down to their day of enlistment.

Opposite page, top: The Taylor Street Jousters originally consisted of both Italians and Mexicans, their emblem being a knight's helmet, their colors baby blue and navy blue. Most gangs reflect the neighborhood they occupy. If they have a strong presence, as the neighborhood changes, so does the gang. The demographic around that area had been in constant change. The Taylor Jousters that moved to the North Side (see Chapter Five) were in opposition to Puerto Rican gangs, and this branch was no different. The Mexicans would go after Puerto Ricans as well.

Opposite page, middle row, left to right: Like "Hitler," the name "Capone" spoke to power and evil, and took on an element of fear. Al Capone's notoriety struck such a chord within gang lore, almost every gang seemed to have had a "Capone," especially in the earlier days before "Gotti" started popping up in the 2000s. Kapone from the Noble Knights used a "K" to both invoke this folk hero and represent his own gang. "Dukes" was a popular name for street gangs in big urban areas such as New York City and Chicago, starting in the 1950s through to the late 1970s, as were names like "Lords," "Knights"—and, in Chicago, "Disciples." The Satan Disciples started independently in the late 1950s, while the black Disciples from the South Side were still new as well. The Latin Disciples came in the mid-1960s, so they all likely came up with the name for the same reason. The misnomer "Thee" puts emphasis on the name, exalts and elevates the gang, and presents them as demonstrating the bravado attributed to medieval knights of old. (This word was later used in the same manner by another fraternal organization, the chaos magicians of Thee Temple ov Psychick Youth, a.k.a. TOPY.)

Compliments of Chicagohoodz: Chicago Street Gang Art & Culture

67

Dukes,' he said. We had all heard of the Dukes. They were already legend on the streets, reputed to be the toughest white street gang in Chicago at the time. The history of the Dukes was alleged to go back to the Al Capone era. Probably such gangs served as training schools for later Mafia foot soldiers."
—Robert N. Taylor

The erection of the Eisenhower and Dan Ryan Expressways and the University of Illinois at Chicago (UIC) campus in the 1950s and 1960s devastated and mutilated many old neighborhoods, including the Near West Side. This "urban renewal" gave many clubs new territory to explore when these ethnic communities scattered and reestablished themselves in other areas, such as Cicero, the North Side, and in particular, directly south in the Czech enclave of Pilsen. (Further expansion of UIC has decimated the Maxwell Street Market and Little Italy community, which is now called "University Village.")

Pilsen

The area south of the Near West Side was settled in the mid-1800s by the Irish. By the end of the 19th century it was dubbed "Pilsen" (after the Bohemian city of the same name) due to its predominantly Czech inhabitants. By the early 1970s it became a predominantly Mexican neighborhood, which it remains to this day. For many Mexican-American families in the 1960s, Pilsen became home, with its family-owned businesses, restaurants, museums, churches, as well as the music that extended throughout the area. Pilsen is also known as the "Lower West Side," or simply "18th Street," the neighborhood's main thoroughfare and artery of gang activity.

Like the European immigrants before them, those from Mexico came in waves. When the stockyards, railroads, and factories started advertising for cheap Texas labor, the Czech population shifted westbound to Little Village, then to Cicero and Berwyn. Throughout the 1970s, Mexicans were by far the ethnic majority in Pilsen, and it seemed like every corner was a gang, but the opening of Benito Juarez High School in '77 created new territory for the bigger ones to claim. Two rival gangs known as the Counts and the Ambrose were notorious for turning people out. The multitude of crews were eventually consolidated into the six gangs

Compliments of Chicagohoodz: Chicago Street Gang Art & Culture

Top: A view of 18th Street from Ashland Avenue in 1992. Note "18th St. Boys" towering in the background. A small group down to fight with fists, the 18th Street Boys had one block around 18th and Damen. Already old graffiti when this photo was taken, as Chicago's water towers had become obsolete and were disappearing, so too were its gangs of the past.

Left: A Juarez High School yearbook page from 1983. When Juarez first opened up in Villa Lobos' hood, it caused many gangs to encounter each other on a regular basis. This was the peak era of the Ambrose and Latin Counts attempts at expansion, and made for a real hot time period in Pilsen. The principal was even a former Count himself who would allow gangs in the "People" alliance to wear their sweaters, but not those in the "Folks." Every Monday, students would wonder which classmate wasn't going to show up because they had been killed over the weekend.

Thee Almighty Allport Boys

Arthur, Beaver, Manuel, Pablo, Louie, Neto, Mando, Weecho, Reno, Abel, Bichy, Rafa, Sal

Compliments Of Thee B.T.O.s

Of 21st. -n- Damen
We Kill For A Thrill

Mike, Heavy, Randy, Boogie, Chato, Steve

Compliments of Thee Bang City

Stone, Ice, Buff, Nato, J.J., Demon, Timbo, Al, Horse, Mars, Joker, Fly, Gaby, Butler

Future Boys of Hoyne

Compliments of thee Almighty King Cobra's of Throop-Cermak

Lil Romeo, Tony, Mr. Kool, Lil Nick, Wino, Mr. Cobra, Kool, Nick, Shorty, Lil Guy, Chito, Nino, Wezo, Tunco

Compliments of LOS PISTIADORES of 17

Danny, Lloyd, Dino, Dave, Louie, Vic, — II —, Tony

Compliments of Thee Almighty Tiny Pistiadores of 16th St.

Alfredo, Carlos, Din, Abel, Eddie, Diego

Magnificent Players of 17th St.

Big Cesar, Dragon, Mr. R.R., Conan, Mr. T., Gil, Thee Almighty Memo, J.R., Cano, Louie, Eddie T., Rick, Dancer, John, Casper, Rich, Bobby, Ray, Lando, Carlos

compliments of thee Almighty Chicago Players

Limbo, Rat, Moe, D, K, Lil Man, Baldy, Artie, Mr. C.

Top three rows: The Allport Boys were around in the early/mid-1970s in the area of 19th and Allport in Pilsen. Their colors were blue and baby blue; they may have been the predecessors of the Racine Boys, being that some of their members were the same. B.T.O. = "Big Time Organization"

Opposite page: One-Six/16th Street Boys was in the area of 16th and Allport, a few blocks north of 18th, which the Ambrose would later call their motherland; probably for that reason a lot of the One-Six turned Ambro. The One-Six boys were around until at least 1980. "Some of these guys, they got together, and they gave themselves a name, and they hung out all the time. But they tried to front, like they wasn't gangbangers. But eventually somebody was gonna come and fuck with them and make them gangbanging. You could start out with these good intentions…"—Jack Walls/Hi-Fi

Compliments of Chicagohoodz: Chicago Street Gang Art & Culture

Card 1 (yellow)

Lil Joker **Lil Rican**

1-6-K **Stone** ✝
N **One Six**
 Killers

Humpers & Dumpers

Card 2 (light blue)

LIL TONY TEX LIL JC

Compliments of thee
One Eight Boy's of Hoyne
Party-People

WOLFY CASPER

GANGSTER LIL BEAVER MUNCHY

Card 3 (light blue)

Leo	Lil. Joe	Rick	Abe	Mr. R.R.
Shorty				Lefty
Dean	Compliments of thee			Cisco
Lil. Ace	ALMIGHTY			Flaco
Lil. Loco				Tarzan
D.J.	One ~ Six			Vandal
Rocky				Chester
Nacho	21⁴K		18ᴴK	Smokey
Tom				Oscar
Ruben	Lil. Jr.	Rerun	Mando	Marz

Card 4 (gray)

Slim Lil Simbad Mr. 1-8

▶ Compliments of thee ▶
One Eight Boy's
of Wood

Rocky Lil Capone

Rican Lil man Lil Rican

Card 5 (blue)

Lefty Lil Joe Mr. RR Flaco
Compliments of thee Almighty
Abe **One Six** Rick
lil Ace 21⁴K 18ʰK Rocky
Shorty Luv to the Nation Cisco

Middle row, black card: The Cullerton Boys were not a gang, but formed as a result of problems with other gangs around Cullerton and Ashland. Their motto, "Lovers and Drinkers, Tokers and Jammers," states that they were partiers—but they would not back down if they had to fight.

Bottom row: Barrett Boys were named after the park they hung around just west of Damen on Cermak. They were around in the early 1980s, and eventually turned Party Boys.

Compliments of Chicagohoodz: Chicago Street Gang Art & Culture

jap leo mario gramps lou ed

Laflin and 17th

mark jay tony chris kasper joe

COMPLIMENTS OF THEE ALMIGHTY

Sal — Lil Man
Dave — Meme
Miniature Laflin Lovers of 17th
JR — Lil Kasper
Kasper — Joker

The Laflin Lovers emerged in the early 1970s around 18th and Ashland, and got to be known for the first drive-through drug store in Pilsen. While they existed in the area mostly dominated by the Latin Counts, they remained renegades, with their main rivals being the Stone Heads from 17th and Paulina. The Laflin Lovers lasted throughout the 1980s and a good part of the 1990s. The North Side hosted a lot more street-corner dealing and open-air drug markets. This wasn't as blatant in Pilsen, where it's more about turf gangbanging—possibly because such a style might run deeper in Mexican culture, although such an idea risks becoming too gross a generalization. What's undeniable is that Pilsen and Little Village were places where you'd sooner have someone representing to you than running up to your car and asking if you wanna buy a bag. (Although the 24th and Whipple Kings had a good LSD market going in the early 1980s.) For the kids it was more about bravado—although drug cartels have been very much a part of Mexican gangs as well.

Compliments of thee Almighty Stone Gangsters

Mr. Cobra Tony Lil Romeo Nick MM
Chito Kool
Nino Angel

Throop Boy's

Tunco Bronco
Lil Guy Cuervo Lil Cruz George Wino
Wezo Pelon Dead Mr. Kool Shorty

Compliments of thee Almighty

Lil Romeo Tony Mr. Kool Lil Nick
Wino Mr. Cobra
Kool Nick

Throop Boy's

Shorty of Cermak & 21 Lil Guy
Chito Nino Wezo Tunco

Lil Nick Rigo Cook
Rafa Compliments Nick
 of
Chava Thee-Almighty Shadow
 Throop Boy's
Chito Lil Romeo Dino

Lil Nick Rigo Cook
Rafa Compliments Nick
 of
Chava Thee-Almighty Shadow
 Throop Boy's
Chito Lil Romeo Dino

Sly Cooky Shortie

Lady Tokers

Tabbie Peaches Vickie

Lil Nick Rigo Cook
Rafa Compliments Nick
Chava of Thee Shadow
Chito Throop Boy's Dino
 Lil Romeo

The Tokers hung around Cooper School on 19th Street by Ashland, and ran with the Stone Heads and Party Masters. Their colors were brown and green for the color of weed, and their emblem was rolling paper mascot the "Zig-Zag Man." Because of the area, many Tokers naturally turned Count and Bishop, like "Bro," who became "Lil Bro" in the Bishops (who already had a "Bro").

The Throop Boys were by 19th and Throop; most turned Ambrose.

Compliments of Chicagohoodz: Chicago Street Gang Art & Culture

75

that define Pilsen today: Counts, Bishops, Ambrose, La Raza, Party People, and Satan Disciples.

In Pilsen, rival gangs might have had a lot of 'hoods, but they were smaller with more defined borders; North Side territories were bigger and not as congested. In Pilsen, a rival might be an alley away, whereas territory for the Insane Deuces stretched in a half-mile swath from Diversey to Belmont.

Today these 'hoods are fighting a new invader, as a different kind of bohemian penetrates the neighborhood, and Mexican mom-and-pop stores are supplanted by craft cocktail bars and gourmet coffee shops.

SPARTANS

Along with the Rampants, Morgan Deuces, Ambrose, and Latin Counts, the Spartans were among the most famous and definitive Pilsen gangs. They wore gray and blue and fought against the Ambrose. The Spartans spanned the late 1950s to the early 1980s.

It's almost a traditional theme for gangs to name themselves after medieval warriors, so the image of the knight's helmet is common. It was used by the Spartans, as well as the Taylor Street Jousters, Ambrose and Counts, and later the Noble Knights and Latin Brothers. (Because the Ambrose and Counts were rivals in such close proximity, they had to make their emblems distinct. The Counts have a tall plume, whereas the Ambrose plume is standard size.)

Epithets such as "Almighty," "Insane," "Supreme," etc., were originally just a way for gangs to make themselves sound more powerful or threatening, but in the mid- to late 1980s and early 1990s, more gangs started to actually formally incorporate adjectives into their name (although "Insane" became part of the Spanish Cobras' title early on in the 1970s). "Almighty" became official for the Latin Kings the more they used it. "Maniac" became attached to the Latin Disciples' name in the 1980s, but it didn't become a thing until People and Folks started to deteriorate.

On the North Side, these titles developed into three "families": the Maniac, Insane, and Almighty. Two-Six and Party People both became "Gangster," although not associated the same way. The Ambrose are still "Almighty," and La Raza are "Insane." For a while in the 1990s, "Almighty" also became another name for gangs in the People alliance—especially Vice Lords and Kings, who would often just say "Almighty." Some Vice Lords, like the Travelers and 4 Corner Hustlers, unified under "Solid."

RAMPANTS

The Rampants were a notorious Hispanic gang in western Pilsen from the late 1950s until the early to mid-1970s. Their colors were black and gray.

In the 1970s, the term "party people" was popular in a lot of songs; the term "party crew" was new too. You can see the era in which one of their cards has traveled, with the "Rock Sucks" motto written on its back. In 1979, WLUP "shock jock" Steve Dahl's "Disco Sucks" campaign

Compliments of Chicagohoodz: Chicago Street Gang Art & Culture

would culminate in the explosive "Disco Demolition Night" at Comiskey Park.

In Chicago's segregated neighborhoods, rock & roll and disco rarely crossed racial boundaries, and this added fuel to the fire with the gangs. On the South Side, before the opening of Benito Juarez High School, gangs from Pilsen and Bridgeport had to go to Kelly or Curry, where white gangs like the Insane Popes and HEADS ("Help Eliminate And Destroy Spics/Spooks") were dominant.

DJ Steve Dahl joked about throwing marshmallows at disco fans or kidnapping them, locking them in vans, and making them listen to rock & roll. To a kid who didn't live in a racially charged neighborhood, it's a humorous fantasy—but in Bridgeport, they used rocks instead of marshmallows, and a beating might accompany a kidnapping.

The Rampants did not have too many friends, and were the only gang on 18th that hung around with the Latin Kings. In the late 1960s and early 1970s, many government-funded social intervention programs were set up to curb street gang violence. Rampant David "Boogie" Gonzales decided to do just that, and became known as a peacemaker throughout Pilsen.

In 1971 the president of the Coulter Latin Kings, Diaper Deadeye, did a drive-by with two or three carloads and killed Boogie as he was standing around talking with the Deuces in Harrison Park. All of the gangs that were previously rivals acted as pallbearers at his funeral—a Count, a Spartan, an Ambrose, even a Ridgeway Lord, declaring peace in honor of Boogie—all except the Kings. This may have made Pilsen inaccessible for them in the future, as they haven't been able to set up a section there ever since.

Footnote: Whether they listened to Van Halen on the car ride there and back, so many whites ended up at discos because that's where the girls were—especially after *Saturday Night Fever* gave the green light for everybody to like it. Italians liked disco as well: they wore the snaggletooth or "horn of plenty," had the feathered hair, hung the dice, and did the gangster lean in the Monte Carlo.

One-Six/The 16th Street Boys were one of the many individual clubs and party crews that popped up in the 1970s around Pilsen—and, like so many, were given the option of turning out with one of the bigger gangs pushing to dominate the neighborhood. This gang was in the area of 16th and Allport, a few blocks North of 18th—which the Ambrose would later call their motherland. Probably for that reason, a lot of One-Six turned Ambro. The One-Six Boys were around until at least 1980.

The Chicago Players rebranded three times during the 1970s, until they settled on that name and the colors pink and black. They operated on 17th before the Party People, under the patronage of Fr. Terence from St. Procopius Church, and mark a shift from the Afrocentric era of the late 1960s to the pimp culture of the 1970s:

> "KC was the leader of our clique. He was real tall, he was black, and he was the most athletic cat you ever seen in your life. He used to whip motherfuckers' ass. He created the Chicago Players. We started as 16th Street Boys, a small unit in the early 1970s. We had a baseball team called the

Top: The Rampants softball team consisted of Rampants (notice the jerseys have chops), and whoever else wanted to join. Dvorak Park was the meeting place for all the Pilsen gangs before Harrison Park. For the longest time, it was the one place where all the gangs could go and hang out.

Bottom, left to right: For most clubs, there were three levels, classifications, or generations for gangs, which depended on your age. As a young kid, you would come in at say 11-12 years old as a Pee Wee, Miniature, Little, Young Future, Midget, Tiny, etc., and normally graduate to "Junior," or go straight to "Senior." Of course, this all depends on the club. The back of this card tells you how cards passed hands, finally landing in the hands of the Latin Kings.

Compliments of Chicagohoodz: Chicago Street Gang Art & Culture

Top: Spartans softball team, Harrison Park, 1974. Community agencies like the YMCA and the Chicago Boys and Girls Club had gang intervention programs that created sports teams using street gangs' names. They invited anyone from the community to join, in order to promote peace. Other teams were sponsored by, and sometimes named after, local companies. Sometimes competition would actually escalate into gang warfare: a group of kids organize a softball club, and have a scuffle with a couple members of an opposing team. The losers know where the guys hang out and go back at night with bats. Now the neighborhood is talking about how the South Side Crushers hit the Double Aces last night.

Above: Spartans patch design by Franco.

Diamond Kings. We wanted to have us a clubhouse like everybody else. At the same point, KC said, 'I got a vision. We're gonna be the biggest, the baddest motherfuckers around. But we ain't gonna be no gangbangers. We're about women and money. We're gonna change our name to the African Soul Brothers, red, black and green.' Then KC said we need a better name; times were changing. We wanted to be players—that's the name, KC said: 'Chicago Players.' We asked KC, 'Every color is took…' Our colors were pink and black. He said, us being blacks, and pink being that pimp color—KC's elders were pimps, hustlers and dope dealers. He had this influential way, this aura about him."

—Andre

Little Village

The area south of the Burlington Northern Railroad viaduct and North Lawndale was once referred to as South Lawndale, until native real estate mogul Dick Dolej gave it the name of a neighborhood family restaurant, "Little Village," in a public relations campaign to distinguish it from North Lawndale, the reputation of 16th Street, and the burning and riots of the West Side after Martin Luther King was assassinated.

Essentially an extension of Pilsen, Little Village started seeing Mexicans arriving in the early 1960s, and as the Czechs and Bohemians moved westward into Cicero, by the 1980s Little Village had become a primarily Mexican community. Today, it has the highest Mexican population in the Midwest and is a gateway for undocumented immigrants, with Americanized Latin Kings imposing a tax on recent arrivals who are looking for new, fake identities.

As 18th Street is to Pilsen, 26th Street is to Little Village. It is the center of Little Village's business district, and—with the exception of the taquerias and a few mom-and-pop stores—is reminiscent of an outdoor discount mall. The neighborhood around 26th consists of two-flats built a little too close together and a lot of trees, making the area a little darker in comparison to surrounding neighborhoods.

While today's Pilsen has six major gangs vying for the upper hand, Little Village has only two or three: the Two-Six, the Latin Kings, and—tucked away in Marshall Square—the Cullerton Deuces. Although Pilsen had more gangs, its own residents avoided Little Village, considering it too violent and unstructured. You had more of a chance of getting attacked or shot out of nowhere and not seeing it coming. 26th Street made a great street for cruising, but is very congested. When driving on a Saturday night, once you crossed Ridgeway there is always the chance of getting caught by a rival while you're trapped in your car.

At one time, the Ridgeway Lords were one of the biggest gangs in Little Village. Established in the early 1960s on 24th and Ridgeway, they consisted of both whites and Latinos, quickly growing to have territory from Kedzie east almost all the way to Cicero Avenue west.

Compliments of Chicagohoodz: Chicago Street Gang Art & Culture

Lil Pencil was from K-Town in the early to mid-1970s. Like most of that generation, these guys were a pretty rough group, as was the neighborhood during this period. The Two-Six Boys were growing bigger; as the RLs moved out, those that stayed became Two-Six. Lil Pencil stayed and had three big dots on his arm where "RLN" (Ridgeway Lord Nation) used to be tattooed.

At a time in the early 1970s when most gangbangers were still listening to doo-wop and Philly Soul anthems, the Ridgeway Lords heralded the advent of hard rock and hard drugs:

> *"Those guys turned out to be stoners. They were mixed. They were the first ones that came around and started listening to Led Zeppelin and tripping on acid, and they grew their hair long, and they would come around with sandals and shit. But they were getting high, and everybody wanted to get high."*
> —Jack Walls/Hi-Fi

Cicero/Berwyn

Cicero and Berwyn are directly west of the Chicago city limits. Like many suburbs, Cicero was another refuge for those who wanted to escape Chicago, but as time marched on it just became an extension of the city, establishing its own neighborhoods, social clubs and street gangs.

Historically, Chicago residents seem to flow downstream, so to speak—directly west, in other words. The Eastern Europeans that occupied Pilsen until the late 1950s and 1960s made their way down Cermak, through Little Village, to Cicero and Berwyn. The Old World Italians from Taylor Street followed Al Capone down Roosevelt.

The effects of Capone's stay in Cicero remained for generations after, with numbers rackets working out of most penny candy stores scattered throughout the neighborhoods, and establishments catering to vice on Roosevelt and Cicero Avenue. Berwyn, since it is directly west of Cicero, saw the same migration.

The generation that had moved from the city brought the street gang culture of the period with them. The gangs were composed of Outfit kids; they were inspired by the mob and structured themselves after them. The initiations were the same.

Cicero has had a street gang presence for as long as many Chicago neighborhoods, dating back at least to the late 1950s—from the Aces of Grant Works to the Cicero Caprells from 31st. But the Arch Dukes were probably the first to span a few generations, from the early 1960s to the mid-1980s.

The Park Boys, like all youth gangs, reflect the community in which they were raised. Somewhat of an Italian pride club, they consisted of the offspring of Cicero mafia figures, and wore white vinyl jackets with red, white, and green trim. They were around from the 1960s until the 1990s near Austin and Roosevelt. While taking pride in being willing to fight, they never had a "seat" in prison—but because of their relationship with the 12th Street Players, they ended up riding "People" in the street. Even though they walked that line, lots of true gang mem-

Top: The Ridgeway Lords reputation as dangerous bikers and junkies did not sway them from spreading their love, in black and blue, all over this Little Village garage. The word "love" was often appended to a gang's name as a demonstration of group loyalty. Eventually, even traditionally white gangs would at times use the Spanish equivalent, "amor." Although this photo was taken in the early 1990s, the few Lords left in the area would get drunk and come out tagging once in a while. The garage also features their diamond symbol.

Middle row, left: This card is courtesy of an old member from the early to mid-1980s, about the last generation to occupy K-Town—the Ridgeway Lords' last stronghold in the city. This guy at one time belonged to a small gang called the Royal Latin Knights. They happened to meet some Ridgeway Lords who weren't overly excited about this gang's name abbreviated ("Ridgeway Lord Killer"). Rather than going to war over this, they decided to join them. This card was made during the period where the Two-Six were so big that the Ridgeway Lords were given the ultimatum of turning Two-Six or quitting altogether. Some turned Satan Disciples and started a branch on Komensky and 27th.

Compliments of Chicagohoodz: Chicago Street Gang Art & Culture

Top: As the Latino population progressed from east to west, the Ridgeway Lords tried to maintain power and presence. But K-Town at Little Village's western end was fertile ground for a new gang to exist, so the Bros sprung up, as did the Two-Six. As the Lords and Bros either retired or morphed into creative alternatives to gangbanging like the K-Town Party People, the Two-Six continued to grow, and the Kings just kept on moving. Constant skirmishes between the two have only increased over the years.

Bottom: The original and universal greaser hand gesture was the fist to the chest. Some say the first gang sign was from the Kings, although they were already pretty well developed by the release of *Cooley High* in 1975, in which people are seen throwing up pitchforks. They may have come from prison; when new members would come walking in, they would throw up a gang sign because they couldn't just yell it. That goes the same for street corners as well: you'd be able to identify one other from a distance, so as to know not to kill your own guy, or someone from a different section.

Top left: The Royal Cavaliers photo is a good example of how a young person can create something that would grow to become so large. Although they started in K-Town on the western end of Little Village, the Cavaliers relocated to 21st and Leavitt in Pilsen, where they lasted a couple generations. It is uncertain if they ever fought, but as the Satan Disciples grew bigger, the Cavaliers dissolved. Note the "18K" in reference to the 18th Street Boys. Photo courtesy of Mondo.

Compliments of Chicagohoodz: Chicago Street Gang Art & Culture

The Artistic Kents were two different gangs in the beginning. The Artistics were a Taylor Street transplant in the 1960s, and the Kents were from 21st and Marshall Boulevard in Little Village, where the two gangs later merged. The Puerto Rican Stones opened up a section in the neighborhood a little later—and they too merged with the (Artistic) Kents, creating the Stone Kents. Once a very independent gang with deep roots in their community, the Stone Kents (like the Cullerton Deuces) attended Farragut High—and as the "People" alliance became more important, they had to ride with the Latin Kings. The People had helped the Kings dominate, as they continued to increase in power and overshadow any affiliates. The Kents' two remaining sections—their stronghold behind the county jail, and 21st and California—both became King sections in later years. Given their attire, these Kents posing with a large drawing may be outfitted to attend a social function. Photo courtesy of Player.

Top: The Arch Dukes were classic greaser types, and the hottest thing in 1960s Cicero; the popularity of *West Side Story* enhanced gang and greaser culture for that time period. They were established around Cermak and Larmaie (which wasn't even Italian). There were Arch Dukes popping up all over Cicero, and all the Italian kids were wearing their sweaters. Their biggest rivalry was the Ridgeway Lords—but at another border area, for fun the gangs would walk under the viaduct by 16th or Roosevelt into the black neighborhood just to fight.

Bottom: In the old days, you had numerous different Italian clubs: Italian Connection (ICO), Italian Playboys, the Boys of Italy. On the North Side, the Grand and Noble Boys hung out at Burger Baron—some turned C-Note, the rest retired.

Compliments of Chicagohoodz: Chicago Street Gang Art & Culture

bers (including some Park Boys themselves) will say they weren't a gang. The last generation tried to become one, but it never took off.

When most white kids were into rock, the Park Boys were of the *Saturday Night Fever* generation, when every Italian wanted to be John Travolta, with his machismo—and almost greaser-like combing of the hair. Some Italians fell right into the disco thing, and although Cicero and Berwyn clubs disliked blacks, for some reason they rarely advertised it or threw up swastikas.

Greasers

Greasers were a subculture in the evolution of the modern street gang, but being a greaser didn't mean you were a gang member. To be a greaser was to be a man, to like a particular type of music, to build or drive or race hotrods, or just preserve a lifestyle of years past. To be a greaser was to tell young adults from other social groups that you were a badass, which is why the assimilation into street gang culture was so easy. Greasers again were known to be fighters, especially after images created by the S.E. Hinton books *The Outsiders* and *Rumble Fish*, and that made greasers and gangs one and the same for that period.

During the protest era of the late 1960s, greasers didn't like long-haired hippies, anti-war protests, or flower children. Long hair represented hippies during that transitional period, until it became the norm by the early 1970s. Ironically, in the 1950s greasers were known as "longhairs." (Without the grease, their hair was long and made for a good ducktail.) After the 1960s and early 1970s, the drug culture had become so prevalent, many greasers drifted into it; in poor neighborhoods it became more socially acceptable. Greasers embraced the criminal edge more than shunned it, and the greaser style marked you as a dangerous person anyways.

In urban areas across the country, this style held over well into the 1970s with the help of TV shows like *Sha Na Na* and *Happy Days*. These shows spoke of an era that many people viewed as simple, carefree—and yet exciting. And to a lot of people in neighborhoods across the North Side facing ethnic change in the 1970s, being a greaser also meant you were white.

Stone Greasers were a clique of North Side working-class white gangs in the early 1970s, who claimed lineage to the original greaser era of the 1950s and early 1960s, and adopted a white power stance.

Lane Tech High School in North Center was a greaser hotbed during the 1970s. The "Loyal Order of Grease" card was made in its print shop, and documents the brief period in the early 1970s when Simon City Royals considered themselves greasers, and were allied with Gaylords and Jousters (the Royals would go on to join the Folks alliance by the 1980s). "Lenny's Storm Troopers" refers to Lenny's, a greasy spoon restaurant across from Lane where the stone greasers would congregate.

In the mid-1970s, several stone greaser gangs formed the United Fighting Organization (UFO) coalition to fight the rival United Latino Organization. Members included the Gaylords, C-Notes,

Jousters, PVP (Playboys, Ventures, and Pulaski Park), White Knights, Rice Boys, and Hells Devils. There were three iterations of the UFO. UFO II was over in the late 1970s. By the early 1980s, the Hells Devils, Rice Boys and White Knights were gone. A "United Five"/"UFO III" card was made in 1984 by the Gaylords when they joined the People alliance, hoping that if they put them on a card, the C-Notes would join with them. They never did.

The Playboys started in West Town by Division and Winchester and have been around since at least 1960, and perhaps even the mid- to late 1950s. In 1971, Polish Playboy leader Pete "Kong" Smolak from the Winchester and Thomas Playboys was killed at 16 by local Latino gang the Haddon Boys. Like their colleagues the Ventures, the Playboys also had sets in Austin, and went on to establish a stronghold in Cragin Park. The Playboys were founding members of the PVP, PVJ, and UFO—and like most of the others, they went on to join the People. The Playboy bunny mascot became an official logo of several gangs in the 1970s: Two-Six, Simon City Royals, Party People, 12th Street Players, with each adding a distinctive twist—a bent ear, a hoodie, a hat. But the Vice Lords and Playboys were the first.

The Ventures were from the East Village area of Damen and Chicago/Division and Ashland, and their mascot was a musketeer. They became allies with the other gangs in the area, the Playboys and Pulaski Park, to become PVP (Pulaski/Ventures/Playboys). Throughout the early 1970s, these various little alliances would incarnate and split: the PVJ, PVR, and PVG—with the Jousters, Rice Boys, and Gaylords, respectively. The Ventures were gone by 1980.

With black migration from the South Side and white flight, the traditionally European West Side neighborhoods of Garfield Park and Austin were predominantly black by the 1980s. Rice Boys were an Austin gang, and in their attempt at fighting change on the West Side, they would paint swastikas and Klansmen all over the neighborhood in an attempt to deter blacks from moving in.

Although gangs were involved in a lot of racially based confrontation, that was often more of a convenient excuse to fight than anything else. In areas dominated by one ethnicity, gangs fought each other over any pretext. Growing up anywhere, kids just didn't like the guys from "over there." Throw in a different accent or skin color, and that just gave someone another justification.

> *"As for blacks, we really never hated them in a racial sense so much as their simply being antagonistic enemies to beware of. We really did nothing to them that they didn't do to us, but it was always an ongoing warfare with them. It was more or less simply responding to a threat and a challenge... An ironic twist was that culturally the gangs listened to black music. It was the era of doo-wop, and we would sing those songs in harmony on the street corners in the summer evenings. Likewise we dressed in the clothes of black culture and listened to Herb Kent the Cool Gent on the radio."*
> —Robert N. Taylor

Compliments of Chicagohoodz: Chicago Street Gang Art & Culture

Top: Commonly conflated with rockabilly, greasers were a related yet distinct subculture, whose adherents were just as likely to listen to Dion and the Belmonts' doo-wop as Gene Vincent's "Be-Bop-A-Lula." Photo courtesy of the Chicago History Museum.

Bottom: Once upon a time, Wicker Park was Playboys 'hood; the whole area was teeming with them. A very large gang, it's no wonder they were able to open a section at Cragin Park, as the white diaspora pushed westward. Designed in Chicago by Art Paul in the 1950s, their Playboy bunny emblem evokes the distinguished and sophisticated ladies' man, and it swiftly became pervasive among Chicago gangs. Note the Ellen Boys tag in blue (the flipped "E" may be in reference to them) as well as flipped forks in reference to nearby Disciples.

Opposite: This Howard Street Greasers image says a lot about social change during the 1970s. From left to right, the two members embody the transition from straight legs to bell-bottoms; from pomade to ponytails; from greasers to freaks. The HSG fought the Kings; the raw patches on the jacked sweater aren't flipped yet, but that was probably in the works.

Compliments of Chicagohoodz: Chicago Street Gang Art & Culture

UFO
Gaylords Whiteknights
Riceboys C-Notes Playboys

Top: This basement wall illustrates the C-Notes' unification with the United Fighting Organization (UFO), as well as the UFO's sub-coalitions revolving around the Playboys and Ventures (PVP, PVR, etc). Note the striped pole representing their striped sweaters, unique among gangs. "W-K" for White Knights, "G-L" for Gaylords.

Middle row: Street gangs tend to be unstable in their relationships. Once a powerful entity, as the UFO progressed through its ever-changing configurations, it wasn't strong enough to maintain cohesion into the 1980s. Although the C-Notes had identified with these gangs for one reason or another, here they display trophy sweaters from both the Jousters and Playboys.

Top: This Ventures wall was in the East Village neighborhood central to the PVR and PVP alliances. It was destined to soon be hit by graffiti writers, or erased by the Graffiti Blasters which came not too long after. Circa 1992 or 1993.

Compliments of Chicagohoodz: Chicago Street Gang Art & Culture

Top: Another relic from the last struggle of racially fueled street gangs, in K-Town east of Kostner. A prime spot to see gang graffiti was an alleyway entrance; it made for a great neighborhood billboard. Circa 1990 or 1991.

Tom and his brother John (a.k.a. Mugsy) started out as Hells Devils of Diversey and Major, and when their family moved up north, they started a branch at Dunham Park. In the early 1980s, some Moffat and Campbell Gaylords convinced the Devils to flip, and the brothers finished their gangbanging careers as Dunham Park Gaylords.

Chi-West came about in the 1960s and, like so many gangs of the early years, named themselves after their intersection: Chicago and Western, at the edge of Ukrainian Village in West Town. The Chi-West seemed to have found their cause when Puerto Ricans began to migrate to the Humboldt Park area—and were also one of the more criminally minded white gangs, with reputed ties to the Ukrainian Mafia. In 1988, Chi-West member Jack Darrell Farmer was apprehended at age 35, after being placed on the FBI's 10 Most Wanted list and featured on *America's Most Wanted*.

Like many white gangs, the White Knights became pretty popular during the late 1960s as a rebellion against racial change. They had a few South Side branches in the 1970s, one being Kelly Park, run by 6-Pack. Coincidentally, these White Knights wore black-and-white sweaters—as did the Insane Popes from nearby Hoyne Park, just blocks away.

Their cards are from the northern West Side area known as K-Town, where most streets between Cicero Avenue and Pulaski start with the letter "K" (with the exception of Tripp). Although they may have had the same motives, their colors differed in that the North Side wore black and blue, and the South Side wore black and white. "KC" is likely for Keystone and Cortland.

THORNDALE JARVIS ORGANIZATION

The Thorndale Jarvis Organization (TJO) was at times known as the "Truth and Justice Organization," "Thieves, Junkies and Outlaws"—and most famously, the "Thorndale Jag Offs." Varying accounts attribute this last moniker to either a juvie judge, or late Chicago-cop-turned-actor Dennis Farina. In any event, the gang took a liking to the name and ran with it. Arising in 1960s Edgewater, their raison d'être may have been racism, but these neighborhood greasers graduated from instigating racial riots at Senn High to assault and battery, burglary, narcotics trafficking, extortion, and murder for hire—with ties to both the mob and outlaw bikers. Under dual leaders Joe Ganci and Gary Kellas, the TJOs ran much of the far North Side throughout the 1970s, their territory stretching from Thorndale in Edgewater up to Jarvis in Rogers Park. Ganci was known to be highly intelligent, and in 1975 staged a short-lived escape from Cook County Jail with five other inmates from North Side gangs, including the Playboys. In Menard, Ganci would found the white prison gang the North Siders, along with the Gaylords and Wilson Boys. By the late 1970s, the 'hood was changing, and the TJOs were fading. They went out with a bang in 1984, when 35-year-old Kellas (along with accomplices Eric Huber and Patrick Deering) sprayed undercover DEA agents with an Uzi from his Trans Am in a

Top: Damen and Augusta, 1993. At that point probably the last stand for the Chi-West. I stopped to ask the Kings from Hoyne and Huron about them, when a carload of scandalous-looking blond white boys pulled up. The Kings went over to talk to them, then came back and said the Chi-West didn't want to talk. I started driving away, when I noticed in my rearview mirror that the car was following me around. As it was reminiscent of an Iron Cross, the Maltese was shared at times. The Chi-West had an on-and-off relationship with the Spanish Lords; the upside-down heart may be in reference to them, as Chi-West grew up—and surprisingly got along—with the Latin Lovers. "AL" = Augusta and Leavitt.

Top: I moved to Edgewater in the mid-1980s. I'd heard about this notorious local gang called the Thorndale Jag Offs. Just by that name I really didn't want to meet those guys. White power greaser thugs, the TJO weren't known as upstanding citizens, but were theoretically protecting the neighborhood—at reasonable rates—from racial change. When engaged for battle, the TJO would gear up in football helmets and shoulder pads, armed with baseball bats. This was their emblem on the building I lived in.

Compliments of Chicagohoodz: Chicago Street Gang Art & Culture

Carson's Ribs parking lot, after a sting-operation-turned-drug-burn went bad.

"Their names rang out like cannon fire in the neighborhood anytime they were brought up. Everybody listened when people talked about Ganci and Kellas, even 30 years after they went away. Kellas was real regal, smooth and cool like a mobster. He was a good storyteller and kind of a wise old-school guy, funny too. Ganci was like Al Capone of the the old neighborhood, but now that he's gone Kellas is. They kind of both always were. When Kellas went down for the second time, they lost their structure. The neighborhood was changing; blacks and Latinos took over. Some hung on, but they were getting old and not very relevant."
—Bill Hillman, former TJO associate and author of The Old Neighborhood

Those who weren't locked up were junkies; some became Gaylords, some Royals. Ganci died in prison during the 2000s, and Kellas was recently released.

The Howard Street Greasers were located in Chicago's northernmost community area, Rogers Park, Howard forming part of the city limits. With easy "L" train access, blacks from Section 8 housing began moving up from the South Side; this influx may have explained the rise of the TJO. The Howard Street Greasers were around until the early 1980s when the area became heavily black, and retired fully around 1985. Many turned Royals, some TJO, some Gaylords. Rogers Park is now an area diverse in both income and ethnic backgrounds.

"Rogers Park was a hotbed of white gangs until the neighborhood started changing in the late 1970s/early 1980s, when the last of them were fighting to keep their presence, when the TJO's and Howard St. Greasers were disappearing. These guys felt like they were the last crusaders."
—Telly, Farwell and Clark Royal

After the hippie era of the late 1960s and early 1970s, the fashion style of wearing your hair long gave way to a new group to be known as "freaks." This gave the greasers new rivals, and a new cause.

Freaks

"Freak" is a relative term which identified a person who favored the intoxicated lifestyle, usually with the aid of illicit drugs, and was originally used to define the hippie counterculture in the late 1960s. The label became synonymous with drug use, and kids throughout the city and suburbs embraced the term, considering themselves "freaks" if they partook, then donned the style of long hair and concert T-shirts. This would almost guarantee you were a freak in the eyes of others.

In Chicago, there were numerous unassociated groups using the name "freaks" to identify themselves in the 1970s. Some were more like party crews and some were considered gangs.

Compliments of Chicagohoodz: Chicago Street Gang Art & Culture

One gang that didn't come up with an acronym after the fact, the HEADS wanted you to know their perspective on neighborhood change through their initials, "Help Eliminate And Destroy Spics." I had taken this picture in an industrial area directly east of the Satan Disciples' Sleepy Hollow neighborhood, which is why the forks are flipped. The black "6" in the "D" says that a Disciple came across this, but he must not have had enough paint to deface the whole thing, as the right fork is simply converted into a Bishops' cross upside down. A relic circa 2000.

In neighborhoods that were dealing with change, fights would break out between a local youth and one from another race—and if the latter belonged to a gang, this particular branch of freaks became that gang's target, almost naturally becoming a gang themselves. Freaks who fought other gangs moving into their neighborhoods eventually either associated themselves with the gang, or disassociated themselves all together. Eventually, freaks citywide were being viewed as a gang by others.

Almighty Freaks were black and red; United Freaks from Grace and Kedvale were blue and gold; the Stoned Freaks were green and white. When they started fighting, these groups who all had different colors and wanted to gangbang started getting together; whichever the dominant group was changed them all to black and red, and they became the North Side gang the "Stoned Freaks," adopting a cross and skull as their emblem. (See Chapter 5.)

Heads

"Heads" meant different things in different parts of the city. In the areas of Pilsen and Little Village, "heads" meant people who liked to get high:

> "They would say, 'Oh, look, there goes so-and-so. Nah, he don't gangbang anymore; he's a head.' Two-Six had heads. Every gangbanging community had their heads … they used to be in the gang, but all of a sudden they grew their hair long, and they just became pot dealers."
> —Jack Walls/Hi-Fi

On the near South Side around Bridgeport, Clearing, Gage Park, and Marquette Park, HEADS stood for "Help Eliminate And Destroy Spics." Stoners as well, they weren't known as a gang as much as a bunch of racist whites. A Latin King from Bridgeport described the way you would recognize a HEAD: blue jeans, biker boots, black concert T-shirt, and a chain wallet.

The "Head Killers" cards are likely referring to them. (Their motto, "One Nation Under a Groove," is also a 1978 song by Funkadelic.) "HKN" meant Head Killer Nation.

Perhaps inspired by the Nation of Islam, gang use of the term "nation" has been around since the late 1960s, when Woodlawn street gang the Blackstone Rangers expanded into the politically inclined "Black P-Stone Nation," comprising 21 representatives from individual member gangs. While the concept may have designated federations like the Black P-Stones and Vice Lords, or large gangs with numerous citywide sections like the Gaylords, most gangs began to considered themselves "nations" (signified by the letter "N" in their acronym), in the tribal sense. Some have now also adopted "world" or "camp."

"Heads" gangs are easy to differentiate by the names and logos on their cards. Hispanics were a target of the white HEADS, so one wouldn't expect to see "Tito" or "Ruben."

Second row, first card: The card with the Klansman is the only one related to the racist white gangs from the South Side. The other gangs they rivaled, according to the initials, are (in order) Two-Six, Party Boys, Disciples, Latin Kings, Saints, and Insane Popes.

Bottom: Pot-Head Brigade was made by a a bunch of partiers that went to Prosser High.

Compliments of Chicagohoodz: Chicago Street Gang Art & Culture

Opposite page, top: Lady Party People. One T-shirt promotes Harrison High School (which closed in 1983); the other bears the classic logo of popular rock station WLUP. At a time when both still existed, the Party People crossed a few boundaries. Your choice was disco or rock, and they had both. This was a crossover period as the Party People, Brazers and La Raza assimilated to American culture, while at the same time were respectful of the Mexican culture of their parents. "A lot of us were still into rock & roll. Levis with our Converse All-Stars."—Vandal

Above: Lady Two-Two. If a picture throwing up a gang sign isn't strong enough to emphasize love and dedication to the organization, using a marker to draw additional imagery or write on the photograph made up for it.

Girl Gangs

"...The girls who hung out with us were of a mixed lot. Some were the sisters and cousins of guys in the gang. Many of them were as tough and ready as the boys were in their own right. Working-class girls who grow up with brothers learn how to fight and tussle with men. This did not detract from them as females. It sort of enhanced them, in a sense, because you could count on them in a pinch. They didn't snitch, and you admired them for their way of standing up to the guys who often treated them rough. The girls also served to carry contraband like drugs and guns for the guys. They were less likely to be searched by the cops. Some of the girls formed their own gangs

Compliments of Chicagohoodz: Chicago Street Gang Art & Culture

or ladies' auxiliaries to their male counterparts."
—Robert N. Taylor

There were plenty of girl gangs on both sides of the city until the late 1970s, one example being the "Pink Ladies" from Taft High School in Norwood Park. An inspiration for the raunchy musical *Grease*, they wore razors in their hair, and—although they claimed that Pink Ladies didn't have any—their champagne glass emblem was garnished with a cherry. The Lady Aces from Pilsen were known as straight-up badasses that were even down to fight the guys. Lady factions of male-dominated gangs remained, and while just as violent, they aren't as "loud" as the original gangs themselves.

> "The baddest girl gang was the Valkyries from Bridgeport: Mexican and white girls. Everybody loved them. Then you had the Duprees. These bitches were

Opposite and above: Women played a vital role in the street gang structure, from hiding artillery from a then male-dominated police force legally unable to search young females, to being able to infiltrate and gather information from other gangs. Many women were also just as willing as men to take part in violent altercations. They were down to box and fight—and even more, down to pull a trigger.

bad; they were the sister gang to the Ambrose. They had the Lady Counts, the Morgan Deucettes... They had this all-black gang called the Supremes, and they were openly gay. They had sweaters and processes—big Little Richard hair. They were bad. Legendary. I was in a gay bar in the mid-1970s and a couple Supremes came in wearing the sweaters. They had this reputation, and nobody fucked with them—because you don't want to be like 'I got my ass kicked by this faggot,' so they did whatever they want. They had the mascara, and they were flamboyant, and you did not fuck with them... The Spartans had a notorious brother that was a drag queen. There was drag queens in Pilsen that we dealt with regularly."

—Jack Walls/Hi-Fi

The Ghetto Brothers and the Yates Boys Organization were closely associated gangs in Logan Square, and gained notoriety for many shootings in the 1970s and early 1980s. At one time tight with the Latin Kings—both sharing rivalry with the Imperial Gangsters, Capone Lords, and Spanish Cobras—the two gangs would have a falling-out, resulting in the shooting death of Cowboy from the Kedzie and Armitage Kings. Sir Fro is doing 60 years for that murder, and turned Vice Lord in the joint. Indio ended up turning Unknown, Cano turned King, and Gripper is dead. A number of other GBOs turned Insane Deuce, including Wino. After turning Deuce, Wino was killed by the Project Latin Kings.

Compliments of Chicagohoodz: Chicago Street Gang Art & Culture

Opposite page top: Paulina Barry Community, photo courtesy of Satan.
Opposite page bottom, and above: Latinettes photos courtesy of Spanky.

Top row: The Low Riders were a car club, as were the Titan Cruisers. Car clubs are exactly what they sound like. It wasn't uncommon for gang members, like anybody else, to be interested in cars or car clubs, whether it be low riders or drag racing.

Compliments of Chicagohoodz: Chicago Street Gang Art & Culture

Top left: This is a popular card, but it may not be a real gang. At the peak of the trend, gangs and clubs were passing around cards so much that smart alecks had to goof on it.

Middle left: Compliment cards were pretty popular in the 1960s, but even more so in the 1970s—so much so that it made for a good novelty to some. These cards were made by a couple of guys who didn't belong to any social club at all, and they were passed around as a joke.

Bottom left: Berwyn and Cicero are directly west of the Chicago city limits, and shared in the compliment card trend of the late 1970s and early 1980s. *Saturday Night Live* had a skit starring Steve Martin and Dan Aykroyd that was popular at the time; it's only a guess that this card was made as a goof during that era.

A lot of clubs and crews popped up with only a few members that were like flashes in the pan.

1. The M/A (Monticello and Augusta) Players were the "Players" in the UPK coalition with the Insane Unknowns and Latin Kings.

2. The Imperial Dukes were from Uptown; some of their graffiti is captured in Bob Rehak's documentary photography of the neighborhood in the 1970s.

3. There was an old guy on 45th and Justine who made cards in his basement. Everyone was making them because they could get five hundred cards made for $5.

Opposite page, bottom: The Wilton Boys later became the Latin Eagles, when Wrigleyville was their 'hood.

Compliments of Chicagohoodz: Chicago Street Gang Art & Culture

113

Top, left to right: The Spanish Chancellors were a big gang from Bridgeport that dates back to the mid- to late 1960s at least. The Chancellors almost disappeared, until resurrected in the late 1980s and early 1990s. Black Gents lived in the ABLA public housing complex in the area of Racine and Roosevelt, about three blocks south of the viaduct that separated the Pilsen neighborhood and University Village/Little Italy. The Party Boys were from 19th and Carpenter. It is unknown what brought these two clubs together. The "U-K-K" would normally be "UnKnown Killers," but there were no Unknowns in that area. "I-P-K" would be "Insane Pope Killer," who are just south of I-55 from them.

Middle row, left: The United Latino Organization (ULO) was composed of the Latin Disciples, Spanish Cobras, Imperial Gangsters, and Latin Eagles. This gang coalition was created in the 1970s to combat the local white youth gangs that had banded together under the United Fighting Organization (UFO). This card is from that period, given to the shorties of the ULO known as the Young Latino Organization. With the development of both the Folks and the People, both the ULO and the UFO dissolved by the early 1980s.

Middle row, right, and bottom left: Coal Yard were hillbillies that hung out at South Lakeview Playground Park at Wolfram and Lakewood. They started in the 1960s, and lasted a couple generations. The park used to be a coal yard back in the day, so they called it "Coal Yard Park." They were friends with the Southport and Fullerton Royals, and Halsted and Wrightwood Unknowns. In 1970s Lincoln Park, there was peace between gangs—unless there was a reason to war.

Compliments of Chicagohoodz: Chicago Street Gang Art & Culture

Top: If you talk to any member of Orquesta Albany, they will tell you the GBO/YBO were gunners. But like the Warlords, they were more like a party crew in their early days. Even *Welcome Back, Kotter* portrayed this kind of transformation in its "Sweatside Story" episode. Once you've got a sweater with a club's name on the back, somebody is gonna try and jack it—and if one of your boys shows up with a black eye or broken nose, you're either gonna fold or start a rivalry.

Kool Gang was located in the area between Halsted and the Dan Ryan expressway, between the Ambrose and the Bishops, and were mostly Puerto Ricans.

"I always liked Kool Gang. One time we went cruising into their 'hood and they were all out there—with brims, all black and gray. They had canes, styling on the corner."—Chuy, Latin King

In respect to the playboy image which so many gang members liked to portray, a popular practice was to have a cane or walking stick. Not only did it represent a gentlemanly style on cards, in graffiti it also evokes the religious overtones of a shepherd's staff.

Compliments of Chicagohoodz: Chicago Street Gang Art & Culture

117

The Maniac Latin Hoods of Logan Square were in close proximity to both the Palmer Street and Moffat and Campbell Gaylords. They may have been Puerto Rican pioneers in that white neighborhood, and a precursor to other Latin gangs coming around. Their colors were orange and brown, and upon folding many would become Latin Lovers. Their leader Polaco, a blond with a big afro, was killed by the Latin Kings. Sabu is also RIP. The cane symbol was also used as a slash between the initials of a gang's name or a particular branch.

Top: The Night Crew was from the area of 45th and Justine in Back of the Yards, where they fought the Latin Souls. They wore white and black, and their mascot was a hooded figure with an upraised arm called the "Death Dealer."

Compliments of Chicagohoodz: Chicago Street Gang Art & Culture

SIMON CITY

Almira Simons Park is a one-acre lot containing a fieldhouse, basketball court and playground, but for this 1960s greaser gang it was "Simon City." Made up of hillbillies and bikers, Simon City was one of the last remaining white gangs in the now heavily Puerto Rican Humboldt Park area, and would almost certainly have met the same fate as most other greaser clubs of the age. But as the story goes, two brothers from Simon City, Arab and Ahab, traveled east to Lake View, where they fought for the naming rights to what would become one of the largest and most notorious criminal gangs in the Midwest and southern United States. And as drugs started flooding the city in the early 1970s, and gang culture grew more violent and criminal, Simon City gave way to the rise of the Simon City Royals.

Previous spread: A pretty lucky find that day. I like walking railroad tracks around Chicago. I didn't know where I was going, and had no idea what I might find, when I came across this on the east side of the Kennedy Expressway, just east of Jefferson Park. This wall disrespects three of the Simon City Royals' biggest rivals, with the inverted Familia Stones' pyramid, Latin Kings' "Master" and Insane Deuces' spade.

Compliments of Chicagohoodz: Chicago Street Gang Art & Culture

chapter 2
ROYALS: "NO PITY IN SIMON CITY"

AROUND LAKE VIEW HIGH SCHOOL IN the late 1960s, out of a legendary clash between Mike "Motormouth" Kraft and an Arab emigrant from Simon City, a new greaser gang emerged to claim the title of the "Almighty Simon City Royal Nation." This organization would in time become emblematic of the shift that occurred in Chicago gang culture during the mid-1970s.

Under the leadership of Rashad "Arab" Zayed, along with the Irish Gilfillan brothers—Jeff a.k.a. "Tuffy," and Timothy a.k.a. "Bimbo"—the Simon City Royals (SCR) were well-liked and respected by other North Side white clubs, and in the early 1970s they forged diplomatic relationships with the Gaylords and other "stone greasers" (older white gangs that could trace their lineage back to the "social athletic clubs" of the 1950s). Although more welcoming to other races, the Royals were still on the white power kick in the 1970s. On collaborative cards from this period, one can see the names Simon City Royals and Gaylords sharing space, both in opposition to the Insane Deuces of Hamlin Park, and Puerto Rican pride gangs—the Latin Eagles, for example.

On July 10, 1974, at the age of 25, Royal patriarch and Vietnam veteran Arab was ambushed and assassinated by the Insane Deuces:

"He was going out with the president of the Jahn Deuces' (Rat's), sister. Her name was Joy. The family lived in the middle of the Deuces' stronghold. Arab went there in his maroon-and-white Eldorado to pick her up. He pulled up out front, beeped his horn. Next, all you heard was gunshots. There was three Deuces, two with

pistols and one with a rifle, and they killed him."

—Satan, Paulina Barry Community

Tuffy, a star athlete and football player at St. Andrews, was killed at age 16 by the Latin Eagles later the same year. Many representatives from other greaser gangs came to his funeral to pay their respects. His gravestone reads "A True Champion." Tuffy's older brother Bimbo was killed by the Latin Kings at age 19 in April 1975 in Albany Park. Many consider Bimbo to have been a great connector of conflicted white gangs. As he lay in hospital that night, his expressed wish was to "put my sweater in with me."

Under new leadership, the Simon City Royals' subsequent actions would fatefully alter the course of Chicago gang history.

By mid-decade, the Gaylords were engaged in greaser warfare with the Insane Popes over claims to Kilbourn Park, a territorial dispute which led to the 1975 death of charismatic Pope leader Larry "Larkin" Morris. With the Simon City Royals' pivotal decision to side with the Popes instead, both the "Royal / Pope Nation" (RPN) and one of Chicago's bitterest gangland rivalries were born.

By the late 1970s, the Almighty Simon City Royal Nation (ASCRN) had expanded into one of the city's largest gangs, with numerous branches scattered across the North Side—and transformed from a racially oriented turf club into an organized criminal enterprise with a shady reputation and a specialty in burglary.

Through an extraordinary guns-for-muscle deal with the Black Disciples from the South Side, these white boys became early members of the largely black and Hispanic Folks alliance—a far-sighted maneuver, but further distancing themselves from the stone grease coalition. Ironically, many of these self-proclaimed "white power organizations" would end up joining the El-Rukn/Vice Lord/Latin King-led "People" by the mid-1980s.

By that time the Royals were contending with the Gaylords for the position of largest predominantly white street gang in Chicago, and many of the cards in this chapter illustrate the brutal and ongoing war between these two onetime allies.

The Simon City Royals have also fought extended wars with numerous other gangs, and are credited with murders of members of the following: Insane Unknowns, Puerto Rican Stones, Gaylords, Vice Lords, Latin Kings, Insane Deuces, Latin Eagles, Spanish Cobras, Latin Disciples, Imperial Gangsters, and most recently, the Spanish Gangster Disciples. With few friends to speak of, it is said about them that no other street gang has killed more of a variety of rivals than the Royals. This has given rise to their slogan, "There Is No Pity in Simon City."

At one time a force to be reckoned with in Chicago, by the mid-1990s their ranks had greatly diminished. Through the recruitment of Latinos they retain a presence; however, it is far beyond the city limits that the ASCRN now flourishes again, with large branches in Wisconsin ("Brew City"), the Mississippi prison system, and Kentucky (the Mississippi branch was the subject of a 2013 Discovery Channel documentary, *Dixie Mafia*). All in all, they are now the largest white street organization in the U.S.

Compliments of Chicagohoodz: Chicago Street Gang Art & Culture

Top: An old Pope from Independence Park, not long after Pope leader Larry Larkin was shot in 1975, was introduced to the Simon City Royals at Koz Park. When asked how it went, what he thought of those guys, he said he felt a little uncomfortable. "These guys don't seem like greasers," the Pope said. "They seem like criminals." Photo courtesy of Clown.

Oddly enough, with the Folks prison alliance fracturing into three street factions, the Royals find themselves at the helm of its "Almighty Family"—united with the Lake View Puerto Rican gang called the Latin Eagles, whose antagonism contributed to the formation of the SCR in the first place.

In February 1993, Eric Morro, 19, was shot to death two blocks away from Albany and School in Avondale. For this murder, a 13-year-old "Pee Wee" Royal of Polish and Mexican descent, Thaddeus "TJ" Jimenez, was arrested, charged and—despite all evidence to the contrary—convicted, eventually serving 16 years of a 45-year sentence, much of it at Stateville. Exonerated in 2009 and awarded $25 million in 2012 for his wrongful conviction, Jimenez set about using his bonanza to resurrect his struggling gang by paying West Side Vice Lords and others to brand their faces with Royal symbols. "Batman/Bruce Wayn," as he was styled, created numerous promotional YouTube videos, cruising around old Royal neighborhoods in luxury cars, flashing wads of cash and taunting rivals. Jimenez's YouTube career would come to an end in August 2015. As Batman and a sidekick rode through Irving Park looking for trouble—while proclaiming their "self-sovereignty" and "true royalty"—they displayed good taste by playing Schubert's "Ave Maria," but extremely bad judgment by shooting 33-year-old Royal Earl Casteel in his legs on video, with a .380 Kimber Sapphire blue pistol. In March 2017, Jimenez was sent back to the slammer for nine years.

"Earl called it for Central Park. He said, 'Don't bring none of them paid, pancake-ass motherfuckers by; we don't want nothing to do with them.' TJ was trying to take over everything. TJ's crew is still out there, Diversey and Laramie. Spanish and black. All dudes that were in other mobs flipped Royal cos dude was paying them."
—Apache

The Simon City Royals' colors are black and royal blue. While some gangs have only one or two emblems, the Royals utilize several: the Latin cross with intersecting swords or canes, or more frequently emanating three rays (representing Arab, Bimbo and Tuffy, the founding fathers at the heart of Royal legend); the Playboy bunny (at times with a bent ear and top hat); Lowenbrau lion rampant; the cane; and a "V" (for "victory") with a lighting bolt. Like the Gaylords, the SCR were also known to use the saying "Cross is Boss."

Paulina and Cornelia

Known for the Cubs baseball team at Wrigley Field and the LGBT community of "Boystown," Lake View is also the birthplace of the Simon City Royals, with most gang historians agreeing that they originated at the corners of Irving Park and Ashland. Its members were originally made up of teenagers that attended Lake View High or lived in the area. In the 1970s, scores of them could be found in the Hamilton School playground.

Ashland and Irving's sister branch Paulina and Cornelia (PC) was one of the

Top left: Simon City Royals and Insane Popes. Photo courtesy of Jake.

Second from top, left: Todd "Dillinger" Thompson (commonly known as Brewer) RIP, second to left, was originally an Unknown Gangster until joining the ranks of the Royals in the 1970s. Well-respected as a natural-born leader, Dillinger was killed in Albany Park by former allies the Puerto Rican Stones in 1983, and became the sole Royal to attain the title of "Prince." Photo courtesy of Clown.

Bottom: The Star of David is a key Folks symbol honoring "King David" Barksdale of the Disciples, and was adopted by other Folks gangs. The rounded crown has been used by the Royals for years. 1970s cards have it upside down; 1980s have it right side up.

Compliments of Chicagohoodz: Chicago Street Gang Art & Culture

Top, left to right: Cross cracking an upside-down five-pointed star atop an inverted Latin King crown. Pitchforks are also an important Folks symbol. "UKK": UnKnown Killer; "CVLK": Conservative Vice Lord Killer; "IDK": Insane Deuce Killer. "Fist City" is a term used by a branch that is down to fight with their hands.

city's oldest branches, and is considered the birthplace of the gang.

Apart from the Insane Deuces from North Center, their biggest rival during the 1970s was the Latin Eagles, who also attended Lake View, as well as Hamilton and Blaine grammar schools—both major breeding grounds. It is alleged that an Eagle was responsible for the murder of Tuffy in the mid-1970s. Tuffy came from a long line of Royals, with two of his older brothers being members themselves.

This conflict would last until the early 1980s, when the Simon City Royals joined the Folk Nation. They were no longer claiming Irving and Ashland by then, instead moving all their operations to other branches in Lake View, North Center, Roscoe Village—and most importantly, Albany Park. The Latin Eagles, on the other hand, expanded their grasp of Lake View well into the late 1990s.

Paulina and Cornelia was also home to another Royal family, the Brewer clan: Randy, Mike, and Todd, with Mike becoming leader in 1979. His brother Todd was part of the last real PC crew, before moving to Central Park and Wilson, which would become their new headquarters. In the early 1980s, the section had a brief revival, but by the end of that decade, Paulina and Cornelia was fading.

> "Paulina and Cornelia was great. We used to have '50s parties over there, where everyone had to come dressed like the '50s. Long poodle skirts with bobby socks, and the 'L' like 'Laverne,' and the saddle shoes, '50s music playing."
>
> —Apache

Southport and Fullerton

North of the Loop lies Chicago's largest pleasure ground, Lincoln Park, and the community area that bears its name. In its northwest corner, the Southport and Fullerton (SF) Royals had been hanging around Wrightwood Park for over ten years when the Chicago Police Department named the Fender brothers, Frank (a.k.a. "Flash") and Billy (a.k.a. "Shadow"), as the branch's leaders in 1985. During the 1970s, the SF Royals maintained a close friendship with the Insane Unknowns of Halsted and Wrightwood—until 16-year-old Unknown leader Jose "Capone" Arroyo was killed by Frank.

Both Fenders—but especially Billy—had the reputation of being stone-cold killers. As one former Royal stated, "I don't like talking about Billy. Billy was scary. Bill was the one you had to watch out for. He was the quiet one."

> "That dude was the biggest killer in the Royals. There's probably 30 cold cases out there from him. His brother Frank wasn't that bad. He did kill Capone, the chief of the Unknowns. Southport and Fullerton were tight with them, real cool with them. They grew up together from childhood. A lot of Unknowns were white over there. Woody, Clown and Pablo flipped Royal, and one day all these West Side Unknowns from their motherland, Leavitt and Schiller, came over and beat the shit out of them, ripped the Simon City Royals shirts off their backs. Southport

Top, left to right: Card by Weasel, 1987/88. It shows disrespect to the Insane Deuces, Latin Kings, Insane Unknowns and Puerto Rican Stones. On the collaboration card between Ashland and Irving and its sister branch Paulina and Cornelia, "R=Love" means "Royal Love." Many members in the 1970s would write this as graffiti on walls.

Bottom left: This card pays tribute to Magician, shot in the head with a rifle in the 1970s by the Spanish Gangsters while kissing his girlfriend; she was eight months pregnant. "I was locked up with the guy who was with Luis Ruiz when he did it. His name was Fro; he ended up turning GBO. He told me them two walked all the way down there on a sunny summer afternoon with a bolt action .30-06 rifle and two bullets. It's about six miles, round trip. Luis got arrested for it, but he beat the case. Luis Ruiz was a crazy one. Then, him and a couple other Kings killed three guys and a girl cos they said they knew a Latin Eagle. They slit all their throats."—Satan, Paulina Barry Community

and Fullerton had that big wall; the Unknowns came and painted all over it. The next day they pull up wanting peace. Deadeye was leaning in the car talking to them. Frank come up, bam-bam, shot him like three times in the chest. Got four years."
—Apache, Simon City Royals

This incident triggered a vicious gang war, culminating in the murder of leading Royal, 22-year-old Darryl "Bulldog" Griggs, in the backroom of a North Side tavern in September, 1985:

"He was sitting in a bar with Billy Fender, right by Fullerton and Clybourn. The Unknowns, Weso and G-Man, came in there and lit the whole bar up—bartender, shot like four people. Killed Bulldog. They were trying to kill Billy. Bulldog was great. Southport and Fullerton—they were animals. They were all hillbillies."
—Apache

With the death of 18-year-old Royal Aurelio "Poochie" Hernandez in 1989, and the incarceration of their two main gunners, Frank and Billy, for narcotics trafficking in 1990, the 'hood was up for grabs. In the end, Southport and Fullerton lost the park and everything else to the Unknowns—and eventually the yuppies took them out too, without firing a single bullet. With Paulina and Cornelia and Southport all washed up, Central Park and Wilson was now in full effect.

After spending time in and out of the penitentiary during the last 40 years, Flash decided he'd had enough of Illinois,

Reminiscent of the pachuco, the Chicago gang cross with rays or halos is less subcultural than strictly gang-related. Variations distinguish these symbols from each other, gangs eventually giving them meanings. Adding new concepts to literature and evolving symbolism keeps the false flaggers and perpetrators at bay. The Latin Souls use the cross of Lazarus. The Bishops' cross brings to mind a modified "Krückenkreuz" or cross potent with crutches on the ends, used by the Crusaders. The Counts' has five slashes; white gangs like the Royals, Gaylords, and Popes have three, two, and a halo, respectively.

Compliments of Chicagohoodz: Chicago Street Gang Art & Culture

Top: On September 26, 1985, 22-year-old Darryl "Bulldog" Griggs RIP (far left) was killed by Insane Unknown, Edwin "Weso" Suarez, after Suarez walked into the Over the Hill bar and opened fire with a semi-automatic weapon, injuring four patrons including Griggs. Bulldog himself had just been released from prison two weeks prior, and was the only one to die from his wounds.

and currently resides down South—where some say he continues to spread the gospel of the Simon City Royals. His brother William "Shadow" Fender died in the custody of the Illinois Department of Corrections in 2015.

Lincoln Park is today one of Chicago's most exclusive areas, home to upwardly mobile young professionals.

Central Park and Wilson

Albany Park, once predominantly Jewish, has now become Chicago's melting pot. In the mid-1970s, the Simon City Royals migrated there from Paulina and Cornelia, taking control of Roosevelt High School and their new headquarters at Central Park and Wilson (CPW). Although not originating there, most Royals consider Central Park and Wilson their motherland, and members throughout the city seem to flock toward this chapter. By the 1980s it was their largest branch, and Agim Hotza was its president. When the Folks board members had issues with the Royals, they met with him.

> *"Hotza was an Albanian that came from a wartorn country where Muslims were being oppressed. When these guys—no matter what race they are—come to Chicago, gangbanging comes second nature. That's the closest thing to what they experienced they're gonna find."*
>
> —Telly

On April 13, 1975, Timothy "Bimbo" Gilfillan died four hours after being shot during an altercation with Latin Kings a few blocks away from Central Park and Wilson, at St. Louis and Leland, and the Kings shot up to become archenemy number one.

One of Central Park and Wilson's main income sources has always been the sale of narcotics. While other local gangs were selling nickel and dime bags in the 1980s, Central Park and Wilson met them in the middle, and began a word-of-mouth marketing campaign offering the sale of seven-dollar bags of weed. The word spread throughout the North Side, and soon the branch was making a boatload of money.

Before long, law enforcement caught wind and began to put pressure on the boys, and many found themselves facing criminal charges. Knowing that a narcotics conviction carried more time, some resorted to the sale of stolen merchandise, which carried less time than burglary did. Central Park and Wilson capitalized on this venture, while other chapters continued to burglarize homes throughout Chicagoland.

While their main enemy has always been the Latin Kings and other gangs affiliated with the People coalition, Central Park and Wilson went to war with the Insane Spanish Cobras in the mid-1990s over Jensen Park. Today that war continues, and they also find themselves at war with the Spanish Gangster Disciples, who began to encroach into the Royals' neighborhood in the early 2000s. Some on the streets don't know how much longer the Central Park and Wilson Royals will be able to hang on to their once most powerful corner. All three of these gangs are

Top: I went to Central Park and Wilson in the mid-'90s and met a bunch of Royals. For some reason there were a lot of them there that day; I never saw a crowd like that there since. I took a series of pictures. The guy crouched down is throwing up North Siders (a white prison gang which pre-dated Folks and People).

Compliments of Chicagohoodz: Chicago Street Gang Art & Culture

I was driving around the North Side: Uptown, Lake View…it was getting late, so before I went home I thought I'd drive by Central Park and Wilson. I knew it was their main section at the time, so I wanted to see if anyone was around there. I ran into Spooky (no relation to Christiana and Wellington) and a couple other guys, and asked if I could take a picture—but I didn't know there were others listening from the window and before I knew it, there were about eight more guys coming out of the building. Just goes to show how many eyes could be on you in a neighborhood that looks dead.

credited with the majority of the crimes that take place in Albany Park.

In the late 1990s, former Central Park and Wilson president Agim Hotza became a devout Muslim and retired from gang life.

Christiana and Wellington

Coming into existence in mid-1970s Avondale, Christiana and Wellington (CW) was founded by Richard "Apache" Fox and the two Dayton brothers, and was most famous for committing burglaries throughout the city and surrounding suburbs. By the mid-1980s, most original members were behind bars for participating in such crimes.

The "Toddy-N-Spooky R.I.P." card was drawn by Stooge and printed in 1987 by shorties trying to revive the old set. The branch was not active long, as the leadership of nearby Albany and School forced them to either join, drop their flag or join another set. As a result, some went to Albany, nearby Kosciuszko Park, or Bell School Yard—while others simply dropped their flag or flipped to other gangs, particularly the Maniac Latin Disciples, who had a branch blocks away at Barry and Spaulding. One member who went to Albany and School and rose through the ranks throughout the late 1990s and early 2000s was Oscar "Lil Man" Martinez. Lil Man was eventually convicted of ordering the 1998 murder of an ex-Royal turned Imperial Gangster in Legion Park, is serving a 50-year bid and is not eligible for parole until 2050.

Although the card pays tribute to Todd Brewer, he was not from Christiana and Wellington. The three slashes above the cross were meant to be ribbons emblazoned with "Simon City Royals," which the printer was unable to achieve. Also on the card is a cracked Gaylord Klansman's head, a cracked five-point star disrespecting all gangs under the "People" alliance, and an upside-down five-point Latin King crown. At the base of the cross is a drop of blood.

> "The Deuces killed Spooky. He was all high on PCP. They pulled up in a van, 'We're Popes; what up, bro?' Spooky staggers up to the van. They slid the door open, snagged him and took off. They were stabbing him with steak knives, like 50 times. They stabbed his eyes out. They threw him back out on St. Louis and Leland. He had Chuck Taylors on. He walked up Leland, turned in the alley, fell. You seen the blood prints from the bottom of the Chuck Taylors for like ten years."
> —Apache

Albany and School

Albany and School (AS, ASR) in Avondale was originally started in the late 1970s as an offshoot of Christiana and Wellington, and California and Fletcher. It was once considered to be one of the most notorious Royal sections of all time, and was the first to use "Insane" instead of the traditional "Almighty." By the mid-1980s,

a new generation had taken the reins. "Stooge" was considered a resident Royal artist and would be commissioned by other branches to execute artwork for them.

"All the older guys went to jail for the big burglary ring, and Maddog's down for murder. Basically, you've got a bunch of 18-year-olds running it, with no rank higher. LA (Lawndale and Altgeld Gaylords) was making cards going against ASR specifically, and that bothered other Royal branches. They were used to being the rock stars from the Toddy years in the late 1970s and early 1980s. Hotza would come and try to push us around, make us deal, and get mad at us for not showing up at nationwides. We were kind of renegade. We didn't like being told what to do by the other branches."
—Stooge

During the mid-1980s, the Albany and School Royals were in the middle of a card-printing war with the Gaylords from both Kilbourn Park and Lawndale and Altgeld. To some, it seemed that both sides were printing a card a week. While bodies were piling up in the city morgue, cards were also piling up—not only on rivals' corners, but also on their front lawns.

Ohio native Gabriel "Playboy" Farley moved to Chicago as a young boy, where he joined the Royals at age 13, eventually becoming president of Albany and School. He was killed at age 19 on May 24, 1991, while getting a late-night snack at Dakin and Broadway. His

Above: "I was really drawn to the Simon City Royal look: the cross with the lines, the bunny thing, and the name." —Stooge

Left and below: "There was something about Albany. Very inviting—the setup there, the parties, everything was just better at Albany. It was a very special time in Royal history during the mid- to late 1980s at Albany and School. Everyone knew we had the best neighborhood. We had those tracks. We were the most hated." —Stooge

1. "Poochie from Southport once told my president, Kool-Aid, 'You can't write ASR anymore.' We were writing ASR instead of ASCR (Almighty Simon City Royals). That was like a logo; it just got known: 'Albany and School Royals.' We were everywhere."—Stooge

2. This 1986 card disrespects the Gaylords with the inverted Klansman and cracked flaming Maltese cross, as well as four of their most hated enemies: the Kings, Stones, Deuces and Unknowns—all responsible for killing Royal leaders (Bimbo, Dillinger, Arab, and Bulldog, respectively). This was the first card Playboy was allowed to be on.

3. The "Compliments of Kool-Aid" card circa 1985 depicts their opposition to the Gaylords, as well as the Latin Kings and Insane Deuces—their three biggest rivals of the time.

4. Even more so than Mr. Stooge, Albany's best artist was perhaps Scorp. Known for his ability to draw Lowenbrau lions freehand, Scorp made a cardboard stencil that would be used in drive-through spray paint hits on Kilbourn Park.

Front and back of a joint Albany and Avers Boys Organization (ABO) card. ABO was a nearby crew associated with—and sometimes considered to be—Simon City Royals. Some Royals jokingly referred to them as "subcontractors." In 1998, ABO member David Harwick, a.k.a. "Glum," killed his own mother with a hammer while robbing her for drug money.

Compliments of Chicagohoodz: Chicago Street Gang Art & Culture

attackers were Latin Kings who were on the hunt for Latin Eagles in the Lake View area. At the time of his death, Farley was planning on leaving the gang life behind, with hopes of becoming a police officer or a lawyer.

> *"Playboy was a neighborhood kid when I first joined. He was around longer than I was. Scorp would tell me, 'That little 11-year-old kid—he's down. He'll stab you; he'll shank you in a second.' He was just this little kid that wanted to be around us all the time."*
> —Stooge

Once considered a powerhouse on the streets, they now find themselves in bitter feuds with old allies. Due to these feuds, some of their members have opted to jump ship. Kool-Aid, once Albany and School's president, is now a Maniac Latin Disciple. He switched his allegiance after being sentenced to life in prison without the possibility of parole for murder, and currently resides at the Menard Correctional Center.

> *"Kool-Aid was my partner. We were the 'Black and Blues Brothers.' I wish I would have had a card made, just like KP (Kilbourn Park Gaylords) made a few of those crazy offshoots, like the Stooge Brothers. I never made it. He tries to stick up a small tavern at the corner of Belmont and Sacramento. The only two people in the bar was the old drunk guy bartender and some drunk woman sitting on a stool. Comes in. 'Stick 'em up.' Woman throws a drink in his face. He reacts, shoots, kills her. He shoots the other guy too and then leaves. Tells his girlfriend at the time. She kept the secret for a long time. But they break up and they fight. She tells the secret to Moose. It was years later, and he ended up tricking on him. He said, 'We might be birds of the same feather, but we don't flock together.' Kool-Aid had gone on a downward spiral…"*
> —Stooge

Another former Albany and School member is Brian "Mouse" Nelson. A lookout man for an armed robbery and murder at age 17, Mouse was sentenced to 26 years in the early 1980s. After Agim Hotza's retirement and Frank Fender's incarceration, Nelson was considered SCR's leader throughout the late 1990s, sitting at the Folks table in Statesville prison with the other shot-callers, with Lil Man calling it on the streets.

Transferred to the infamous Tamms "supermax," Nelson experienced the horrors of solitary confinement for 12 years. In "the gray box" he spent his time hand-copying the Catholic Bible and Rule of St. Benedict, and took part in hunger strikes. Nelson has since become a paralegal at the Uptown People's Law Center, and an activist for prisoner's rights.

Koz Park

The Kosciuszko Park chapter in Logan Square, known by locals as "Koz Park," has pulled off thousands of burglaries since

Top: "In case you missed it the first time": Hubby and Joker's names appear three different times on this card.

Left, bottom two cards: Odell and Waveland in Dunning, on the Northwest Side, was originally a Pope, then an unrecognized Royal section. Since Albany and School, the term "Insane" has had connotations of "renegade" for the Royals. Some members such as Stooge and Lil Rebel went on to transfer to Albany.

Compliments of Chicagohoodz: Chicago Street Gang Art & Culture

KOZ PARK
SIMON CITY ROYALS
COME SEE US IF YOU FEEL BRAVE • BUT
IF WE CATCH YOU WE'LL PUT YOU IN THE GRAVE

GAYLORD KILLERS KING KILLERS

| R-LOVE | CASPER R.I.P. | GL's COME SEE US AND |
| 6-ALIVE | SPOOKY R.I.P. | GET YOUR ASSES BEAT |

KOZ PARK
R's
GAYLORD KILLERS
K-K 2K

BIG MONEY $ — SAVAGE
SATAN — LIL SPOOKY
LIL ACE — PUMA
LIL K-K — LIL BAT
LIL GLK — MUGSY
DENNY — LIL SIMON
SANDMAN — BEAR
RIFF RAFF — KRAZY R

KILBOURN GL's ARE BITCHES
AND TRICKS LA AINT SHIT

Top: A Koz Park "junta" (nationwide meeting) during the 1990s. Every Royals section had a president and vice president, who would meet with the constituency of their individual branch, all the branch leaders then convening to discuss "nation business." During the 1990s, the Almighty Simon City Royal Nation would undergo a power struggle between Frank Fender of Southport and Fullerton, and Agim Hotza of Central Park and Wilson: "Hotza and Fender were at each other for years. Hotza wrote a petition saying how Fender's stealing all the money. As long as everything is flowing, so what? There was bond money, lawyer on retainer. But after all this shit happened, Frank gave his spot up, then Hotza left too. Almost destroyed all of us."—Apache

Card 1 (Top)

KILBOURN-PARK — **SIMON-CITY ROYALS** — **L A AIN'T SHIT. ASK SPY.**
G Ls ARE BITCHES.

CYCO REMEMBERED ALWAYS.

WACKY	LIL ACE
BIG MONEY	LIL LERCH
MUGSY	LIL G L K
LIL K-K	SHORTY
PUMA	SATAN
DEVIL	LIL SIMON
LIL SPOOKY	LIL ROCKY
CASPER	RAT
SAINT	WEST
CAPONE	MANIAC
SCORP-A-S	LIL RON
PLAYBOY-A-S	DROOPY
STOOGE-A-S	OUTLAW-A-S
DEVIET-A-S	LIL REBEL
	CAPONE-A-S

SPY ROTS — KOZ PARK

Card 2 (Bottom)

We kill Kings for fun. — **ALMIGHTY KOZ PARK** — **G-Ls see us and run.**

SIMON CITY

CYCO	SAINT
SLIM	DEVIL
PUMA	SATAN
MUGSY	K-K
ROCKY	LIL SPOOKY
SHORTY	WACKY
LIL	SAVAGE
G-L-K	MANIACK
	RAT
	SIMON

ROYALS

GAYLORD-KILLERS
2-K K-K
U-K-K

Top: Mike "Lil GLK" (GayLord Killer) Roberts was killed in 1988 coming out of Cook County Jail in Little Village: "It was a Stone Kent that killed him. Dude died in prison—he didn't get caught for that; he had another murder. They were walking up 26th; they had colors on and everything. You don't do that—Kings be waiting on you to come out of there. They were getting on the bus. Dude come out of the gangway: 'You're dead.' Boom, boom, boom. Shot Lil GLK right in the back of the neck. He fell right in Mugsy's arms. Mugsy got shot in an artery; he died three times on the table. He laid there shot, bleeding; Lil Mikey died right in his arms, 18 years old." —Apache

Compliments of Chicagohoodz: Chicago Street Gang Art & Culture

Above: In the alley behind Clark Street near a local video game arcade, 1991. During the late 1970s and early 1980s, game rooms like Dennis' Place for Games, Wizard's and Silver Sues were everywhere, and got the attention of teenagers—especially wayward teenagers. This game room still existed at the time, so perhaps while taking a break from Ms. Pac Man, someone had gotten a gallon of paint and a roller.

Left: The card shows their allegiance to the Insane Popes (RPN ="Royal Pope Nation") and the Black Gangster Disciples. Unfortunately, there is a misspelling: where it's supposed to read "BGD," it reads "BGO."

their founding in the early 1970s. When its members were not hanging in the park, they could be found hanging at the old Rainbo Lanes on Diversey Avenue. For nearly three decades, Koz Park ruled the west side of the neighborhood it occupied—until John "Big Money" Yonkers gave up the park to fellow Folks the Spanish Cobras, Orquesta Albany and Dragons in the early 1990s:

> "He was the chief over there. He ran a lot of them shorties off. He let the Cobras have a set on Schubert and Avers. I said, 'Don't let them motherfuckers over there, dude.' He turned Cobra, tattooed a Cobra on him."
> —Apache

A sit-down was called for, and the Almighty Simon City Royal Nation requested that the three aforementioned clubs relinquish their claim to the park, and return the land to its rightful owners. The Cobras refused to surrender the lucrative drug trade they had set up, and thus war began. Dozens of members on both sides have been maimed by gunfire, and several of them killed. The Dragons have since pulled out, leaving only the Cobras and OA to deal with the SCR. As of this writing the war continues.

BELL SCHOOL YARD was North Center's most well-known Royals section. Their card was made by Lil Insane, and features a modified Polish eagle drawn by a Polish kid Hubby met in the joint. Although all copies of this unauthorized "Royal pigeon" card were ordered burned, and Lil Insane was violated, it was a favorite amongst collectors due to the big names listed.

Bell School Yard held the 'hood down for nearly two decades before fading away.

Chester and Argyle

The Chester and Argyle card features dual hanging and castrated Gaylord Klansmen pierced by pitchforks, and was drawn up by Stooge from Albany and School, and printed by Mr. Vagrant in the late 1980s.

In mid-1980s Chicago, the word "tall" was common youth slang for "excellent." By this time, the Folks prison alliance had hit the streets, and its symbols, such as the pitchfork, were often used by Folks-allied gangs. "Spy-N-Wizard Rots" refers to two Gaylord members killed by the Royals in the 1980s. Mr. Vagrant transferred to Christiana and Wellington, changed his nickname to "Hit Man," and for the next few years jumped from one Royal set to another, finally ending up at Bell School Yard. Having left the Royals in the mid-1990s, and facing a short stretch in the joint, he opted to flip to the Maniac Latin Disciples, and entered the Illinois Department of Corrections as an MLD.

ROSCOE AND LEAVITT in North Center was around since the mid-1970s and lasted until the yuppie invasion of the mid-1990s. During the 1980s, this section was run by one Fred "Rip Van Winkle" Cosme.

Their primary enemies were the Gaylords and Deuces. The "Gaylords Beware" card depicts a bunny with a bent

149

Top: These Farwell and Clark photos are from a later generation of Simon City Royals, when they were tight with the Gangster Disciples, and the Spanish Gangster Disciples were just coming up on the North Side. This unity held that neighborhood tight and solidified the Folks in Rogers Park. All archival Farwell and Clark photos courtesy of Telly.

Opposite, top: "Campbell and Lunt didn't want to ride under the fork. We were like old school Royals—the cane and the cross. Albany and School boycotted the fork for a long time. Certain members wouldn't throw up the fork—depending on where they were at. You're partying with the Imperial Gangsters, you're throwing up forks. You're like 'Yeah, Folks, man!' But then you're with the Popes; you're drawing Klansmen…." —Weasel

Opposite bottom right: Eddy Street was a small section in the late 1970s, and was not around very long due to its proximity to the Kilbourn Park Gaylords. Members of the KPGL often joke that the chapter lasted less time than it took to smoke a Lucky Strike cigarette.

Compliments of Chicagohoodz: Chicago Street Gang Art & Culture

151

right ear holding a pump shotgun to the head of a Klansman. It gives a warning to the Berteau and Leavitt Gaylords, and it also informs two of their members that they are next on the list to die. It also pays disrespect to the Black P-Stones/El-Rukns, Deuces, Unknowns, Kings, Spanish Lords, and Vice Lords. Neither Dillinger nor Casper belonged to Roscoe and Leavitt.

This chapter had an active faction of females known as the "Royalettes," who amounted to nearly 20 members at their peak in the mid-1980s. Roscoe and Leavitt could often be seen associating with their sister branch at Bell School Yard, and vice versa. As of this writing, both the male and female factions are inactive.

FARWELL AND CLARK was around from the mid-1970s until the early 2000s and became the Royals' most notorious chapter within Rogers Park. Initially called the "Silver Sue's Royals" after the game room on Farwell and Clark, the section was renamed in the early 1980s by the members who hung out there. One of these was Jimmy "Sinbad" Hayes. Half-black and half-white with freckles, Sinbad was Farwell and Clark's well-loved leader.

Reflecting the neighborhood, other "FC" members included Montel (a.k.a. "Bubba"), covered in Gangster Disciple forks and winged hearts—he had to rep Disciple in the joint, but was a Royal when out. Another African American, Roland (a.k.a. "Rollo"), held the rank of a senior Royal, even though he wasn't even a member. Farwell and Clark could often be seen hanging out with their sister branches, Touhy and Ridge and Campbell and Lunt, or patrolling the local CTA terminal, where they would prey on unsuspecting rivals traveling in the neighborhood. Their main enemies were the Kings from Edgewater, Gaylords from Uptown and Lincoln Square, and—as Rogers Park continued to change to African-American—the Vice Lords and Black P-Stones.

The beginning of the end for Farwell and Clark was Sinbad's death during an attempted armed robbery of a drug dealer in a Rogers Park parking lot in 1990. He was 23 years old.

CAMPBELL AND LUNT was established in the early 1980s as an unsanctioned Touhy and Ridge offshoot in West Ridge. The intersection is located at the southeast corner of Indian Boundary Park, their favorite hangout. It was not unusual to spot a dozen or so Royals in this park on any given day. The chapter itself lasted well

Top: Brynford Park is a small park within the North Park area, just southwest of Rogers Park.

Compliments of Chicagohoodz: Chicago Street Gang Art & Culture

Collaborations

Collaboration on cards has been going on for decades; by having multiple branches pitch in, it would alleviate some of the printing cost.

Top: Troy "Hillbilly" Mansell: "We used to call him 'Troy the Blue Boy' because he always had blue on him. Troy was in and out of the joint; he was a burglar. He met a girl while he was in prison, from Effingham, Illinois. Started writing her. When Troy got out of prison, he paroled to her crib. His brother comes there from Alabama; they go rob a bank in Effingham. Come out with the bags of money. State trooper pulls up and gets out of his car, and Troy shoots the trooper right in the head. High-speed chase down the highway, there's like 15 trooper cars chasing them. There's a junction road next to the highway. Cop with a high-powered rifle shot Troy's brother in the passenger seat. Troy was doing like 140 miles an hour. and all his brain matter splattered all over him. And he crashed and flipped like eight times in the car. He died in the hospital from his injuries. That was my boy. I grew up with him from little kids, third grade."—Apache

Bottom: In 1987, a Gaylord on a motorcycle opened fire on Casper's vehicle, parked outside Puma's house, a block away from Koz. Casper was killed instantly; although shot in the neck, his girlfriend survived. "There was only about four active members from Koz out at the time. The bottom three names on the Koz side are actually Albany or California and Fletcher guys. Most of those guys on the Koz side were locked up, including Mike 'Cyco' Hynes. That's why Albany was hanging by Koz—to bring it up, to give them some presence. John Yonkers used to give me tic—PCP—for free, to put hits on Koz, cos he wasn't much of a writer. He was trying to get me to join Koz, but they were a little funnier in the head. They had a few screws loose up at Koz. I didn't have the good feeling with Koz that I had at Albany."—Stooge

Top: "Me and Outlaw always wanted to be on a card with these kind of lions. I got these off a Sayre Park card. I take this design that I drew using French curve stencils and a ruler, we have the Gaylord card with us, we want five hundred made. Me and Outlaw pay for it; we go in halves. And right before we're putting it in, Casper gets killed. So we decided to throw "Casper R.I.P." on there. But you know what they did? They shrunk those lions down, so there were these little baby lions on there. So, we go back there. Outlaw was like "Well, the card looks awesome, so we're gonna get five hundred more made. But you gotta reprint. Why would we want little lions that tiny?"—Stooge

Center: The DW / CW card represents Drake and Wolfram and Christiana and Wellington. In the late 1980s, Pat 'Wacky' Saunders went to prison in Wisconsin for burglaries and home invasions. "High-speed chase, he ran three trooper cars off the road in a big SUV. He got weird. His brother Mike a.k.a. 'Hit Man' is an animal, agile. He'll smash stacks of wood with his hands. Pat was supposed to be out a year ago, but got caught fucking a female officer and lost a year's time. She got fired. She's still with him. He turned out over five hundred Royals in the Wisconsin prison system."—Apache

Compliments of Chicagohoodz: Chicago Street Gang Art & Culture

Compliments of Sir Lil Apache

C-W C-P-W

The All Mighty Simon City Royals

There Ain't No Pity in Simon City

Apache		Beeper
Hillbilly	Bozo	Yugo
Diamond	Shorty	Buddha

Top: A prominent Royal, Anthony Diamond is currently serving an 80-year sentence for stabbing a 16-year-old Gaylord to death in an alley, after a squabble outside a bar in 1986. In his mid-20s at the time, he reportedly stated afterward, "It was the first one, and it felt good." Apache joined the Royals at age 12 in 1974: "All I did was play sports, Pee Wee football, Little League—all that. I went to Lane Tech, played varsity football there my freshman year. Met some Royals. Started smoking weed, drinking. Started hanging by Christiana. There was like 50 of us, all the same age."

Satan from the Paulina Barry Community in a Stateville prison cell during the summer of 1984, just before a riot jumped off. Satan is throwing up the North Siders prison gang hand sign. Before the advent of the Folks and People prison alliances in the late 1970s, racially oriented gangs ruled the Illinois Department of Corrections. The North Siders controlled Menard and the majority of medium-security prisons, where most whites were sent at the time.

Compliments of Chicagohoodz: Chicago Street Gang Art & Culture

chapter 3
FOLKS: "ALL IS ONE"

AS GANG CULTURE SHIFTED IN THE 1970s, and more gang members began entering the Illinois Department of Corrections, they found no sense of order on the inside. Since Chicago is one of the most segregated cities in the country, it's no surprise that rival ethnic gangs confined to a small space would be that much more prone to violence.

In 1978, Stateville prison ("the White House") inmate Larry Hoover organized the allies of his Black Gangster Disciples street gang into the "Folk Nation" (a.k.a. "Folks"), a city-wide, racially mixed gang alliance and non-aggression pact. Folks would also soon envelop the tightly knit United Latino Organization (the Spanish Cobras, Latin Disciples, Imperial Gangsters and Latin Eagles), as well as numerous smaller Hispanic gangs who all shared a common opposition to the Latin Kings.

Although white, the Simon City Royals, Insane Popes and C-Notes would fall with this Hispanic contingent under the umbrella term "Latin Folks." This treaty served to alleviate the chaos, and also increased power and safety inside the prison system.

The Folks were immediately opposed with the "People" compact between the Black P-Stones, Vice Lords and Latin Kings. This divide grew organically out of pre-existing hatreds and prior gang coalitions, such as the United Latino Organization, the United Fighting Organization, the Unknowns Players Kings, and the Black Gangster Disciple and Black P-Stone nations themselves.

With common enemies, the alliances fell right into place for most gangs. These agreements helped to quell racial tension, and introduced a whole new multi-racial model for prison organizations. It wasn't until the mid-1980s that Folks and People began to move from the prisons to the streets.

"A lot of Folks used to hang out at the lakefront. It was cool—it was like The Warriors, *because a lot of gangs were still race-based*

back then. It was a great time. You could tell who was coming just by the race. You saw the blacks coming, you know who that would be—Mexicans: Brazers; hillbillies with baby carriages: you knew that was the Royals."
—Telly, Simon City Royals

In the beginning, Folks and People also created a great deal of peace on the outside. Gangs that once couldn't travel into other neighborhoods were now guaranteed some measure of safety, using the pitchfork symbol as a kind of passport.

"We were kicking it with the Ambrose on a regular basis, because Lil Rebel and Sneaky were always big on driving around the South Side looking at hits. We'd go looking for Satan D's and Two-Six. Back then, it was great. Being Folks meant just about unilateral loyalty everywhere you go. There wasn't much dissent back then. Eventually, it broke down, but back then, throwing up the fork was just as common as throwing up your own gang sign. That's how you shook hands."
—Stooge, Simon City Royals

In the early days, many Folks street gangs utilized these Black Gangster Disciple symbols, but over time most organizations not named "Disciples" dropped them—some like the Two-Six even boycotting the fork because the Satan Disciples were trying to claim rank over everyone, just as the Latin Kings did to other People gangs.

Initially a basic pledge of allegiance, the Folk Nation would evolve to incorporate the organizational concept Spanish Growth and Development (SGD), with a constitution, by-laws, registration paperwork, and an executive board, "La Tabla." Consisting of Latin Folks chiefs, this ruling body was designed to resolve any of the rapidly unfolding internal disputes and grievances.

On the inside, there is order because justice is swift, but the streets are full of testosterone-driven kids trying to prove themselves to be leaders. The eventual incarceration of gang "shot-callers" in out-of-state "supermax" prisons created a power vacuum, and with ambitious youth trying to fill the top spots, chaos ensued once more on the streets. On the North Side, the United Latino Organization wing collapsed, as the Cobras, Latin Disciples and Gangsters respectively established the "Insane," "Maniac," and "Almighty" families. On the South Side, where sub-alliances were not formalized, it was a war of all against all. At present, both alliances are once again only relevant behind prison walls.

Satan Disciples

The Insane Gangster Satan Disciples were spawned as a Hispanic and white gang in the late 1950s in the Douglas Park area around 16th and Fairfield, and soon migrated to Taylor Street. Their colors are canary yellow and black, and their Satanic mascot is the Harvey comic book character Hot Stuff the Little Devil. They also regularly utilize the pitchfork and Star of David.

Top: In a parking lot off North and Ashland in the mid-1990s, when the Maniac Latin Disciples were at their peak. Signatories of the Folk Nation included the Gangster Disciples, Black Disciples, Satan Disciples, Ambrose, Brazers / La Raza, Two-Six, Two-Two Boys, Two-One, Party People, Latin Souls, City Knights, La Familia, Maniac Latin Disciples, Milwaukee Kings, Spanish Cobras, Imperial Gangsters, Latin Eagles, Orquesta Albany, Latin Lovers, Latin Jivers, Harrison Gents, Ashland Vikings, (North Side) Insane Popes, C-Notes, Paulina Barry Community, Simon City Royals, and eventually, both the Insane and Cullerton Deuces from the People alliance.

Bottom: A very well done Satan Disciples' shield under the Pilsen "L" tracks by 21st, east of Damen and south of Harrison Park, in close proximity to the Bishops and "Wild Side" Ambrose. Oakley—in particular 18th and Oakley—was the very heart of that section of Satan Disciples, who dominated all down the street. This emblem would later be splashed by a rival.

Above: Rival federations, David Barksdale's Black (formerly "Devil's") Disciples and Larry Hoover's Supreme Gangsters would unite by 1969; out of this synthesis would appear the Black Gangster Disciple Nation (BGDN), a tribe ruled by two kings. Sentenced to two hundred years for murder in 1973, from Stateville Correctional Center, Hoover became sole chief after Barksdale's 1974 death from kidney failure due to gunshot complications. The BGDN ultimately fractured into three different splinter gangs: the Gangster Disciples ("GDs"), Black Disciples ("BDs"), and Black Gangsters ("BGs," later "New Breeds"). Hoover modeled himself after Mayor Richard J. Daley, and instituted a highly organized corporate structure, with directors, governors, regents and coordinators. Now the "Chairman" as well as the "King," GD came to stand for "Growth and Development," a new concept for community outreach outlined in a text entitled *The Blueprint*. Convicted of drug charges in the mid-1990s, Larry Hoover now resides in Florence ADX, along with "Lord Gino" Colon of the Latin Kings, and Black P-Stones leader Jeff Fort. The Gangster Disciples still retain the distinction of being the largest street gang in the city. Their colors are black for the black man, blue for blue skies. Both primary symbols of the Folk Nation, the Star of David and the pitchfork, honor "King David" Barksdale and his Devil's Disciples. This juxtaposition of Jewish and Satanic symbolism pervades much of the Folks' imagery. To the six points of the star are assigned the principles of "Love, Life, Loyalty, Knowledge, Wisdom, and Understanding," activated by the assumption of a "six-point stance." The Folks also identify with the number 6, and the right-hand side. The Spanish Gangster Disciples are a Latino gang associated with, but independent from, the Gangster Disciples. Their image illustrates a common arrangement of the twin Folks symbols, with two forks jutting from the Star.

Opposite, top: The Satan Disciples' most well-known corner, at 18th and California—and they liked to make sure you knew it.

Opposite, bottom: Although all Disciples gangs use the pitchfork, the Satan Disciples may have adopted it independently as part of their comic book mascot.

Compliments of Chicagohoodz: Chicago Street Gang Art & Culture

161

Compliments of Chicagohoodz: Chicago Street Gang Art & Culture

Opposite, top: Early to mid-1990s, 24th and Washtenaw section. I don't know if this is a memorial wall for the names in the scroll, but the names bottom right are most likely the artists' signatures, and the style of those names is that of graffiti writers. It's not uncommon for guys to be part of the two subcultures. (I wish they didn't put that fork in his hand.)

Opposite, middle: 24th and Washtenaw in the easternmost side of Little Village, directly across California from the Two-Two Boys—note the four-point crown on the bottom left and the 22K on the top of this emblem.

Above, bottom left: You could always count on the Disciples to have a mural around the corner that they were known to hang around, whether it was 51st and Wood, 42nd and Campbell, or 18th and Cal—but another thing you could count on is that someone was going to be out watching that corner. This is what happened the day I shot the wall behind this guy. 18th and California is pretty much two blocks away from the rival gangs depicted on this shirt, with the Deuce spade and Latin King Master drawn upside down.

Throughout the 1970s and 1980s, the Satan Disciples had six main branches (18th and Oakley in Pilsen; 18th and California in North Lawndale; 24th and Washtenaw and 32nd and Lawndale in Little Village; 47th and Campbell in Brighton Park, and 50th and Western in Gage Park), although their membership could often be found floating from one set to another. They have since expanded their operations to several other suburban areas as well as states. The Satan Disciples are known to encourage an free enterprise approach to business amongst these chapters.

The 24th and Washtenaw card is from the 1970s. Perhaps its creator, in keeping with the "Old English" style so many Chicago gangs use, made up this term "Countsseus" in an attempt to merge the words "Counts see us," and make the phrase "(We kill) Kings for fun; Counts see us (and) they run" more colorful. (These rhymes were used across the city, just with the names of the clubs changed: "Chitty-chitty-bang-bang; nothing but a --- thang," etc.) This is a jab at two main rivals of this branch: the Latin Kings and Latin Counts. (The Kings were in close proximity from west of Marshall Boulevard and Coulter, and for some time the Counts were in the projects by 26th and Washtenaw, within blocks.)

In 1974, Agapito "King Aggie" Villalobos, already in his late teens, was busy putting in work on the streets in an attempt to get cred when he was stabbed in the head by a rival. A little over a decade later, Agapito would go on to become the undisputed leader of the Satan Disciples. According to former Morgan Deuce, Jack Walls:

"King Aggie—that cat was always at my house. I knew Aggie since he was like 13, 14. Aggie and my brother Charlie were best friends. They even lived together. Before he got to the Disciples, he had already been a Villa Lobo, an Ambro. Apparently, he had been in every gang on 18th Street before he ended up as a Satan Disciple."

FORTY-SECOND AND CAMPBELL have been around since the late 1970s. Their card has the same rivals depicted. Notice how this card uses the "Almighty" to describe them, long before they assumed the moniker of "Insane" in the early 1990s.

"Insane this, insane that—all that shit started coming later. They had 'insane' everything. And there may be only three or four or eight of them, but they were 'insane,' and so they ran by that. The Satan Disciples, they had a break-off group called 'The Wild Bunch' (Aggie, Charlie). They were still Disciples, but they included girls. Even in the Deuces, we had a break-off—it was only four of us, but we considered ourselves 'Aces.' There was always, like, these crews. They were still in the gang, but some of the crews, like the Supreme Clique—they were Latin Kings, but they became so fierce, they broke off and became their own thing. The Ambrose had a section called the Crusaders— they got so fierce, they became another gang all to themselves."
—*Jack Walls*

Compliments of Chicagohoodz: Chicago Street Gang Art & Culture

Top: A Gary School 8th grade graduation day photo featuring Aggie Villalobos.

In 1995, King Aggie ordered the murder of Danny "Gizmo" Valencia, an up-and-coming Disciple. That murder would set off a civil war within the Insane Gangster Satan Disciple Nation that would pit soldiers loyal to Gizmo against those loyal to Aggie:

> "Aggie killed that little kid, and then he fled to Texas, which is what they always do," said Walls. "If you wanted to escape Chicago back then, you hide out in Texas. Apparently enough of those motherfuckers got to Texas, where they started gangbangin Chicago style. They're all down there: the Ambrose, Two-Six, the Latin Counts—gangbanging. They just left 18th Street, went down there and didn't miss a beat."
> —Jack Walls/Hi-Fi

Ambrose

Originating in the 1950s, the Almighty Ambrose are one of the older gangs in Pilsen. Some say they began as the "Ambrose Dukes," hanging out close to Taylor Street around Vernon a.k.a. "Peanut" Park. Others say they are named after the Ambrose Bar at 19th and Halsted in Pilsen. Although the Ambrose first started around 18th and Racine, they soon took root at 18th Place and Throop, which they claimed as their motherland for the next 40 years.

Their membership has consisted mainly of Americanized Mexicans, who readily identify themselves by the ash blue and black attire they wear. Their main emblem consists of a knight's head, usually accompanied by a spear. The Ambrose can frequently be heard boasting "Spears for years," meaning that their club has endured, and will continue to endure for many more years to come.

The older members are heavily involved in the narcotics trade, and especially became known for the sale of "wicky water," a.k.a. PCP, a.k.a. embalming fluid. With the funds generated from the sale of illicit drugs, many older members have established businesses throughout the Pilsen community. As a result of their expansion efforts, the Ambrose decided to join the Folk Nation in the early 1980s.

By the mid-1980s, the Ambrose found themselves periodically engaging in various skirmishes with fellow Folks that bordered their turf, due to disagreements involving the drug trade. And thus, war was often called on newer gangs like the Party People, La Raza, and the Two-Six.

In 1989, the Ambrose Nation, along with nearly 20 other gangs deeming themselves Folks, organized what is now referred to as "Latin Folks," and began to follow the Spanish Growth and Development concept—an attempt to curtail violence among Latino Folks gangs.

By the early 1990s, law enforcement began to launch their operations against the Ambrose. The unfortunate shooting death of officer Brian Strouse caused a constant police presence, making it impossible for the Ambrose to remain on 18th and Throop. Their membership there began to dwindle, thus giving La Raza a pristine opportunity to expand their territory.

Compliments of Chicagohoodz: Chicago Street Gang Art & Culture

Top: Just south of 18th Street, west of Throop, was the Ambrose motherland; I took this picture there around 1991. Driving through those alleys back then, you would find big emblems like this in every gang's neighborhood, and to them it was important to make sure everyone knew whose 'hood you were in, because from block to block it would change. The next block east were the Allport Lovers; the next block south was the border of La Raza; less than two blocks west were the Latin Counts—all rivals.

Above, bottom row, left: The Ambrose of 18th card was made to provide a 3-D effect. A light blue piece of cardboard cutout was glued onto the black background piece and gave the finished product a border. "Peter" Guzman was just one of many Guzmans that ran the Ambrose for much of their existence, including Elvia "Queen Ambrose" Guzman. "Link" is nearly 60 years old as of this writing.

Above, bottom row, right: A rooftop emblem. Even though it says "18," I found it on 63rd, where another main branch reside. Rooftops were great for the gangs because it's like a billboard, and is harder for rivals to destroy. Me and a friend climbed up there in the middle of the day. The chance that an Ambrose saw me was pretty good, but they may have thought I was a cop. Of course, if I attempted to deface that emblem, I wouldn't have made if off that roof alive.

Compliments of Chicagohoodz: Chicago Street Gang Art & Culture

The Brazers/La Raza

The Brazers started in Pilsen in the late 1970s, on 17th and Carpenter and 19th and Ashland. The term "brazer" is a derogatory term used to describe an undocumented Mexican migrant worker—and for that reason they chose the colors of the Mexican flag.

Many children of second-generation Mexicans were more Americanized, and didn't speak Spanish as a first language. The Chicano population was still small, and until the 1980s, the ethnicity listed on their birth certificates was "Caucasian." There was a lot of prejudice from these second- and third-generation kids toward the newer immigrants. The gangs would jackroll brazers because they knew they would carry all their money in their pockets. As the population of Mexican immigrants increased, their kids started their own gangs to protect these newcomers, and this helped gangs like the Party People and La Raza grow.

The Brazers expanded to the North Side, near Chase Park in Uptown and Morse and Wayne in Rogers Park. Meanwhile in Pilsen, the Brazers turned into "La Raza," keeping their colors while the North Side kept the name and changed their colors to black and red. The Brazers' emblem is a "diamond" similar to the Cobras.

La Raza ("The Race") emerged in the mid- to late 1980s as the next generation of Brazers, out of the same area in Pilsen, with the same colors: red, white and green. La Raza's emblem is the Mexican eagle, often rendered Aztec-style, as well as a cross.

Tiny Raza emerged around 1982; their card came out in the early or mid-1980s. They then started their own branch on 21st and Throop, to soon graduate to (senior) La Raza. This branch was only one block from the Ambrose's main section or "Motherland," a dangerous war zone. Because this gang started after compliment cards and sweaters had become less popular than they once were, this card is most likely a rarity.

Party People of 17th

Started around 1980 by Michael and 11 originals, the Party People of 17th were one of the first party crews (if not the first) with the title "Party People" to turn into a street gang. The term was popular in a lot of dance music of the time, and it quickly caught on in the streets. Many of the early Party People were also DJs.

"Party People" popped up in all corners of the city in the 1970s and 1980s, but this particular group held on to the name, and today it refers to the street gang that started on 17th and Carpenter, near the Brazers/La Raza. Like them, the Party People were composed of recent arrivals from Mexico. Sharing family, friends and neighborhood, together La Raza and the Party People defended Mexican culture in Pilsen. As the Counts and Ambrose began messing with them, they chose the colors black and white—supposedly because there were no other ones left.

Phil started the Damen Party People branch, and you will see his name on a lot of cards. Phil eventually turned Ambrose

Compliments of Chicagohoodz: Chicago Street Gang Art & Culture

Top: There was no mistaking where you were when turning a corner and seeing La Raza painted on a wall in the colors of the Mexican flag. The emblems displayed underneath the name represent the number of enemies this gang has accumulated over the two decades of existence up to the time I took this picture.

Top: Gil, the brother of the president Coca at the time, was responsible for this wall. Party People walls usually consisted of variations of their name in black and white, abutted with a bunny head. Pete (Raton) described the process: "One guy would be rolling the wall white, and a guy with a can of black would be following along doing the letters." In front are Vicious, Bunny Face and Pelon. Note "CPD was here." The cops were tagging gang emblems around that period citywide.

Middle row, left: This drawing of two reaper bunnies by Lil' Frank and Vandal flips the emblems of the Kings, Counts, Bishops and Ambrose, while inviting them to come "get some."

Compliments of Chicagohoodz: Chicago Street Gang Art & Culture

to quench his thirst for wicky water (PCP), and in 1988 he shot Lil Frank of his former gang, paralyzing him from the waist down. Phil would later join the Satan Disciples, by whom he would be shot to death, and the Ambrose would go to war with the Party People.

The rest of the original Party People of 17th are still alive, many of them growing up to have good careers and families. Pepe is a pastor in Phoenix, AZ, JJ is now a brain surgeon, and Peppy turned border patrol.

Having staked out a permanent place in Pilsen, the Party People continued to grow and branch out there, as well as in other neighborhoods and suburbs.

Two-One

There were a lot of Two-One branches in Pilsen, all the way down 21st, from Western to Ashland. The Paulina branch was gray and white, while the Leavitt branch was black and green. Their emblem is a reaper with a scythe. They came up in the 1970s and lasted until the late 1990s, when they had problems with the Satan Disciples, who were trying to make them join. There are rumors that they still have a branch, but most seemed to have turned Ambrose. Their numerous references to "R.B.K." indicate the Leavitt Two-One's displeasure with the Racine Boys.

Racine Boys

The Racine Boys started in the mid- to late 1970s in Pilsen, where their territory extended from Carpenter to May, and

Compliments of Chicagohoodz: Chicago Street Gang Art & Culture

Opposite page, top: 21st Place, 1990. This is a wall bordering a railroad yard that separated Pilsen from Little Village. The "RBK" and "BCK" display their rivalry with the Racine Boys and Bishop / Count Nation. To the right are the inverted emblems of the Latin Counts, Cullerton Deuces, Saints and Bishops.

Opposite page, bottom: This Racine Boys photo is from a transitional era: the graffiti-style piece behind them displays the period when hip-hop was the craze, circa 1981 or 1982. Courtesy of Beto.

Botom right: "L-T-D" = "Lords, Two-Six and Disciples," a unity between the Ridgeway Lords, Two-Six and Satan Disciples to combat the Latin Kings, growing at a fast pace in the 1960s and 1970s.

Middle row, left: "Literature" ("lit") is the gang's internal documents and constitutions—its philosophy and secret teachings, codes of conduct, symbology and esoteric lore. Like a secret handshake, this served once again to deter infiltrators who didn't earn their stripes. The "T-sword" insignia represents strength; the "S" represents unity. A single drop of blood represents sacrifice.

Opposite page: When Two-Six first started, there weren't as many branches—Sawyer being the first, K-Town, then Albany, soon afterward "Dark Side" in the late 1970s, and then the rest of the neighborhood broke up into sections. This large collaborative drawing between sections displays an array of rivals, and includes an inverted Party Players cross and the haloed logo of the Latin Angels from Cicero.

Compliments of Chicagohoodz: Chicago Street Gang Art & Culture

177

Cullerton to Cermak. Their colors are blue and light blue. Their cards are from the mid-1980s, and on them you will see "21-K"/"2-1 Killers." It's almost natural that they would be "K-K" ("King Killers"), because they are Folks. The Racine Boys' original president, Flip, was killed around 25th and Western by the Satan Disciples in the early 1980s, making them "D-K" ("Disciple Killers").

Two-Six

Two-Six was founded by the Ayala brothers in the early 1970s in west Little Village. They started out as a softball team called the Two-Six Boys that hung out at McCormick School, on Sawyer by 27th. Some claim they were the little brothers of the Ridgeway Lords.

They were a loose group until the Latin Kings started messing with them. Tyrone and Al Ayala started to organize, with Al calling meetings. Their father Alfonso was associated with the Mexican mob, and opened two popular Al's Khaki stores, where everybody got their pants—the Kings sending their girls shopping for them because they couldn't go into that 'hood. The Two-Six held their meetings upstairs. Wherever the heavies went, the bodyguard Wine was also there.

Al, as organizer, fell into becoming the first technical president. After the Ayalas moved to K-Town, they made it their motherland, with the borderline being Central Park. Al was shot and killed in the late 1970s, leaving brother David Ayala to run the gang.

Compliments of Chicagohoodz: Chicago Street Gang Art & Culture

Opposite page, top: Names were often organized by rank—the highest on top, and so on down. Presidents were usually in the upper left, right or center. This Insane Two-Six card ("Action Time") is an original K-Town card full of original members, with the names "Al" and "Dave" and "Tyrone." "Stretch" started the Cicero Two-Six, before Sir Vic moved there. After many years spent gangbanging, Stretch ended up getting shot to death in a road rage incident.

Top: K-Town, 1989 or 1990. Ridgeway Lords hung tight there, their last neighborhood in Chicago. By the mid- to late 1980s, it was "Turn Two-Six or get out."

Middle: The three dots progressing in size on the "ITS" (Insane Two-Six) image represent "Our Continuous Growth," a concept from Two-Six literature.

Compliments of Chicagohoodz: Chicago Street Gang Art & Culture

Opposite page, top: Albany (often written as "AllBunny") Two-Six were from 38th, just south of the I-55 expressway. Their main rivals were the Latin Kings from the Boulevard (Sacramento and 26th) and 51st and Kedzie, and the Insane Popes from 35th and Hoyne—as well as Archer Park near Curie High School, which a lot of K-Town Two-Six attended. I wish I'd found this wall before the Ambrose did, but it still looked good (note their helmet flipped on the right).

Top: 19th and Cicero Avenue is the motherland of the Two-Two Boys' Cicero chapter. This rooftop emblem sits on that corner for all traveling south on Cicero to see. A rooftop was probably the best place to paint an emblem, as the chances of being caught, or for the opposition to get at it, were slim. And moreover, it makes for your own personal billboard hanging over the neighborhood.

Middle: A factory wall on 36th and Albany. Sometimes big and loud makes more of a point than a pretty mural. This wall's been hit so many times, the factory gave permission to graffiti writers to piece on it so the gangs would leave it alone.

"In the Little Village area, nobody used hard drugs except for these Ridgeway Lords. They were shooting up heroin, and they became junkies—and when you become a junkie you're like a lowlife. You ain't on top of nothing. Nobody wanted to follow nothing like that."

—David Ayala, former Two-Six leader

Alfonso was killed in Bonnie's Tavern on Super Bowl Sunday, 1981 by one Clayton Rockman; it wasn't uncommon for the mob to hire black guys to do their dirt. In August of that year, David oversaw a hit upon some Latin Kings at Keeler Park in K-Town. A young man in the military who was on leave and his girlfriend, who had moved out of the neighborhood to get away from the violence, were both killed. David is doing natural life for the murders.

Like Brian Nelson of the Royals, David Ayala was sent to Tamms, where inmates spent 23 hours a day in solitary confinement. There, he reportedly passed the permitted hour in his exercise pen feeding insects to his collection of pet spiders. Tamms is now closed, and Ayala has been transferred to an out-of-state prison.

Two-Six colors are black and beige, and their symbols are three lines ("Maniac lines") with three dots; the bunny (both the Playboy and Nesquik ones—and occasionally Bugs—often featuring a hat, a bent ear and a hoodie); the 2 and 6 dice; the spade, diamond and clover; and the "T-Sword," originating within prison in 1985.

Compliments of Chicagohoodz: Chicago Street Gang Art & Culture

183

Opposite page, top: "Trigger's dead. One of his own boys killed him. They got into a fight in a restaurant over here and he punked out this dude. He left and came back and waited for him to come out, and shot his ass."—Sir Vic

Top: Dark Side Two-Six behind Georgie's Restaurant. Dark Side was so named because they were "evil," because they would cut the streetlight wires, and because of their proximity to North Lawndale. Dark Side bunnies are recognized by a hoodie. First thing they said after taking the picture was "Now take this to the Kings."

Two-Two Boys

The Two-Two Boys are comprised of both whites and Hispanics, and were in the area of 22nd Place and California in Little Village during the mid-1970s. There they wore brown and beige, and fought the Kings and the Kents. They soon made their way to Cicero by the late 1970s, blew up to open up numerous sections there, and changed their colors to black and baby blue. Both branches were once allied with the Satan Disciples. Like several other Chicago gangs, the Two-Two Boys were known to have a penchant for "wicky water," or PCP.

The Two-Two Boys utilize many symbols, including a shield with a four-pointed crown, lines with dots (like Two-Six's, but two instead of three), a cross with two dotted slashes, and dice displaying the number two. The half-pitchfork is an older insignia adopted in the late 1970s.

Maniac Latin Disciples

Humboldt Park on the West Side became home to Chicago's Puerto Rican community after their displacement from Lincoln Park in the 1960s, and is the motherland of three large gangs: the Latin Kings, the Spanish Cobras and the Maniac Latin Disciples. These gangs section themselves off by area: to the west side of the park are the Kings; the Cobras and Disciples are the dominant gangs to the park's east.

The Maniac Latin Disciples (a.k.a. "Latin Disciples," "Maniacs," "MLDs" or simply "Ds") have been roaming this

185

Top: In 1970, original member and leader Albert "King Hitler" Hernandez was killed by the Latin Kings in the early 1970s; he is believed to have been their first casualty. The organization has paid tribute by displaying a swastika as part of their logo ever since, and MLD leaders thereafter adopted the title "Prince." The Disciples and Kings have maintained a feud that is very active to this day.

Cards: In the 1980s, the inverted cross referred to the Gaylords—not to be mistaken for Satanic worship. The MLD were never part of the Cobras' "Insane Family" coalition, which emerged in the early 1990s. Having adopted the "Maniac" moniker in the 1980s, the Latin Disciples created the "Maniac Family" in response. This faction of Folks included the Latin Lovers of Logan Square, the Latin Jivers of Humboldt Park, the Milwaukee Kings and the Maniac Campbell Boys.

Top: "The Twilight Zone" was the name for the MLD's motherland, their Rockwell and Potomac section, 1994. Throughout the 1980s, anyone wanting drugs went here. It was the spot to find anything, complete with prices spray-painted on the walls, and cars lined up for blocks. The MLDs held this fortress down with 30-50 members at a time, and no fear of the police or of getting burned. I never got to know any MLDs, but I tried. One here said to me, "Another white guy trying to make money off of us." (This coming from a guy who probably made thousands off a drive-through drug spot that wasn't discriminatory to whom it served.)

Middle: Riis Park Maniacs. The Jousters were long gone, but you do see the Pachucos who had picked up where they left off. This drawing (in red and gold markers, but oddly no blue) says much about alliances, as it disrespects more Folks gangs than People. The Satan Ds and Maniacs share little besides a name, some symbols, and for a time, some territory in East Village.

Bottom: "JC" stands for John Coonley Elementary School, and the letters "BPBst" stand for Belle Plaine and Bell Street. This neighborhood was controlled by the Gaylords until the MLD took it from them in the late 1980s. This branch also fought the Kings and Puerto Rican Stones. The words "Get Some" across the heart invite rivals to come and test their bravery. The six-pointed star shows their allegiance to the Folks; the cracked five-pointed star, their rivalry with the People.

Compliments of Chicagohoodz: Chicago Street Gang Art & Culture

area for the better part of the last five decades. Their main emblems are a heart with tail, horns and wings, as well as the pitchfork. Their colors are black and light blue, and their mascot is a fiendish hooded figure they call a "monk."

During the late 1970s, the Latin Disciples and Spanish Cobras were first cousins and original members of the United Latino Organization (ULO); both developed "Young Latin Organizations" (YLO) to move up the ranks into the ULO. YLO Cobras (YLOCs) and YLO Disciples (YLODs) would go on to become their own gangs as they broke off from their mother clubs. (Raymond Rolon was a prominent YLOD, and would go on to become a key member of the organization in the 1980s and 1990s, establishing political ties to one of Chicago's most powerful aldermen, Richard Mell.)

In the early morning of July 2, 1983, a single act of violence catapulted Fernando "Fernie" Zayas to the top of the MLD hierarchy, when Insane Unknowns Miguel Vargas, Luis Cuaresma and Ruben Gutierrez were shot while hanging out on a front porch in West Town. These slayings were in retaliation for the 1978 murder of teenaged Latin Disciple leader Ramon "Chi-Chi" Vazquez. They were also fallout of the "War of the Insanes" between the Unknowns and Spanish Cobras, the Disciples being closely allied with the latter. For these killings, Zayas received three consecutive life sentences. Prince Chi-Chi had been opposed to gun violence, and was moving away from gang life at the time of his shooting.

1996 was a tumultuous year for the Maniac Latin Disciples. As Prince Fernie languished in Tamms, civil war broke out between their "Real Side" branch at Talman and Wabansia, and the "Bum Brothers" of the "Twilight Zone" at Rockwell and Potomac. Suffering major losses in incarcerations, many Disciples also lost their lives in this conflict, including Real Side chief Enrique "Rick Dog" Garcia and Baby Bum of the Twilight Zone. The fragmented and weakened Latin Disciples at the time were entering into what would become known as the Maniac/Insane War.

Insane Spanish Cobras

The Spanish Cobras were hatched in Bridgeport in the 1960s, where their colors were black and maroon. Two members known as "The Twinkie Brothers" moved to the Division and Maplewood in Humboldt Park, where they changed their colors to white and purple, before they finally turned black and green. Their primary emblem is a straightforward green cobra poised to strike, along with a rhombus-shaped "diamond."

Like the Maniac Latin Disciples, the Cobras have mastered the street sale of narcotics, and it has become their number-one source of income. They have also become experts in the art of the drive-by shooting—a tactic they continue to use not only on their archenemies, the Latin Kings, but also on anyone who threatens their business operations.

In the early 1990s, the Spanish Cobras set up the "Insane Familia," comprised of the Insane Deuces, Orquesta Albany, Insane Dragons, Harrison Gents, and Insane Campbell Boys; the Ashland Vikings and Insane C-Notes came into the fold much later. Incidentally, many of

Top: This was a memorial wall for Spanish Cobra leader Richard "King Cobra" Medina, whose life was taken by the Insane Unknowns in 1979, sparking the infamous "War of the Insanes." I saw it from two blocks away. A guy in a black and green flannel shirt was hanging around the fast food restaurant across the street; I asked him how I could get on the roof. We went behind the building and he pulled out a pistol, but just to put it in a more secure location on his body, because he had to get a ladder from under the porch and carry it to the top floor so we could get up there. I wish I'd asked him if he wanted in on the photo, but I wasn't going to press my luck at that point. After KC, the next president was Tuffy C. Tuffy was serving time in New York; the Cobras would drive there to visit him once a month. By the time I showed up, Bradley was running it on the outside. Bradley was a tall guy of Irish descent; I met a lot of Irish members in Latin gangs. His older brother fought in the War of the Insanes; he told me they used to pull hits against the Leavitt and Schiller Unknowns in a big green Cadillac.

Bottom: The "Folks Know" card was made by a Schurz student in the mid- to late 1980s with a misprint: "G-K," which most on the street interpreted as "Gangster Killer," causing quite a stir among both clubs. It was then reprinted correctly with "GLK" for "Gaylord Killers" (their LA branch was blocks away from Central Park and Schubert). Some believe that relations between the Cobras and Gangsters never did recuperate. Spats escalated as the years passed, and today they are mortal enemies—even though at one time they shared not only turf, but an alliance as well.

Compliments of Chicagohoodz: Chicago Street Gang Art & Culture

Top: Early 1990s. The side of the building on Artesian and Lemoyne where Bradley was living at the time. They did a few good walls there around that period. I would go out there at least once a week and they would show me a new mural they did, even telling me "we did this one for you."

Middle, left to right: Soul C (RIP) was pretty cool, and let me take his picture with his Cobra shirt. As I did for a lot of guys, I brought back a copy of the picture for him, but he had been killed. The green card represents Simons Park and Springfield and Hirsch. "S-H" competed for members with their ally of the time, the Imperial Gangsters, whose territory overlaps theirs. Both gangs recruited from Cameron School, and would defend this area against the Insane Unknowns, Latin Kings, and Latin Brothers. Circa early 1980s.

Bottom right: I took this picture in the gang room at the police station. You can see the "DM" on the belt for Division and Maplewood.

these gangs, including the Vikings, wear the same colors of black and green, albeit in different shades: kelly green for the Deuces; the C-Notes had lime; the Cobras a darker forest green. This division of the Folk Nation originally started with the Deuces and Cobras talking about the "Black and Green Machine":

> "The Cobras came up with a concept to get gangs together, because they seen the Maniacs was gonna be a big gang to have problems with. Chino and Bradley and Corky came up with the idea: certain gangs that have problems with, or don't necessarily like, the Maniacs to get together, in 1990, 1991."
> —Sting, Insane Deuce

In the mid-1990s, war broke out between the Cobras and the Disciples, both of them having recruited the other clubs to join on their sides. As of this writing, the Maniac v. Insane war continues, as casualties continue to pile up on both sides.

Imperial Gangsters

Once an all-white neighborhood, Logan Square to the north of Humboldt Park would become a notorious Folks haven in the 1980s. The Almighty Imperial Gangster Nation came into existence there in the early 1970s. Kedzie and Wrightwood was their original set, then Palmer and Drake, then Cameron School at Grand and Division. Their main rivals at this time were the Gaylords occupying territory just north of Fullerton.

Compliments of Chicagohoodz: Chicago Street Gang Art & Culture

Opposite page, top to bottom: The IGs adopted the image of the Pink Panther cartoon character as another symbol in the mid-1980s. Photo of Cuba courtesy of Sting.

Top: Between the hot pink and the baby blue this popped loud as hell. The blue has nothing to do with their colors, so this visual effect may have been intentional. The Gangsters also used baby pink at times.

Middle row, middle card: This card was supposed to say "Spanish Imperial Gangsters." Middle row, right card: The Armitage and Spaulding card (AS) displays their main emblem, a rounded crown.

Emulating *The Godfather*, the Gangsters sported spectator shoes, white scarves, straw boater hats, and canes. Stolen bicycles funded their black and pink sweaters—the pink, as legend says, in honor of "Morena," a female member killed by the Latin Kings. Originally predominantly Hispanic, the Imperial Gangsters are today interracially mixed.

A founder of the Imperial Gangsters at age 13, Carlos "Lil Mexico" Quintanilla went on to become president of the gang, then numbering two hundred heads. By that time, he had been shot multiple times and had witnessed the deaths of several friends. The one that impacted him the most was that of Alley Cat, a homeless white youth who was taken in by the Gangsters and ended up losing his life in the mid-1970s. After his murder, Quintanilla decided to get his life back in order. At the age of 17, he quit the gang, enrolled back in school, and went on to graduate from college.

Orquesta Albany

Orquesta Albany (OA) were founded in the late 1960s around Darwin Elementary School as a Hispanic musical group that played at local parties. The word "Orquesta" was later changed by the media to its English translation, "Orchestra," when one band member was killed in the mid-1970s by a Latin King. Shortly after this murder, the band known as Orquesta Albany transformed itself into a gang, and made the Kings its number one enemy.

Although this gang has always been small, it grew in size once they joined Folks in the late 1970s. They are one of the most violent gangs in Logan Square, known to do whatever it takes to protect their 'hood against all rivals. Throughout the 1970s, they fought the Jousters, Royals, and Gaylords—they are credited with killing Tesse from Palmer Street; Lil Rocker from Lawndale and Altgeld; Kato from St. Louis and Altgeld was killed by Spidey.

Their colors are brown and gold, and like their cousins the Cobras, they ride under the diamond. The Orquesta Albany occasionally use an eagle as well.

Latin Lovers

The Insane Latin Lovers, as they are currently referred to, got their start in Logan Square during the mid-1970s, around Fullerton and Rockwell. Their card is from the late 1970s, and was most likely printed in Clemente High School's print shop class. The Latin Lovers' colors are yellow and red—the yellow from the Latin Kings, the red from the Spanish Lords. Like the Maniac Latin Disciples, their emblem is a "monk," but with a "Universal" figure similar to the Wolfsangel rune.

Hooking up with the Disciples in the 1980s, their main rivals became the Spanish Lords themselves, who bordered their territory just east of them across Western Avenue. Their deep hatred for each other continues to this day. The Lovers' president, "Lucky," was murdered in the early 1980s, and a mural was painted in his tribute near Campbell and Lyndale. It stood there for several years, guarded 24 hours a day.

Shortly after Lucky's death, Nelson "Babyface" Padilla led the Lovers as part of the Latin Disciples' Maniac Family, until

Above: The OA had two brothers who were former IRA members. During the 1960s and 1970s many came from Northern Ireland to Chicago, and promptly joined street gangs upon arrival. They would say, "Yeah, we have a gang in Ireland; it's called the IRA." One joined the Royals and taught them how to make napalm to throw at the Kings, pouring gasoline over Styrofoam while smoking a cigarette, with a two-inch ash hanging over the jar.

The "FOA" (Future Orquesta Albany) card above is from the '70s, and displays not only the member's real name, but also his nickname, address and home phone number. It was very rare for a gang member to print cards with personal information.

Compliments of Chicagohoodz: Chicago Street Gang Art & Culture

Top: This memorial to Lucky (note the four-leaf clover) was one of the most famous gang murals of its generation; gang members would come to take pictures in front of it. The Lovers also did an homage to Pink Floyd's *The Wall* album cover on these bricks.

Middle: You can see the Lovers' unity with both the Gangsters and Disciples, with the crown and pitchfork on the wall.

Compliments of Chicagohoodz: Chicago Street Gang Art & Culture

he was found cooperating with authorities, causing the Lovers and Disciples to grow apart. Mark "Rambo" Rosado took over in the early 1990s, and was a key figure in negotiating the Lovers' acceptance into the Spanish Cobras' Insane Family, creating major friction with the MLDs.

Today, the Latin Lovers find themselves fighting not only the People Nation and Maniac Family, but the Insane Family as well, as they fight a turf war with the Orquesta Albany in Logan Square.

The Paulina Barry Community

The Paulina Barry Community (PBC) was a multi-ethnic Lake View gang founded and led by a Panamanian named "Panama." Initially, every other member was white, as was the neighborhood. Spaniards, Peruvians, Mexicans, and Puerto Ricans joined the second generation, making it half Hispanic and half Caucasian. Romani, called gypsies then, joined in the third.

> *"It was a group of friends who got fucked with by the mobs of the day and decided to fight back. They were all jocks in their youth. Most turned into junkies. I don't know how they came up with the 'Community.' I heard it was from the neighborhood newspaper. The reporter wrote something like 'Violence broke out in the Paulina and Barry community, and several people were injured.'"*
>
> —Satan, PBC

Their area was around Lincoln, Belmont and Ashland, where their main enemy was the Insane Deuces. They also had a volatile alliance with the Royals. The PBC lasted from the mid- to late 1960s through the early 1990s. Their symbols were a skull and the number 13 (for the letter "M" = "marijuana").

> *"Dopey is Eli; he passed away a couple years ago. He had a heart attack, they said. I believe it was drug-induced. Wee Gee was more a brother to me than my real one. He was my dude, that's for sure. Fearless, respectful, and respected! No matter what kind of shit I got us into, he always had my back. When he passed away, a piece of me died too. He's been gone about six years now. Lil Rock is Dwight Laten. He was on his way home to get fishing poles. He was on a bike and got hit by a drunk driver and died instantly. He was my generation's first loss. He was loved by all of us. He was a good brother. We tried killing that fucking drunk driver a few times. He ended up going to prison for killing D and got killed in a riot in Pontiac. They were getting rid of all the stool pigeons, and I guess he was one. Karma's a bitch!"*
>
> —Satan

> *"I moved by Paulina and Barry the winter of 1971. Lake View was huge. We all had giant neighborhoods. The Royals were down Ashland, the 'Douches' were on the other side of the tracks.*

COMPLIMENTS CRAZY MAN
OF: BIRD PRES.
 ALMIGHTY
 P.B.C. 13
 INSANE AND DEADLY
 C - LOVE

Compliments of Chicagohoodz: Chicago Street Gang Art & Culture

Eagles were by Lemoyne School and Lake View. And we fought every one of those guys. There was no gang in our neighborhood. PBC became a gang to defend it. We were all so close with each other growing up. Like a giant family. I did it at first cos it was the thing to do, not cos I was afraid. I stayed with it to keep the niggas out."

—Satan

Almighty Latin Eagles

The Almighty Latin Eagles rose out of the turbulent Puerto Rican civil rights movement of the late 1960s and early 1970s. In the midst of this unrest was the Jimenez family. While Jose "Cha-Cha" Jimenez tried his hand in leftist politics, with the Young Lords Organization, other family members like Ismael "Kooks" Jimenez were trying their hands at gangbanging, with the Latin Eagles street gang. They made Wilton and Grace in Lake View their headquarters throughout the 1970s, and grew to include whites and blacks as well. Their colors are black and gray, their emblem an eagle with outspread wings.

The Eagles controlled Lake View well into the late 1980s, when gentrification began to disturb their nest. Due to the encroachment of their lands by the yuppie invasion and the expansion of the gay, lesbian, bisexual, and transgender community known as Boystown, the Eagles were forced to spread their wings. To the north, they settled around Gill Park; to the west, near Armitage and

Top: Originally, the "Universal" was used to represent the Latin Lovers, Eagles and Latin Disciples when they were unified, although the Lovers and Eagles were the only ones that used it. The Eagles dropped the Universal when they went to war with the Disciples. The Lovers came up with that symbol and therefore kept it. Frog's tattoo has all three gangs' symbols on it.

Bottom left: This card is compliments of Belle Plaine and Clarendon, who controlled Buena Park during this time. The most important name on the card is Ismael "Kooks" Jimenez, allegedly killed by their biggest area rival, the Uptown Latin Kings, on December 21, 1981.

Compliments of Chicagohoodz: Chicago Street Gang Art & Culture

Kostner in Kelvyn Park. Both areas would become the Eagles' last refuges throughout the 1990s.

Original members of the once-powerful United Latino Organization in the 1970s, along with the Imperial Gangsters, Spanish Cobras, and Latin Disciples, the Latin Eagles moved on to become Folks by the early 1980s, then part of its "Almighty" family in the following decade.

Insane Popes (North Side)

The "Almighty" Popes were a North Side greaser gang formed in the 1960s; they re-christened themselves "Insane" around 1973. Papal patriarch Larry "Larkin" Morris was a missionary with the gift of gab, and would travel to little green spaces like Independence Park to proselytize unbelievers.

By the 1970s, the Insane Popes had parishes sown across the North Side, and a South Side diocese whose vestments were black and white, instead of the traditional black and baby blue. On the North Side those colors were shared with the Gaylords—as was Kilbourn Park in the early 1970s, when Popes stood for: "Protect Our People; Eliminate Spics."

Their unstable relationship with the Gaylords came to an end in 1975, when Larkin was killed by a an excommunicated Pope turned Gaylord named "Shirtze," over land rights to Kilbourn Park. Like King Hitler of the Latin Disciples, Larkin is revered as a sacrificial hero, inspiring generations of Popes.

Bottom: This patch was made in the late 1970s. "There wasn't no emblem until 1971 or 1972, not that I ever saw. One of the guys that went to Lane drew it up, pitched it to us, and we ran with it."—Jake

Top row, left to right: Chicago and Wood was an old West Town set from the 1960s, consisting of burly Poles and Ukrainians. Mayfair is just south of LaBagh Woods nature preserve on the far North Side, and along with Independence Park, they were the primary sections until Larkin's death. Mayfair was ruled by Dago, then Babyface, then Goblin.

Second row, right: Some believe the North Center card was a marketing ploy to recruit members and promote their gang in the area. Some say their leaders made an ill-fated attempt at starting up two branches without the full support of other Pope sets. In any event, with pressure from the Royals to drop their flag, and their main rivals the Kings blocks away, Irving Park and Ravenswood—along with their other sets in North Center—were short-lived.

Third row, right: An Insane Pope party in the mid- to late 1970s. Members are wearing trophy sweaters they took from rivals, including the Gaylords and Latin Kings. Photo courtesy of Chicano (bottom right), Dago's brother and an Orquesta Albany member.

Compliments of Chicagohoodz: Chicago Street Gang Art & Culture

Top: Standard white boy attire for the 1970s. Also note the Klan patch on "Crazy Eddy's" jacket. His name suited him. Eddy moved to the South Side and joined those Popes (see Chapter 5), then various white supremacist groups. Photo courtesy of Jake.

Middle row, left to right: Although some did, it wasn't practical to wear a sweater in the middle of summertime. Iron-ons of a gang crest could be applied to a T-shirt, just like a patch for a sweater. When Kilbourn Park was still Popes 'hood (note "K/P") and the greaser unification among North Side gangs was strong. Gaylords and Popes were two of the big powers at this time, and it was the Gaylords' killing of Larkin (third from right) that brought the Popes and Royals into unity. Photo courtesy of Jake.

"After Larkin died, the guys from those sections didn't hang out or gangbang as much. Maybe they were just getting older. When we clicked with the Royals is when the greaser gangs made way for the criminal gangs. Royals were already on that path. In the 1970s, they were already major thieves, and we just became like them. The Royal Pope Nation was strong."
—Spook, Insane Pope

From the German enclave of Lincoln Square reigned the Lawrence and Rockwell Popes. Founded in the early 1970s, it became the gang's holy seat after Larkin's death. Predominantly Greek, with Albanians and Hispanics as well, these "Opa Popeas" fought the Lawrence and Kedzie Kings and—although not considering themselves "white"—hassled the Vice Lords with chants of "white power."

The Popes were one of the first white gangs to ally with blacks and Hispanics, when they joined Folks along with the Royals. Conversely, the South Side gang of the same name elected to join the People, due to animosity with the Satan Disciples and Two-Six.

What remains of the Insane Popes today is a truly "catholic" gang, including many members of African-American descent. Generations of Popes used a Klansman mascot; when other races started to join, the figure transformed into more of a "reaper"—creating a brand at once diabolical and divine. At times they use a papal tiara and a three-slashed cross.

"C/P" = California and Peterson (Mather High), 1984. GG stands for "Greek Gangster." Wolf killed a King in a drive-by, and several months later, he himself was killed: "1984 Kings were chasing him with their car while he was on his bike around Mather ... he turned down an alley flying but missed the cut and smashed into a wall ... that was the downest Pope they ever had! He was crazy and the Kings from Lawrence and Kedzie feared his ass, cos they knew he was a shooter. All the other guys are still alive, I heard, but some became drug addicts and shit ... Snake is in the joint for beating a cop's ass ... Shorty is Snake's brother. He was my partner. I lost track of him in the early 1990s, cos he went the wrong way ..."—Spook

Compliments of Chicagohoodz: Chicago Street Gang Art & Culture

Harrison Gents

The Almighty Harrison Gents started in the early 1960s around Harrison and Western, and have been a racially mixed club since their inception. Their colors are black and purple, and their emblem of a top hat, cane, and white gloves was to show that they had style and class. The original Harrison Gents were an SAC that liked to conduct themselves in the image of their name "Gents," a manner they still like to reflect today. As the generations passed, different branches found themselves having to deal with surrounding clubs to a degree that would be consistent for their survival.

By the mid-1970s, the Gents had begun to migrate, and chapters popped up in various North Side neighborhoods; those in Uptown lasted nearly two decades. Prior to the formation of the People and Folks, the Uptown Gents had a friendly relationship with the Latin Kings of the area until the late '70s, when hostilities between the two would arise.

Although the Harrison Gents have faced many challenges, they can still be found to this day in their last stronghold, on the corners of Ashland and Cortez in East Village. Once proud members of the Folk Nation, the Gents have been fighting other gangs who deem themselves Folks as well. A savage 20-year war has been going on with the Ashland Vikings, whose borders touch theirs. Another is with the Satan Disciples, who have been encroaching on their southern borders for years.

Compliments of Chicagohoodz: Chicago Street Gang Art & Culture

C-Note$

Founded in 1952, the C-Note$ (CN$; a "C-note" is slang for $100) are perhaps the oldest predominantly white street gang in Chicago. Like the Gaylords, the C-Note$ materialized in the West Town area. Their founding fathers were of Italian heritage, and they have always been considered a farm team for the Outfit.

The C-Note$ have always been a relatively small, low-profile gang with two main factions: their mother branch at Ohio and Leavitt ("OL") in the once predominantly Italian Smith Park neighborhood ("The Patch"), and the Jefferson Park ("JP") faction based on the Northwest Side. Like Ohio and Leavitt, Jefferson Park had a quite a few Italians in the beginning, also Germans, Irish, and Polish. Gangs recruit whoever is in the neighborhood, because they share an ideology. Where a branch was located would determine its ethnic makeup.

In the mid- to late 1970s, the Gaylords and C-Note$ were the United Fighting Organization's standard-bearers. At times, the C-Note$ adopted a Klansman mascot, along with their traditional dollar sign and money bag.

As the one former UFO constituent to remain independent of Folks and People in the early 1980s, under their "Family" banner, the C-Note$ declared war on both the Gaylords and Jousters, as well as the Insane Deuces. Many C-Note$ cards illustrate their opposition to gangs in both the People and Folks: the Kings, Disciples, Freaks, Simon City Royals, Jousters and Popes.

By the late 1980s, OL and JP were together, but not; each basically did their

Top: A very well-done cracked Gaylord cross on the back of a factory by the railroad tracks, and another example of the fragmentation of the UFO white gang alliance in the 1980s.

1. Normandy and Belden were from out west in the early 1980s, and fought with Vice Lords at school or the Brickyard mall. After Snake went to jail in the late '80s, his brother Skull turned SF Royal. After hanging out with the Royals, robbing and getting high, he overdosed.

2. In the late 1980s OL was taking a lot of hits, and JP bolstered their ranks with reinforcements. Mick was a talented writer who drew this collaborative card. Both Ozzy and Lil Ozzy are dead, Ozzy killed by the MLDs on Grand and Oakley. On the left is a Gaylords cross (at the time, JP's biggest rivals); to the right is a heart, disrespecting the Satan Disciples, to this day OL's biggest rivals. At the time of printing, the C-Note$ were considered independent, with no allegiance to any of the other hundred-plus gangs in the city.

3. The nickname "Moron" was based on the individual's last name.

4. Rico and Judas started Argyle and Lavergne as a hangout away from the main corner—to drink and smoke up on the tracks, or play hackysack under the bridge. After tagging "AL," Rico brought unwanted attention, but the corner eventually became official. This card was drawn by him in the mid-1980s, while the Playboys (P-B-K) were still around. It features a Royal bunny impaled on a fork, and a Jouster impaled on his own cross. Sabbath added the "WPO" and "KKK," but the members on the card were of Italian, Filipino, Irish, Polish, and Puerto Rican descent. Note the "F-L-K"—the Freaks were not yet "Stoned." "Family" started in 1983 when the UFO ended, and everyone started joining People or Folks. The CN$ rode Family by themselves, and went to the joint with no problem: if you minded your own business, you were good to go.

5. Inspired by Hawk's design, the Young Notes card was drawn by Rico's brother around 1985. Both factions had members sharing the same names; Curley and Ripper are different than the ones from OL. "Sinner" was supposed to be "Lil' Sinner" to distinguish the one from Olcott and Roscoe. "Stick" was supposed to be "Sticky."

6. Carmen and Lavergne was the original JP section and its headquarters at one time, started by the Hobo Brothers when they moved to that area, followed by Cicero and Gunnison. 1980s.

7. The fluorescent lime-green card is from the 1980s; it represents the C-Note "patch" to create a 3-D effect.

8. The seven Hobo Brothers founded Jefferson Park in 1976. Half Polish, half Mexican, they attended Prosser, where they fought the Jousters. The Ford logo is a tribute to their favorite car, the Mustang. "Hobo" is the oldest brother's nickname; they were called the "Hobo Brothers" because everywhere they lived, even prior to moving to JP, they lived by, and used to party around, the railroad tracks. Bowzer passed away in his mid-30s from diabetes. The Hobo Brothers are still around.

9. Harlem and Addison in Dunning was an OL offshoot. The girls on the "Cocs Lives" card were "G-Notes" (for "girl") in the 1980s. This section fought the Popes, Gaylords, Royals and Freaks.

10. This card is from the 1970s; as of this writing, these guys are getting close to 60 years old. Gulliver is currently doing 18 years after getting pinched robbing the cartels.

11. Starsky and Hutch were partners in crime in the mid- to late 1970s, named after the television show of the same name.

Compliments of Chicagohoodz: Chicago Street Gang Art & Culture

Top right: The "Midget" card with flags was drawn by Rico ("C"= C-Note). Schurz was littered with Deuces; the animosity starting over a girl, the Deuces bricking a CN$ car—and they were part of the People alliance, while CN$ were independent. Today the two are associates in the Insane Family, and cordial for the most part.

Middle, left to right: The Lil Guys were like Young Notes before Young Notes. The C-Note$ hierarchy is: Pee Wees, Midgets, Seniors. On their sweaters, each stripe (the CN$ never had chops) denoted moving higher up the ranks. At one time, the ultimate goal of any C-Note who wanted to be a career criminal was to be a part of organized crime—first an associate, then hopefully a made member; circa 1970s. People wrote on cards all the time. Initially made by OA (Ohio and Ashland) and ON (Ohio and Noble—after the Gaylords had left the neighborhood), whoever defaced the card was on the west side of Damen, changing the A to an L and the N to an E.

Bottom, left to right: A-Rab and his brother lived in the same building as Joseph Lombardo, hence his brother's nickname, "Clown." OO = Ohio and Oakley. Almighty Furies were OL guys from the neighborhood, inspired by 1979 gang film *The Warriors*. This is a different Rico; the original, Kenny Rodriguez, was shot and killed in 1992. Before Rich LaCoco ("Coc$") was killed in 1980 at age 17, he was seen in his sophomore Prosser yearbook picture styling a confiscated Imperial Gangster sweater. Some say Coc$ was killed by "the boys"—probably over a job or money, because he was well on his way.

Compliments of Chicagohoodz: Chicago Street Gang Art & Culture

Top, left to right: While many graduated to the Outfit, a few C-Note$ graduated to neo-Nazi organizations. Clark Martell recruited Eddie "Lil Waster" Miller from JP for his Chicago Area Skin Heads. "CASH" was all over the Jefferson Park "L" train terminal handing out literature. In the end, Martell went to jail, and Lil Waster got his wig split at a rally downtown while wearing a Nazi uniform. "Stan the Klan Man" also joined a Nazi group. The gangster and Klansman card was drawn by Hawk in 1984. Although the JP CN$ utilized the Klansman at times, you won't see any C-Note$ card with a swastika. Olcott and Roscoe started in the early 1980s. All these guys liked heavy metal: "Trooper" is an Iron Maiden song; "Deceiver" and "Sinner" (RIP) were Judas Priest tracks. Every gang was trying to outdo the next with a different design, writing or card stock. The fancier the card, the more impressive or collectible it was. By 1990, OR were gone.

Bottom left: The "Gangster Midget C-Note$" card disrespects the Huron and Cortez Gents, and Division and Wolcott Kings; the latter became major rivals when the Kings opened at Huron and Hoyne. This section was started by two Hispanic C-Note$ who had grown tired of getting picked on and called "spics" by older members—eventually becoming Kings, with backing from other LK corners. Circa early 1980s.

own thing. Apart from the occasional beef, the two branches got along—but it wasn't until 1993 that they got on the same page. As OL pitched to become Latin Folks, and asked JP for backing, they came under one umbrella and one leadership structure.

By the mid-1990s, for a gang with a onetime white power stance, the C-Note$—like most other white gangs by then—had a sizable Latino membership. By that time, the organization would go on to join the Folks' "Insane Familia." Once considered rivals, they now found themselves breaking bread with members of the Insane Deuces. Like them, their colors are black and green; originally, they were those of the Italian flag.

The C-Note$ have been occupying Ohio and Leavitt since 1952, and are one of the few historical gangs holding down their original corner to this day. Their relationship to both the Chicago Outfit and the Folk Nation are thoroughly examined in Professor John Hagedorn's book *The Insane Chicago Way*.

City Knights

Back of the Yards is named after the Union Stock Yards, the slaughterhouses and meatpacking plants that made Chicago "Hog Butcher to the World." Numerous gangs fight for this area: the Latin Souls, Party Players, Saints and City Knights have all had sets here over the years.

Top: "STK" = "Saint Killer," but the Latin Souls weren't getting along with Two-Six either. On the other side of the inverted "Saint" is "PPK" for "Party Player Killer."

Bottom: In addition to stenciling their cross on stop signs, the Latin Souls would place a "K" in the front of the "ST."

Opposite page, top: This City Knights wall inverts the Saints halo, Two-Six lines, and Party Players axe, and displays their own chess piece and scythe.

Opposite page, bottom: Like so many gangs who staked out a spot at the lakefront, the Latin Souls had a beach hangout too.

Compliments of Chicagohoodz: Chicago Street Gang Art & Culture

chapter 4
"GOD FORGIVES, GAYLORDS DONT"

ONCE A CHICAGO INSTITUTION, THE Gaylords (GL, occasionally Gay Lords) were for decades one of the largest and most violent street gangs in the city. Arising in the early 1950s as a social club in West Town's Noble Square, just blocks from their contemporaries the C-Notes, the Gaylords experienced phenomenal growth throughout the 1960s and 1970s. In their prime, the Almighty Gaylord Nation (AGLN) was the largest white street gang in the city, with several thousand members in independent chapters spread out across the North Side, as well as several on the South.

They claim to derive their name from a library book about the French "Gaillard" (meaning "strong" or "strapping," but also "bawdy") people of Normandy, but an alternate theory holds that their sports team was sponsored by the Gaylord Container Corporation. By the racially heated 1970s, their name had come to stand for "Great American Youth Leading Our Right Destroying Spics." (The last two words were later amended to "Demanding Strength.") In reaction to Puerto Rican migration northward, the Gaylords led the charge of the "Stone Greaser" movement, and formed the core of the United Fighting Organization (UFO) defense league[1], against their archrivals the Latin Kings, and other smaller Hispanic gangs.

While most C-Notes came from working-class families united by neighborhood, and remained in economically stable areas like Jefferson Park, the Gaylords expanded to many different branches—some in depressed areas like Uptown. As the economy tapered off in the 1970s, many poor whites weren't able to abandon changing neighborhoods, and were more apt to engage in drug abuse and fall on hard times.[2] Nevertheless, unlike the C-Notes, Chi-West, Thorndale Jag

Opposite, top: In the 1980s, many gangs citywide started using this phrase (either using "Fork" or "Crown").

This page: Recalling a chivalric military order, the Gaylords' dominant symbol is a variation of the Christian cross. This Gaylords emblem was acquired from a girl on Taylor Street who was dating a Gaylord from Grand Avenue. Both neighborhoods were predominantly Italian in the 1960s, as were the Gaylords at the time. Franco copied the emblem from a sweater patch.

WHEN I DIE
BURY ME DEEP,
WITH 100 KINGS
AT MY FEET
LAY A SHOTGUN
ACROSS MY CHEST,
AND TELL MY BOYS
I DID MY BEST.

SQUIRREL OF
St. Gen's

BLACK, MAY HAVE SOUL,
BUT WHITE HAS CONTROL

Doc Marco Rat Thor Jose Micik
Zorba Keeb Shuba Bugs Paudi
Iggy Nose St. Gen's Ears Squirrel
Rican Mop Pollock Dago Mills

WELCOME
TO
CHICAGO
BLACKHAWK GAYLORDS

GAYLORDS RUN
THE WHOLE
FUCKIN' THANG
MUTHA FUCKER
BLACKHAWK GAYLORDS

COMPLIMENTS OF
Lil West & Lil Fuzz
ALMIGHTY
GAYLORDS
ALL SECTIONS
G L's W P O

Top left: Disgraced former Illinois governor Rod Blagojevich grew up with the Gaylords from St. Genevieve's. His childhood friend and ex-Illinois Department of Transportation official, Daniel Stefanski ("Squirrel"), was reputed to have Gaylord tattoos as well as mob ties.

Above, bottom: WPO = "White Power Organization." This slogan was taken as the battle cry of the Stone Greaser crusade, in reaction to the "Black Power" movement of the 1960s. Like the South Side "White Beret" campaign, this was an informal designation, unlike the officially chartered United Fighting Organization.

Compliments of Chicagohoodz: Chicago Street Gang Art & Culture

Left, top to bottom: The Gaylords consider themselves the last "pro-American" street gang. (The Jousters would celebrate its colors in murals as well.) Besides paying tribute to five fallen brothers from five different branches (Kilbourn Park, Lawndale and Altgeld, Sayre Park, Moffat and Campbell, and Belden and Knox), the "Insane-N-Deadly" card disrespects Spooky, a Koz Park Royal. Whereas the Royals are known to say "There is No Pity in Simon City," the Gaylords contradict them here.

Above: The images show the front and back sides of a card dedicated to 16 loyal members who perished in the 1970s and 1980s, some at the hands of rivals—like Honky, killed by the Latin Kings—while others died by their own hands, like Capone, whose death was ruled a suicide. Yet others died accidentally, like Happy who died in a motorcycle accident in 1979. Gaylords have been killed in the heat of battle by both white and Hispanic gangs, including the Orquesta Albany, credited for killing Lil Rocker, Kato, and Tesse, and the Simon City Royals, credited with killing Wizard and Spy. Lil Rocker was killed by Candyman, who happened to live on the same block. Candyman has since been released from prison, and was last known to be living in his old stomping grounds. The "7-12" refers to the seventh and twelfth letters of the alphabet: G and L, respectively.

Offs, and the Simon City Royals, the Gaylords avoided organized criminal rackets, largely remaining neighborhood-oriented gangbangers and petty criminals. Accordingly, the gang did not have many gunners in their ranks, preferring to fight with fists, bats, chains—or even bullwhips.

The dawn of the 1980s saw the disintegration of the UFO and a rift with the C-Notes, escalation into total war with the Royals, and the integration of the Gaylords into the multiracial "People" alliance, led by the El-Rukns, Vice Lords, and Latin Kings. Flourishing well into the mid-1980s, the Gaylords (along with the Taylor Street Jousters and Playboys) can be considered the last vestige of greaser gang culture, encountering the rising tide of heavily armed black and Hispanic criminal organizations which monopolize Chicago today.

Faced with increasing change as "white flight" to the surrounding suburbs continued in the 1980s, Chicago's Northwest Side became one of the last havens for the city's working-class white population—and its gangs: the Jousters, Freaks, Playboys, C-Notes, Popes, most Gaylords' sets, and many Royals.

Gaylords had plenty of Hispanics in their ranks since the 1970s, and they increased in the 1980s: Spider, Link, Kato, Ringo, Rican, Spy, Hitler, Crazy Mex, Shadow, Stoner, Tank, Scorpio, Lucifer, Jack The Wetback ("JTW"), the Perez brothers from Sayre Park, and more; the Lawndale and Uptown branches had black members. Still, the Gaylords—unlike the C-Notes and the Royals—did not admit enough Latinos to bolster their ranks.

Succumbing to drug abuse and shifting demographics, the Gaylords were outgunned and outnumbered, and experienced a rapid decline and fall in active membership numbers by the early 1990s. As of this writing, their active status is disputed, with some maintaining that they have essentially reverted to a bona fide "social athletic club." A 2011 bust in Addison, Illinois, of several senior members on gun-trafficking charges shows more of the hallmarks of outlaw motorcycle gang activity.

At its peak, the Almighty Gaylord Nation was one of the city's most prolific card-creating gangs, printing dozens from the 1960s up to the present day, many of them highly detailed and finely crafted. On most appear their official symbol, a Maltese cross emanating an aureole of flames. The Gaylord cross can also feature two rays (occasionally three, depending on the branch) jutting above the crossbar. During the 1970s and 1980s, several gangs used a stylized Klansman as a mascot, but it is most closely associated with the Gaylords. Although Palmer Street wore black and gray, and the South Side black and brown, their primary colors are black and baby blue, and they often sported beige baggies with black suede shoes.

Footnotes:
1 See also: Chapter 1, "Old School"
2 A similar contrast can be seen in Cicero, between the "jockish" Noble Knights and the PCP-abusing Two-Two Boys. This difference between gangs again reflects more on the neighborhood itself—e.g., different Royals branches from various parts of the city.

Kilbourn Park

The Gaylords' Kilbourn Park (KP) branch came into being in the late 1960s. Prior

Top to bottom:

A lucky find while driving around Kilbourn Park in the mid- to late 1990s. This painting on a factory rooftop didn't seem that old, so it might have been the last hurrah for Kilbourn. The Gaylords continue to claim the park, but as of this photo you mostly see the older generations showing up on weekends. The "3" might stand for "Lords, Masters and Rulers." The wall also inverts the Royals' Old English "R" insignia.

By the 1980s, Chicago street gangs had perfected the compliment card as full heraldic achievement. The Gaylords made their cross its centerpiece, with Klansmen serving as attendants, in intricate tableaus emblazoned with insults. "Comps of Slick and Jake" displays their opposition to the Royals with the inverted "Rs," and to the Gangsters with the upside-down crown. It is duly noted that the saying "God forgives; Gaylords don't" is also used by a local "1%" motorcycle club, the Outlaws. The flames on this copy were colored in with red ink.

Although the Gaylords and the Royals had skirmishes throughout the years, it was the severe beating of Lil Gunner and the killing of Wizard that would forever pit them against each other.

Top, left to right: Several cards pay tribute to Steve "Wizard" Beverly. On Labor Day weekend of 1981, Wizard was stabbed to death at age 17 on the Kilbourn Park tracks by Casimir Jablonski, 24, an Avers Boy/Simon City Royal on a weekend release program from jail. Jablonski was a convicted felon with repeated burglary convictions dating back to the mid-1970s. Cornelius "Dago" Altobelli died of complications from AIDS. Some speculate that he contracted the disease from the use of drugs, others from unprotected sex. Drawn and printed by Jake and Slick in 1984.

Middle, left to right: Some believe that Dago's brother, Giovanni "Sly" Altobelli, was allegedly killed by his own boys on June 19, 1989, after it was suspected that he had cooperated with the authorities against two of his own. Both individuals ended up beating their cases. The last card Sly was on while alive, circa mid-1980s. Most Kilbourn Park members attended both Lane and Schurz High Schools, with Schurz being only blocks away, while some attended other local parochial schools. The "Sir Crazy" card was printed by a Schurz student.

Bottom right: The Kilbourn hierarchy originally included "Seniors," "Pee Wees" (P.W.) and "Juniors." Sometime in the mid-1970s, the "Slylords" were created. The Slylords were to Gaylords what "Futures" are to gangs today. In the 1980s, the rank of "Midgets" was introduced.

Compliments of Chicagohoodz: Chicago Street Gang Art & Culture

The cross is an elemental and primordial symbol whose archetypal power made it attractive to many street gangs. Its countless varieties include the Christian cross, and more specifically the "Maltese," derived from the Catholic fraternal order of the Knights of Malta. It is a variation of the cross pattée (a cross whose arms taper to its center and are typically equidistant in length) with concave or indented ends. On Gaylord emblems, such as this, these arms frequently appear in the dimensions of a Latin cross. They will also at times appear with convex, pointed, or the flat ends evoking an Iron Cross.

to the Gaylords taking control of this Irving Park territory, it was occupied by the Insane Stooges and later the Insane Popes. At one time allies who shared the park, the Gaylords and Popes went to war after Pope leader Larry Larkin was killed in 1975.

When not hanging out in the park or drinking beers on the bordering Milwaukee District / North Line Metra tracks, the Kilbourn Park Gaylords could be found at the Triangle restaurant on the corner of Milwaukee and Addison, which went on to be called "Pig Out's" in the 1980s. Although Kilbourn always had a large number of members, it wasn't until the late 1980s when their ranks began to really swell, due to other chapters being shut down. Those that still wanted to be Gaylords flocked to Kilbourn, at the time one of their last strongholds. KP began to absorb members from chapters such as Lawndale and Altgeld, Lyndale and Leavitt, Belden and Knox, and Kildare and Fullerton.

Many Gaylords will say they still have the park; active or not, some old-schoolers will show up there in the summer months.

Lawndale and Altgeld

Lawndale and Altgeld (LA) in Logan Square was one of the best-known, and among the Gaylords, most respected sections. With Kilbourn Park, they were also the largest. The Imperial Gangsters were in close proximity, and their main enemies; many LA cards feature an upside-down Gangster crown. The

Top: Compliment cards of the early 1970s were simpler than those of the 1980s and beyond, and usually consisted of text.

Bottom: Commonly associated with Nazi military regalia, the Iron Cross is a form of cross pattée inspired by chivalric orders like the Teutonic Knights. This design has decorated many men, from Prussian soldiers to surfers and skateboarders.

Compliments of Chicagohoodz: Chicago Street Gang Art & Culture

Left, top to bottom:

This card inverts a stack of rivals' emblems. The Cobra emerging from an Orquesta Albany (reversed as "AO") diamond is adorned with an Imperial Gangster crown, and flanked by two Klansmen flashing the Gaylords' hand sign. Crazy Boy would eventually jump ship in the late 1980s and join the Gangsters himself. To have a member jump ship and join a hated rival is one of the biggest insults any gang could face.

Anthony "Spy" Bermudez was described by the media as an innocent kid, who at one time had even been an altar boy. In reality, Spy was a LA Gaylord—for less than a year—before he was killed on a November night in 1984 by the Simon City Royals, less than a month shy of his 15th birthday. The "Spy Lives" card was printed shortly after his death. A Koz Park Royal, Mike "Psycho" Hynes, was later falsely identified as Spy's shooter and sentenced to 25 years. Hynes served 19, and two years after release was shot to death in a car within one block of Sayre Park.

Albany and School Royals were also one of Lawndale's biggest rivals. In the 1980s, they would go tit for tat, back and forth, for several years.

Lawndale was known as one of the largest Gaylord sections of all time, boasting the most names on some of their cards. This has been disputed and contested by some, claiming that some of the nicknames were made up. This tactic would make rivals think twice about going up against them, by having them believe that they were outnumbered.

Sting wasn't technically a Gaylord, but hung out with them before moving across town and joining the Insane Deuces. He was a great example of a Hispanic accepted by a "white power organization" because he grew up in the neighborhood:

> "I drew the 'Chief Lives' card. Chief died behind my house; he was an Indian Gaylord. Lil' King was a King from Beach and Spaulding. This was our block and we all hung out together. They were all buddies together… Gaylords were kind of racist, but they weren't pushing the white supremacist thing. They were the last of the Mohicans. By that time, it was changing, like from a beeper to a cell phone. They have to go with the groove, but the main thing was the Klansman was their symbol, they just couldn't get past that."

By the 1990s, Lawndale and Altgeld was coming to a close. Eventually, they were overrun by all the gangs they display opposition to: the Spanish Cobras, Imperial Gangsters, and Simon City Royals.

Compliments of Chicagoodz: Chicago Street Gang Art & Culture

In the early 1990s, I was up there on Cricket Hill, at the Lakefront for one of the hippie festivals. I saw these guys walking with a pit bull, flared up with "white power," long hair, teeth missing. I walked up to them and asked, "What are you guys looking for?" One of them goes: "We're looking for Royals."

Compliments of Chicagohoodz: Chicago Street Gang Art & Culture

Close to the last generation of Lawndale Gaylords. In the 1970s and 1980s, certain white gangs began to appropriate white supremacist iconography in order to insult and intimidate rivals. While the Jousters favored the swastika, the Rice Boys—and especially the Gaylords—were most associated with the Klansman. "Look at the Southport and Fullerton Royals. Even when they were rabid white power, they had black-ass Buckwheat with them. It all depends. Sometimes it was used more as a diss than something they really stood on. I used to see Gaylords and Kenmore Boys walking around in 'White Power' shirts in Uptown. I used to call the Latin Kings 'spics' all the time. They hated me for it, cos I was one of the few Hispanics with our guys."—Telly, Simon City Royal

Palmer Street

Palmer Street emerged in Logan Square during the early 1970s as the Palmer Street Heads, a party group with the colors black and gray—colors they kept after turning Gaylord. Their president during this decade was Bobby Mason, a.k.a. "Mace." They were known on the street to be some humbugging dudes who would fight rivals like the Kings, Gangsters, and Orquesta Albany to the bitter end. One Palmer Street member was quoted as saying, "Palmer Street Gaylords don't retire; they expire."

Unfortunately, besides being known as scrappers, they have always been portrayed—by not only their rivals, but also by some brothers at arms—as being drug-addicted hillbillies. This reputation has never escaped them and follows them to this day. Being financially strapped, they always looked for the cheap high. Most notably, they indulged in sniffing glue and paint thinner (toluene), thus receiving the name "tollyheads"—even from other Gaylord chapters. Some even joked that they must have been high when they drew up the brown card in the 1970s.

Due to drug addictions, many members have lost their lives prematurely, but Tesse was killed for his colors in the 1970s by the Orquesta Albany, after walking out of a sweater shop. He was a feared Palmer Street member known for his fighting skills. "Tesse Lives On" was printed in 1984 and distributed throughout many North Side high schools. It shows tribute to the People with a five-pointed star in the middle of the cross, and a crown tilted left. The card was made by Bob "Capone" Nellis.

The card featuring a Klansman hanging on the corner of Palmer and California was put out in the late 1980s by Howard "Joker" Butcher, a well-known Palmer Street member, whose brother Wally happened to be a well-known Simon City Royal—one of their biggest rivals.

Compliments of Chicagohoodz: Chicago Street Gang Art & Culture

I found this wall extra interesting because the splashes on it were the Orquesta Albany's brown and gold. As soon as I took the picture, a skinny white kid in a wife-beater and khakis came out holding a pistol, asking me what I was doing. When I explained, he said "Hold on," and came back out with a poster he had drawn on cardboard, and a black kid who told me he was a Maniac Latin Disciple. He didn't even acknowledge the fact that the Disciples and Gaylords were bitter enemies, or that I might ask why the two would be hanging out together. I wouldn't ask that kind of question, because I'd already seen it while traveling the city. Often family would be associated with rival gangs, or people you've had to spend time with while locked up became friends. Often, the use of illicit substances brought people together.

Top: A Palmer Street patch in black and gray.

Compliments of Chicagohoodz: Chicago Street Gang Art & Culture

Joker in the 1970s; note the old-school garbage cans in the background.

It is ironic that several cards pay tribute to both Tesse and Capone, the latter found dead from a gunshot wound in an apartment. Some claim it was suicide, while others believe foul play was involved. His death remains unsolved.

As of these writings, the following members of Palmer Street are now deceased: Eddie, Tarzan, Lil Tarzan, Ray-Ray, Ozzy, Puncher, Bogart, Mr. Raid, Professor, and Lil Man. RIP.

"Eddie did 13 and Tarzan did 12 years. Both were out about a year when they died. They were barely in their 30s. Tarzan was smart and had common sense. Eddie was another story. They were both from Palmer Street. So they weren't cowards."

—Satan,
Paulina Barry Community

Seeley and Ainslie

Seeley and Ainslie (SA) appeared in the 1970s near Amundsen High School and Winnemac Park, and would ultimately supersede local gangs the Basement Boys, Irish Clowns and Maniac Drifters. An offshoot of Palmer Street ("Little Palmer") in Ravenswood, Seeley and Ainslie adopted black and gray as their colors to pay homage to their forefathers. The Klansman card is circa early 1980s and pays tribute to Honkey and Nono, as seen on the tombstones.

Honkey was the first from Seeley and Ainslie to lose his life, and was followed shortly by Nono. The branch would carry a deep hatred for the Latin Kings, the

Top: The upside-down "360" (representing the full circle of knowledge in People Nation literature) disrespects the Kings—at this time spreading like wildfire in both Ravenswood and Uptown. "Insane Lives On" pays tribute to another fallen soldier of SA.

Compliments of Chicagohoodz: Chicago Street Gang Art & Culture

235

Cards from the 1970s were not very elaborate. In those days, just having a card with a fancy font was seen as having a cool card. Symbols used on many were basic, like the crosses and crown shown here.

culprits of Honkey's untimely death, refusing to join the People. With the C-Notes, Seeley and Ainslie were the original "EBK" ("EveryBody Killer").

The Klansman emblem was used throughout Uptown, not only by the Gaylords, but also their allies the Uptown Rebels and the Kenmore Boys. The upside-down "R," "B," and fork represent their rivalry against the Royals, Brazers, and all Folks. Although not represented, Seeley and Ainslie would do battle with the Lawrence and Rockwell Popes throughout the late 1970s and 1980s, who occupied turf on the other side of Western Avenue.

Bradley "Geronimo" Zeman, a well-known member during the late 1980s and early 1990s, was killed by a Black P-Stone in 1996, not long before Seeley and Ainslie closed in the early 2000s.

Moffat and Campbell

Moffat and Campbell sprung up in Logan Square in the early 1970s, just past the northern border of Humboldt Park, beyond the Bloomingdale railroad viaduct.

This chapter was known on the street to have held their own, and they did so for nearly 20 years. They fought many a battle with the local Hispanic gangs, such as the Latin Kings, Spanish Lords, Warlords, Insane Unknowns, Latin Lovers, Orquesta Albany, and Latin Disciples. During an interview with an old Spanish Cobra, the individual was asked who he feared the most: Latin Kings or Gaylords? His reply was very swift: "We weren't afraid of the Latin Kings. We were worried about the Moffats."

Once mortal enemies of the Almighty Latin King Nation, by the early 1980s the Gaylords had made a deal to join the People alliance in order to survive. The once-proud "White Boy Organization" was now found hanging and representing with gangs that they once hated. Their pact with the Kings, Spanish Lords, and Unknowns would only buy them a little time. Eventually, with the inevitable neighborhood change, the Hispanic gangs that they hated so much would end up running them out of their 'hood by the late 1980s.

Reinberg School

Reinberg School in the Portage Park area started in 1970 as an offshoot of neighboring Kilbourn Park. It began to flourish in the early 1970s, as they had no known rivals to combat in the area.

Reinberg's reputation would be gained by participating in sweater raids conducted by Kilbourn. Their other favorite pastimes were to chase Freaks around Chopin Park with baseball bats to make sure they stayed at their end, or to head down to Manor Bowl and hope to get into some squabbles there. The scene at Kilbourn had changed, as everyone began to pack—to defend themselves against Hispanic gangs that were starting to come up on a regular basis, most from nearby Schurz High School.

By the late 1970s, with mounting police pressure and members moving out of the 'hood due to white flight, Reinberg School closed up shop. Those that wanted to continue on transferred to Kilbourn

Top: On a December night in 1972, Reinberg lost a 14-year-old member to a group called the "K-Town Lords," who happened to be out cruising the streets looking to make a name for themselves. They ran across Harpo and Woody, and ended up stabbing Harpo to death. His killers were apprehended shortly afterwards, and the K-Town Lords were no more, having dissolved their membership within days of capture. As seen on his memorial patch, just like canes and crosses, pitchforks were once just another cool-looking symbol which many clubs used in their emblems.

Orange card: Woody and Gator both lived till their mid-50s; Woody died in September of 2012 after a long battle with cancer, and Gator passed away in March of 2014. They were friends till the end.

Park, while others began the Leclaire and George Street Boys. Eventually, they all hung up their Converses.

Belden and Knox

Belden and Knox in Belmont Cragin reached its peak in the mid-1980s, and were forced out of business due to the encroachment on their lands by the Spanish Cobras, Imperial Gangsters and Insane Dragons. By the end of the decade, they were no more.

Those who chose to remain in the game transferred to Lawndale, the most notable being Bandit, Painter, and Rocker. Others, like Prowler, dropped their flags, and some even joined other clubs—like Sarge, who joined the Jefferson Park C-Notes, having changed his name to "Mr. In$ane."

Cleveland Park

Danny "Slick" Klish was gunned down on a Saturday morning in April 1987 by the Simon City Royals. He was only 20 years old at the time.

The individual that allegedly shot Slick, as well as his friend Kenny Theil in the cheek, was sentenced to 40 years in 1988 for both murder and a count of attempted murder. At the time of the shooting, the alleged murderer lived on Kedvale Avenue in the middle of Stoned Freaks 'hood in Hermosa. During the 1980s, the Freaks were a part of the GFJ coalition, which stood for "Gaylords, Freaks, and Jousters."

The "Remembered Always" card is from the mid-1980s and pays tribute to four fallen soldiers of the Gaylord Nation: Wizard of Kilbourn Park; Tesse of Palmer Street; Chief of Lawndale, killed by the Latin Lovers; and Tiger of Sayre Park, killed by the C-Notes.

Compliments of Chicagohoodz: Chicago Street Gang Art & Culture

239

Top: The railroad tracks near Armitage just east of Cicero Avenue was more of a Stoned Freaks neighborhood, which would explain the Freaks tags all over this. They were allies, but had their discrepancies periodically.

Left, top card: This card from Dante and Mickey is from a prior era (late 1970s/early 1980s) when the Gaylords were aligned with the C-Notes in the UFO, thus the dollar sign on the chest of the Klansman. At the time, the Gaylords did not get along with the Freaks, as the card clearly states: "Freaks Beware!"

Dunham Park

Dunham Park was started in the early 1980s by members of Moffat and Campbell, who had moved into Portage Park after leaving their old section, now under siege by surrounding Latino gangs.

The gray "WPO" card was printed in the mid-1980s by "Krazy-T," a former Hells Devil known as "Crazy Tom."

Gunnison and Mason

Gunnison and Mason is the original Gaylords section in Portage Park that predates Dunham Park. Mr. Bear was an original member from Moffat and Campbell, and is one of the founding fathers of both sections in the early 1980s.

Montrose and Narragansett

Montrose and Narragansett is situated three blocks from Dunham Park, at the intersection of Portage Park, Dunning, and the suburban village of Harwood Heights. It originated in the mid-1980s and was reportedly established by members of Palmer Street.

Members of both Montrose and Narragansett and Dunham Park could often be found together, not only in the park, but also at the McDonald's and Jay's Beef restaurants located on the corner.

The section, along with Dunham Park and Gunnison and Mason, ceased to exist by 1990. After participating in many skirmishes, with mounting pressure from their nearest rival, the Jefferson Park C-Notes, all three sets were driven into extinction.

Berteau and Leavitt

Berteau and Leavitt were around for a hot minute in North Center during the late 1980s, where they fought against the Bell School Yard Royals, and the Latin Disciples from John Coonley grammar school. Their hand-drawn gray card sends a message to nearby rivals: that the Gaylords are white power, and that they rival all gangs under the Folks banner. Eventually this branch would fall prey to the Disciples, who took over their entire neighborhood, making John Coonley their home base in North Center.

Although members like Fist may have lost their fight to keep their neighborhood white as Gaylords, it doesn't mean they gave up altogether. Fist went on to join the Chicago Police Department and is currently doing battle with all of his former rivals—except this time around, he gets away with cracking them over the head without the fear of getting arrested himself. Many Gaylords have gone on carrying their fight as members of the CPD.

Sayre Park

Sayre Park came into existence in late 1970s Montclare, and was considered by many to be the Gaylords' last castle, as it was their last active chapter to fold. In the early 1980s, this was also the last Gaylords chapter to belong to the UFO. When that coalition disbanded, and the

Top left: The WPO card features a hooded figure wielding a downward pitchfork, disrespecting the Latin Disciples. The top right corner disrespects the C-Notes at Normandy and Belden. Popeye was previously a C-Note from Central and Giddings.

Top right: The Gaylords also had an active faction of female members that went by the name "Gaylordettes."

Gaylords became part of the People, several Normandy and Belden (N-B) C-Notes decided to flip Gaylord, rather than stay part of an independent gang with no allies. Among them was "Ape," who went on to hold some rank for Sayre.

By the mid-1990s, drug abuse and the deaths of members began to take a toll. The most notable death was that of Bishop, who would lose his life at the hands of the Insane Dragons in the parking lot of Angel's Restaurant on Harlem Avenue. Addiction began to cripple this chapter, as it did many of their others. Guys like Chip and Prowler were now full-blown junkies, and many of their younger members were getting hooked as well. What was once a powerful chapter now found itself on the brink of extinction.

The final blow came when members became confidential informants for law enforcement, the most notable being "Lil Awful," who, according to federal authorities, cooperated with them for over two years. His cooperation spelled the end for not only Sayre Park, but also a newly started-up chapter in Addison, Illinois, composed of former Newport and Kilbourn Park members.

Central and Berteau

Central and Berteau originated in the mid-1980s as a Kilbourn offshoot in Portage Park. Although this set saw some growth for several years, it would eventually succumb to the pitfalls of drug addiction—like many of their sections.

Tragedy hit this branch when two members got into a drug-induced fight over an eightball of cocaine, one killing the other with a cylinder block. Lest he have to spend the rest of his life in jail, the alleged killer took his own life as well. In the end, both their president, Lucifer, and one of its soldiers, Whitey, were dead. The branch was no longer the same, as members grew apart stemming from this tragedy. One member, Magician, dropped his flag and ended up flipping Insane Deuce, while others simply left the gang life behind.

Kildare and Fullerton

Kildare and Fullerton began in the early 1980s in Hermosa. By mid-decade, its members found themselves fighting viciously for their own survival, constantly defending their territory from Folks gangs starting to move into their 'hood. To the east, they had Maniac Latin Disciples and Imperial Gangsters in the process of expanding west, and to the south, both the Eagles and Cobras were expanding north. The downward pitchfork shows disrespect to the Disciples.

Members of this branch could often count on support from neighboring Gaylords, and could frequently be found hanging out with both Belden and Knox, and Lawndale. When Kildare folded in the late 1980s, those who wanted to continue banging either flipped to other gangs or moved to other branches. Two examples being Lil Baron and Lucifer. While Lil Baron moved on to Lawndale, Lucifer would drop his flag and become an Insane Deuce.

Left column, second from top: The image shows their rivalry against the Royals, with a bunny dangling by a noose.

Right column top: Note the C-Notes dollar bill in pencil.

Right column, bottom: "Fritz Rots" depicts their opposition to the Simon City Royals, by having a dagger-shaped cross pierce a rabbit. Fritz was a Royal, and adding the word "rots" under his name shows total disrespect to not only him, but to the entire SCR Nation. Sayre Park members could once be found hanging around on Grand Avenue, between Harlem and Oak Park—thus their saying "Rulers of Grand." The three-slashed cross on the tombstones is defined with the words: "Lords, Masters and Rulers."

243

Top: Lane Tech was still primarily white between 1988 and 1992: Gaylords, C-Notes, Royals, Deuces, Popes, Freaks, and Jousters all attended this high school. Five of the individuals on the Lane card were from Central and Berteau. Lil' Chico took the rap for the murder of Simon City Royal Casper by an older Kilbourn Gaylord whom he resembled. As a minor, Chico was promised a slap on the wrist, but ended up serving his full term, and killed himself in a church upon release. "R" and "D" flipped show disrespect to the Disciples and Royals. The upside-down crown shows their rivalry with the Gangsters. The banners above the Klansmen state "Cobras Die" and "Vikings Die." It is very unlikely they would have happened upon any Ashland Vikings, a gang clearly situated across town; this makes the statement very peculiar. The backwards dollar sign and cracked money bag show their rivalry with their biggest and closest rival, the Jefferson Park C-Notes.

Compliments of Chicagohoodz: Chicago Street Gang Art & Culture

Wrightwood Street

Wrightwood Street was active during the 1980s in Hermosa, to the north of Belden and Knox. Their main rivals were the Disciples, Gangsters, and Simon City Royals. When Belden and Knox closed shop, those who wanted to continue eventually transferred over to Wrightwood, including Crue, Wizzo, Loki, Lil Loki, and Lil Spade. This move bought Wrightwood a couple more years of existence by bolstering their ranks. By the late 1980s, they would also shut their doors as Hispanic gangs took over Hermosa.

Long and Oakdale

Long and Oakdale was active during the early and mid-1980s in Belmont-Cragin. Its southern borders met those of the Cragin Park Playboys, whose main stronghold lay just south of Diversey. Both gangs were allies and People.

It is unknown why this branch folded so early in the game. Prior to their arrival, the land two blocks away was occupied by the Leclaire and George Street Boys, a party group consisting of former Gaylords no longer interested in gangbanging. When Long and Oakdale folded, those who wanted to continue transferred to other sections, e.g. Road Runner, who transferred to Central and Berteau.

Waveland Street

Waveland Street was opened in the late 1980s by members who previously belonged to both Lawndale and Cen-

tral and Berteau. Their ringleader was Lord Rocker, who by now was looking for a new home, having lost his previous branch to the Folks.

Of the ten members listed on their card, four are now deceased, including Lord Player and Judas, who died from overdoses. Lord Flash became a born-again Christian, while Crazy Boy became an Imperial Gangster. Lord Willard was recently released after serving 20 years for murder, and wants nothing to do with his old cohorts.

Sunnyside and Magnolia

During the Jazz Age in the 1920s, Uptown was a luxury residential and upscale entertainment district known for the Aragon Ballroom; the Riviera Theatre movie palace; and Al Capone's haunt, the Green Mill Cocktail Lounge. By the 1970s, Uptown morphed from working-class family neighborhood to one decimated by poverty. The dilapidated rental units housed the most marginalized of people including mentally ill dischargees from the nearby psychiatric hospital, sex workers, and the unemployed who passed the days with alcohol and drugs.

Uptown was infested with gangs: (mostly white) Latin Kings, Harrison Gents and Gangster Disciples. A little later came the Vice Lords, and from the 1990s to the present, the Black P-Stones. And for decades in this "Hillbilly Heaven" co-existed a confederacy of white power gangs of Appalachian descent: the Wilson Boys, the Kenmore Boys, the Uptown Rebels, and the Sunnyside and Magnolia

Although the Long and Oakdale card shows opposition to the SCR, there were no Royals nearby—as a matter of fact, this branch had no known rivals in the area.

Compliments of Chicagohoodz: Chicago Street Gang Art & Culture

247

Top: A block north of Sunnyside at Wilson and Magnolia, 1991. The Latin Kings from a few blocks away seemed to have wanted to share this wall, but the Gaylord tag above the crown ensures that the Kings know whose territory they're in.

Bottom: The card displays two Klansmen stabbing a Royal bunny through the heart with a pitchfork. "Lords, Masters, and Rulers" is in the reference to the three-slashed cross that is used by Kilbourn, Newport and Sayre Park (although not seen here, the slogan "Three to Be" is also in reference to this). Note the backwards "S" and "C" on either side of the inverted Spanish Cobra diamond-tipped staff.

(SM) Gaylords. Gaylord graffiti from this branch can be seen in the 1986 buddy cop film *Running Scared*.

And in the 1981 documentary *What's Uptown?*, Egghead and other SM Gaylords are interviewed on the street, Egghead expressing his distaste for gunplay. Alongside them stand black Gangster Disciples of the Folk Nation, as a grinning Gaylord shorty waves a "White Power" T-shirt in the background. Nonetheless, neighborhood trumps all, as the two gangs bond over fighting Vice Lords, Stones and Latin Kings, as well as their shared true colors: black and blue.

Miscellaneous

Compliments of Chicagohoodz: Chicago Street Gang Art & Culture

Collaborations

SLICK
ZIGZAG
BUGS

✝

LAWNDALE
- N -
ALTGELD

Lil' Ziggy
Lil' Deviatee
MAGNUM

ALMIGHTY NORTHSIDE
GAYLORDS
G L

GAYLORDS W-P

R - K P - K F - L - K
L - D - K I - G - K L - L - K

JAKE
RICO
PUNCHER

✝

DIVERSEY
- N -
ROCKWELL

REAPER
Lil' Man
Lil' Dagger

When we do right,
No one remembers !

Freaks Beware !

Bell Park
Killers !

W-P-O
COMPLIMENTS OF:
𝔅onzo & 𝔎ipper
AND ALL LORDS OF THEE:
𝔍nsane 𝔑orthside
𝔊aylord 𝔑ation

D/M L/A K/P B/P S/P O/ST. M/A
K/B S/A M/C S/M O/N L/L P/ST.

Come to G-L city if you dare,
Where Bonzo & Ripper have no pity or care !

When we do wrong,
No one forgets !

249

Top: On the "Almighty Northside" card, Puncher and Lil' Man were previously from Palmer Street, and Lil' Dagger was from Moffat and Campbell. Circa early 1980s.

Top: The "All Sections" card from 1987 is one of the most revered of all time. Although a Gaylord card, it was drawn by a Byron and Kostner Boy. Consisting of ex-members and close affiliates of the GL, this party group was in existence from '84 to '90. Note the Klansman throwing the Royals hand sign down, and "SCR" on the top hat. Lil Satan (Kilbourn) and Scarface (Newport) were brothers whose family moved out of the area in the late 1980s. Some say the move saved their lives, considering that many of their cohorts have either overdosed or are in jail due to drugs. Hitler started at Kilbourn but ended his gangbanging days at Lawndale. After putting in many years of work, he eventually retired and joined the "BK Boys."

Compliments of Chicagohoodz: Chicago Street Gang Art & Culture

Top: The yellow card was most likely printed in a high school print shop during the 1970s. Unfortunately, the individual whose task was to print it might not have gotten a very good grade, as he misspelled both "Lawndale" and "Kilbourn."

Tall Gaylords

K-P
- Lil Buzz
- The Kidd
- Sly
- Scorp
- J-C
- Red Eye
- Sir Mad
- Lil Nic
- Lil Dago
- Sir Hood

Kilbourn Par-K
WIZARD — R.I.P.
SPY — R.I.P.
Lawndale -N- Altgeld

L-A
- Rebel
- Lil Casper
- Sir Jap
- Lord Polack
- Sir Champ
- Quasi
- Lil Magnum
- Toker
- Rocker
- Lil Baron
- Lil Rocker

GAYLORDS-ALWAYS!

Almighty Gaylords K-P and L-A

- THE KIDD
- SCORP
- SLY
- J-C
- GONGE
- LIL BUZZ
- SIR MAD
- SIR HOOD
- LIL DAGO
- SHRIMP
- LIL POLACK
- LIL CHICO
- REDEYE
- SICK NIC
- BURNOUT

- LORD CASPER
- LIL CASPER
- RIGHTY
- BUZZ BRAIN
- LORD POLACK
- SIR JAP
- REBEL
- PLAYER
- ROCKER
- LIL ROCKER
- LIL TOKER
- LIL MAGNUM
- SIR CHAMP
- HITLER
- LIL BARON

WIZARD LIVES ON..
SPY LIVES ON..

In Memory of WIZARD and SPY
Comps. Of: LIL SATAN -N- HITLER

Compliments of Chicagohoodz: Chicago Street Gang Art & Culture

Almighty Gaylords

LAWNDALE -N- ALTGELD

ST. LOUIS -N- ALTGELD

GOD FORGIVES, GAYLORDS DON'T!

GAYLORDS TO THE CHEST!

ROYALS DIE, FOR SPY!

IN MEMORY OF PSYCHO - CHIEF KATO - SPY

Stoned Yarders

Lord Jim
Magnum
Baby-Blue

Weed
Maniac
Stoner

Axe
Bre
Champ

Duke
Buzz
Fry

PROUD MEMBERS:

REBEL	LIL CASPER	SIR JETHRO	RIGHTY
BUZZ BRAIN	LIL SAINT	MERLIN	SPADE
SLICER	BANDIT	EYES	RUMPLE
PLAYER	RAY	LIL MAGNUM	LIL STONER
SIR GOBLIN	LIL TOKER	NATIVE	JAY
MONEY	ROCKER	OMEN	LIL JOE
LIL ROCKER	P.J.	LIL JUDAS	LIL PAINTER
STUD	RATT	SMURF	LIL SANDMAN

Opposite page: Both of the Kilbourn Park (KP) / Lawndale and Altgeld (LA) cards pay tribute to two fallen Gaylords that lost their lives in the early 1980s to the Royals: Wizard and Spy. Also unique to these two cards is how Lawndale used the standard Gaylord two-slashed cross, compared to Kilbourn using the three-slashed cross, commonly attributed to the Royals themselves.

Top: The card from Lawndale and its satellite section at St. Louis pays tribute to fallen soldiers from both. Psycho was allegedly killed by the Noble Knights, Kato by Spidey from the Orquesta Albany.

Bottom: Stone Yarders were a rock band and party crew that hung around Springfield and Fullerton, and hung out with the Lawndale Gaylords on Ridgeway. The baby blue card, crosses on each side and "Lord Jim" shows their association, but that was as close as they would get to becoming gangbangers.

"As you can see in the Gaylord cards, they had names like 'Rican,' 'Tonto,' 'Chief,' 'Little Mexico,' as well as 'White Boy' on Imperial Gangster cards. It was all about love for the neighborhood you grew up in: playing ball in the streets, opening fire hydrants, tossing quarters on the sidewalks, drinking on the porch, listening to the boom box. All the neighbors knew each other. The mothers would go to each other's houses and gossip, while the older guys would sit outside and drink beer, while the kids would be running through gangways, hopping fences and stealing tomatoes from people's gardens or skitching from the back of a car in the wintertime. Back then, everyone knew each other in the neighborhood. Back then, the gangs could do a mural on a wall and no one would call the police." —Sting (Insane Deuce)

This Polaroid captures the Gaylord and Freak contingent within the People, and speaks for the time period around 1984 when the film *Ghostbusters* was released. The Noble Knights produced a "Folks Busters" T-shirt as well, with a circle and diagonal slash over a pitchfork hand sign.

Compliments of Chicagohoodz: Chicago Street Gang Art & Culture

chapter 5
THE PEOPLE: "ALL IS WELL"

THE 1978 FOLK NATION UNIFICATION was soon countered by "The People Nation"; these two gang alliances formalized oppositions and rivalries that had already existed long before. The People coalesced around the El-Rukns and Vice Lords, along with the Almighty Latin Kings—three large, well-established gangs with revolutionary, nationalist or religious identities; the term "the People" connotes all three characteristics. Around them assembled all gangs opposed to the Gangster Disciples and their ilk.

On the North Side, the Latin Brothers, Insane Unknowns, Spanish Lords, Insane Deuces, Puerto Rican Stones, Ghetto Brothers Organization, Yates Boys Organization, 4 Corner Hustlers, and Warlords were the major players. On the South Side, the Latin Counts, Bishops, Villa Lobos, Cullerton Deuces, Latin Dragons, Insane Popes, Noble Knights, and 12th Street Players all cut out their own pieces of the pie. The People also incorporated most of the remnants of the white power United Fighting Organization: the Gaylords, Jousters, Freaks, and Playboys.

As traditional turf gangs facing the ever-changing demographic of their communities, as the 1980s rolled around, most gangs in the United Fighting Organization gravitated toward the People. The UFO constituents had no choice in order to remain an institution, especially within the prison system. Despite shared nationalist leanings, this gave rise to some odd couples, but soon even traditional enemies like the Gaylords and Kings had reached a détente and were hanging on the streets. People and Folks helped gang culture shift from being racially oriented and gave former rivals a common cause. Simply having to rub elbows made them realize they had at least one thing in common: having to be locked up in the same place.

At its height in the mid-1980s, the People was comprised of over 20 gangs that used the five-pointed star and num-

Clockwise from above:

Latin Dragons in the South Chicago community area, when they were riding People in the early 1990s and warring with the Spanish Gangster Disciples a few blocks away. The Dragons eventually turned Folks.

The five-point star wasn't part of the Noble Knights' emblem until they joined People; Two-Two Boys becoming Folks most likely pushed that idea along.

This homage to the North Side People shows their strong opposition to the Folks. Drawn by Lil' Duster on the back of a card.

The collaborative card covers a lot of ground, and is a perfect example of the People unity when it was fresh. It features most North Side Latin People gangs, many of whom centered around Wicker Park, Humboldt Park, Logan Square and Clemente High. It encompasses the Unknowns Players Kings (UPK) coalition, and the GBO/YBO unity, but the gang placed in the center is the Latin Kings. As it is gold, they probably made it.

The last actual Puerto Rican Stones section to exist, at Milwaukee and Claremont ("MC"), a block away from Armitage and Western ("AW"). On the left, a pitchfork/Cobra diamond goes down; on the right, the Lovers' "Universal" symbol—all gangs in close proximity.

Compliments of Chicagohoodz: Chicago Street Gang Art & Culture

259

ber five as a unification symbol. Drawn from the Moorish Science Temple of America, a quasi-Masonic order founded by Noble Drew Ali in 1913, the five points of the star represent the principles of "love, truth, peace, freedom and justice." The saying "All is Well" stems from their literature as well. The black nationalist and Islamic roots of this symbolism was not lost on all white gangs. Some used it more than others, others refused to use it at all. With exceptions, People imagery overall tends toward the regal and religious.

When the People Nation was first established, many of its member nations were cool with each other, but internecine wars erupted and conflicts grew—including the Latin Kings v. the Familia Stones, the Black P-Stones v. the Vice Lords, the Bishops v. the Counts, the Kings v. the Counts, the Saints v. the Kings (and almost every other gang), and the Unknowns v. the Spanish Lords.

Vice Lords

The Vice Lords are Chicago's oldest existing black gang. Founded in 1958 by seven youths at the Illinois State Training School for Boys who wanted to be the lords of all vice, they took on the name "Vice Lord." Intended to celebrate a career of evil, the title also connotes a mastery of one's lower nature, as well as possessing a strong grip on matters.

Beginning as a social club centered at 16th and Lawndale ("the Holy City"), the group incorporated numerous unaffiliated cliques into Vice Lord branches like the "Maniac," "Unknown," and their leading faction, "Conservative" (referring to their reserved manner). This federation, the "Vice Lord Nation," would come to be the dominant gang force on Chicago's West Side in the early 1960s. The Vice Lords uniform consisted of a cape and solitary earring, and they were one of the few black gangs to print compliment cards, which served as identification required to be carried at all times.

By the late 1960s, gangs were realizing they could access government funding from grants and foundations to do something good for the 'hood. Rebranded as the non-profit corporation "Conservative Vice Lords Inc." (CVL), under the leadership of Bobby Gore the organization actually did for a while, with community center the House of Lords, as well as the ice cream parlor Teen Town, the African Lion clothing shop, and the Management Training Institute. The word "conservative" now came to mean an eagerness to work within the system, and the CVL took part in the civil rights movement with Martin Luther King, brokering gang peace with the "LSD" (Lords, Stones and Disciples) coalition.

Framed for murder by the Daley administration in 1969, Bobby Gore would spend the 1970s behind bars in Stateville. As heroin flooded the West Side, North Lawndale crumbled, and the Vice Lord Nation's numerous branches ("Traveling," "Insane," etc.) circled back to their original mission statement. Behind bars, Gore's continued peacekeeping efforts there would help to form the foundations of the Folks and People alliances in the late 1970s. By then, like many black gangs within the prison system, the Vice Lords had assumed an Islamic cast, and additional symbolism.

By the 1990s, the organization's new spokesperson was a reputed cop-killer

Top: Spanish Vice Lords in South Deering. The cracked black diamond is for the Latin Dragons. When taking pictures I would ask gang members if they wanted to cover their faces or not.

Bottom: The Four Corner Hustlers (4CH) are a black gang founded by Walter Wheat in the late 1960s at Delano Playground in Garfield Park. In 1994 "King Wheat" would be shot in the head at age 43 by a 17-year-old member of his gang. The following year Wheat's protégé—and conspirator in his assassination—Angelo Roberts was found dead at 24 in the trunk of a car, in the wake of his plot to launch an anti-tank rocket at the 11th district police station. Affiliated with the Vice Lords, their symbols include a top hat, cane, gloves, martini glass and a crescent moon, five-point star, as well as a black diamond. This RIP wall was in an alley off Augusta and Pulaski. There were people around when I took that picture, but nobody was trying to talk to me.

The Spanish Vice Lords (SVL) were from South Deering, a little neighborhood tucked away and consisting of a handful of gangs, like the King Cobras, the Counts, and the Gangster Disciples in the high-rise Trumble Park Homes. There have been Vice Lords of Latin descent, as well as other ethnicities, in various parts of the city. The half-diamond and half-Cobra display their opposition to the Latin Dragons and King Cobras; the pitchfork and crown disrespect the Disciples and Kings. The SVL have since expanded to other areas in southeastern Chicago.

Compliments of Chicagohoodz: Chicago Street Gang Art & Culture

Almighty Spanish Vice Lords

FUCKK KINGSS

ALMIGHTY · SPAN*ISH ·
· VICE * LORD'S

LEFTY

with a fondness for fur coats and limousines, Willie Lloyd. Chief of its "Unknown" branch, Lloyd would declare himself the Nation's "King of Kings," having codified its precepts into a 61-page manifesto entitled *The Amalgamated Order of Lordism*.

The Vice Lords use an array of symbols, evoking both the pimp and the Prophet. Traditional symbols have been bestowed meanings, like the cane ("staff of strength"), top hat (shelter, cleansing of the mind) and gloves (purity), along with cocktail glass and Playboy bunny (swiftness). With their cousins the Black Stones, they share symbols like the star ("eye of Allah") and crescent moon ("the Black Nation"), the circle ("360° of knowledge"), pyramid ("knowledge"), as well as the sun ("truth"). They also wear Louis Vuitton ("VL" reversed) attire. Their colors are red, black and gold.

Black P-Stones

First cousins to the Vice Lords, the Blackstone Rangers were founded around 1960 on Blackstone Avenue in Woodlawn on Chicago's South Side. Under the guidance of Jeff Fort, this black street organization would pass through three distinct phases during its career.

Deriving their moniker from a rank at the Woodlawn Boys Club, the Rangers began as a local teenaged gang set in opposition to the nearby Devil's Disciples. Under the co-leadership of the diminutive but commanding Fort (then known as "Angel"), and enforcer Eugene "Bull" Hairston, the gang grew to control Woodlawn under the slogan "Stones Run It." Fort soon became known as the Al Capone of

Compliments of Chicagohoodz: Chicago Street Gang Art & Culture

the South Side: he might bring food to a struggling mother one day, before shooting her son in the kneecap the next.

By the late 1960s, Bull was out of the picture, and the Rangers had massively swollen by obliging neighboring clubs to unite under the "Black P-Stone Nation," the "P" standing for peace. Key leaders from the subsumed gangs constituted its ruling commission, the Main 21, led by Mickey Cogwell, and represented by a pyramid of 21 bricks. Ostensibly a community organization akin to the Conservative Vice Lords, the P-Stones differed in their militant black power stance and pan-African nationalism, embracing the colors black, red and green, and donning red berets and combat boots. With the sponsorship of Presbyterian pastor John Fry, the organization succeeded in acquiring one million dollars of grant money, and Cogwell even visited Nixon's White House on invitation.

Convicted of misappropriating federal funds in 1972, Fort would spend four years at USP Leavenworth. He emerged with a powerful physique, a different honorific ("Chief Malik") and a new law: Having purged the Main 21, the organization was now an Islamic religious sect, the "El-Rukns" (Arabic for "pillar" or "cornerstone"). The berets became fezzes; a crescent moon and star appeared above the pyramid.

The "Mos" (from Moorish) commenced operations out of a former South Side movie palace turned mosque—furnished with a discotheque and armory as well—dubbed "The Fort." Louis Farrakhan called them his "Angels of Death," and in 1987 Jeff Fort and five cohorts became the first Americans to be convicted of domestic terrorism, in an alleged plot to perform paid acts of mayhem on behalf of Libyan president Muammar Qaddafi. Sentenced to 80 years, Jeff Fort now resides at U.S. penitentiary ADX Florence, along with Gangster Disciples leader Larry Hoover. Now known as the Black P-Stones, the gang has come full circle. Without their chief, they have returned—like many gangs today—to a series of unorganized cliques.

Puerto Rican/ Future/Familia Stones

This gang has gone through three different incarnations. So one story goes, a member of a small North Side gang known as the Buckingham Boys met with Jeff Fort in prison, and although never in the Main 21, they became "Puerto Rican (P.R.) Stones." They weren't known so much as gangbangers, and got along with many gangs that later turned Folks.

As they expanded from their base at Sheffield and Barry (S-B) in Lake View, another generation arose in Albany Park. Led by "Stoney," they adopted the name "Future Stones" in the early 1980s, while the P.R. Stones faded out.

When Stoney got locked up, a clan of Futures united by blood broke off in the mid-1990s, and as the gang was now less Puerto Rican, their name became "Familia Stones." Upon release, Stoney tried to reclaim his Futures, but the Familias had deposed him to become the dominant faction today.

All three versions used the same symbols as the Black P-Stone Nation, the only difference being their colors of black and orange.

Compliments of Chicagohoodz: Chicago Street Gang Art & Culture

Opposite page: Somewhere on the South Side. While representing the letter G in Folks symbolism, in Black Stone/El-Rukn numerology the number 7 is drawn from the "Circle Seven Koran" of Noble Drew Ali and the Moorish Science Temple of America. The circle represents 360° of knowledge, the 7 perfection. The crescent moon and star are derived from Islam. You can see where the Disciples have written on this graffiti.

Above: Both "Slim" and "Shady" tagged this "Future Stones" corner at Montrose and Sacramento. They were the next Stones generation, dominant until the mid-1990s, when the "Familias" took over to become the main gang. Note the fork to the left of the dipped Universal, and the future Stone in the stroller.

JUSTICE
PEOP
POWER T
KIN

ALMIG

500M

Humboldt Park, 1993. Like seeing the Cobras' "KC" memorial from two blocks away, this was the equivalent driving west on Division from Kedzie. I asked someone in the neighborhood if they could get me on the roof. He didn't say much, if anything at all. He just had me follow him to the back stairs. I took one picture, and when I got ready to take another he got in front of it. The flags represent both the Puerto Rican-dominated North Side and the Mexican wing on the South.

Top: Sawyer and 30th, a popular wall. The auto yard it surrounds would let graffiti writers piece on that wall so the Kings wouldn't hit it. The Kings would tax the writers for paint. Can't say no, or your piece would be destroyed.

Left: The Latin Queens is the oldest and largest active female faction of any gang in the city of Chicago, and their membership runs in the thousands nationwide. Latin Queens are involved in the same criminal activities as their male counterparts: narcotic trafficking, drive-by shootings, theft, assaults, and graffiti.

Opposite page: 24th and Trumbull is a big, popular section in Little Village. The spelling of "Shysta T" (for Trumbull) says something about the times. Note the use of the opposition's emblems for the Master's hands.

Compliments of Chicagohoodz: Chicago Street Gang Art & Culture

Above: The Latin Kings' hand symbol represents a crown, and is the sign language gesture for "love." Before "Amor de Rey" ("King Love"), their original slogan was "It's a King Thing."

Compliments of Chicagohoodz: Chicago Street Gang Art & Culture

Above: "Ruthless Side" are a suburban branch. I don't remember seeing marked-up photos before they started sending them to Chicagohoodz. They could have been doing it forever for all I know. Gangs get pictures of rivals from girls who would hook up with them, and tag all over the image.

Latin Kings

The Almighty Latin King Nation (ALKN) is the largest Hispanic gang in Chicago, if not the world, with an estimated membership of over 20,000 known street soldiers in the city. There are numerous theories as to where the Latin Kings came from, but they likely began in the Humboldt Park area as a Puerto Rican rights group during the 1960s that very quickly earned the reputation of being a street gang.

Humboldt Park branches include Beach and Spaulding, Division and Spaulding, Kedzie and Cortez, and Whipple and Wabansia. In nearby Wicker Park, Leavitt and Schiller, and Division and Wolcott were major sections, both of which had been started in the 1960s. About the same time, a Mexican-dominant branch had almost immediately taken root and rapidly expanded in Little Village. Boulevard was the first section, followed by Trumbull, Homan, Sawyer, and others. The Kings from the Boulevard were mixed; white Kings like the nine notorious Novak brothers were downright ruthless.

Other large branches include Lawrence and Kedzie in Albany Park, Columbia and Ashland in Rogers Park, and Bush Kings in South Chicago. With as much noise as the Kings were making, every Latino suddenly wanted to be one—and once the gang grew in popularity, a lot of other kids wanted in as well. The "Flip City" Latin Kings got the attention of Filipino youth and became a thing for a good decade. Branches often come to be at odds with each other, and skirmishes occur, but for the most part all serve as one nation under the crown. The only

Above, middle: Watusi was from Cortland and Whipple, and one of the first black Latin Kings.

Above, bottom: This card used to hang on a corkboard in the Chicago Police 16th District station. While in custody in the mid-1980s, Jefferson Park C-Note "Thief" lived up to his name and lifted the card by way of the five-finger discount. (Note the staple marks on the left side.) Circa 1970s.

Opposite page: This Little Village piece exhibits a certain naïve creativity. It appears to be a cut-out Disciples emblem cracked in half with a marker, then taped to a piece of orange paper, upon which was drawn the usual suspects: Deuces, Two-Six, Two-Two Boys, Ambrose. The Kings and Satan Disciples have fought over colors, and although the Kings are gold and the Disciples canary yellow, without a patch their sweaters can be hard to distinguish from each other.

Compliments of Chicagohoodz: Chicago Street Gang Art & Culture

Top row: Coulter was the only LK branch in Pilsen, surrounded on three sides by Satan Disciples. It was only one block, but those Kings made a lot of noise during their stay. After Deadeye shot Boogie (see Pilsen Rampants section in Chapter 1). they wore out their welcome, but stuck it out until the early to mid-1980s. Note the "Crown of England."

Second row, left to right: Boulevard is the first Little Village section and the motherland there, deep-rooted, generations old by now. Geographically east of them would be Satan Disciples and Two-Two Boys. Augustine "Tino" Zambrano, a.k.a. "Viejo" and "Old Man," was "Corona" (regional officer), and ran street operations during the 2000s. Caught up in a sting led by the FBI, ATF, ICE, and local police, in 2012 Tino was sentenced under the RICO Act to 60 years.

Third row, left: The Spanish Harlem faction in Cicero got their start in the 1980s.

Fourth row, left: The ALKN is controlled through a very structured hierarchical system, organized into "regions." The Little Village region stretches from Fairfield to Millard, and 21st to 33rd. It contains approximately 24 chapters; one of the more well-known is 24th and Christiana. Made by King Jab.

Compliments of Chicagohoodz: Chicago Street Gang Art & Culture

Top: Done on 26th by the 25th and Trumbull section, 1989. The Kings' mascot is the "Master," and the gang has been ruled by dual masters for decades: Gustavo "Lord Gino" Colon on the North Side, and Raul "Baby King" Gonzalez on the South. Members since the mid-1960s, both "Sun Kings" shot to power in 1971, when each committed murder during the same week in different parts of the city, and found each other in Cook County jail.

Bottom: "Ghetto Side" is 23rd and Homan in north Little Village, rightfully named after the area next to the viaduct separating the Latinos from the African Americans in North Lawndale.

Top section: The Kings moved to Uptown in the mid-1970s. This section consisted of Appalachians, Blacks, and Native Americans, and fought the Gaylords, Rebels, Kenmore Boys, and Eagles. They shared the corner of Ainslie and Winthrop (A/W) with the Gents; these two gangs would become mortal enemies by the end of the 1970s. In August, 1976, Professor got a pass from the Gaylords, when they refused to attack another white boy after shooting three other Kings, paralyzing one 18-year-old. A/S = Ainslie and Sheridan. Berwyn was in Andersonville, and rivalled the TJO, Eagles, Royals, and Brazers.

Bottom: The K-Town card on the left is from West Humboldt Park's "K-Town" in the mid-1980s. Although the black card states "TSK" and "DK," the Kings never had a section in Little Village's K-Town.

Opposite page, top: A block from Snake Alley were these kids from Division and Spaulding. I think the pockets hanging is a bunny diss. Damen and Division in Wicker Park, across the street from Duk's hot dogs in the gas station parking lot, 1988. Middle: Gents and Disciples emblems are in the two yellow boxes on either side. I got shot at a few times in that area while an Angel; there were a lot of derelicts around as well. Although it's yuppie town now, this Division and Wolcott section might still be around. There's nothing Latin about the Rosemont and Claremont Kings, consisting of Assyrians, Indians and Pakistanis. Bottom: I pulled a dumpster up to a drain pipe at the back of the building, and climbed to the roof to photograph this. After getting my camera stolen out of my car later that day, I had to drive back and take this picture again.

Compliments of Chicagohoodz: Chicago Street Gang Art & Culture

279

If I saw an emblem with someone standing near it, I would ask if they thought anyone would mind me taking a picture. Like most, he asked why, and I told him about the book. This was right by Farragut High School in Little Village.

Compliments of Chicagohoodz: Chicago Street Gang Art & Culture

gang to separate itself completely was the Milwaukee Kings.

As the Kings grew in size and reputation, they also became notorious for taking over other gangs' territory and turning out members. If someone goes to prison, there will be a considerable number of Kings, and if one goes in representing People as a Latino or white, there is a good chance the Kings will be the ones calling the shots on that deck. That's why they behave aggressively even in the streets ("you got to ride under us"), and that may be why the Saints and the Counts feel animosity toward them. Many Latinos that don't get along with Kings will ride with the Stones or Vice Lords in the joint.

Like the Black Stones, the Latin Kings are revolutionary, nationalistic and cultlike, with reputed ties to the Puerto Rican paramilitary group the FALN (Fuerzas Armadas de Liberación Nacional, or Armed Forces of National Liberation). As outlined in their manifesto, the gang practices "Kingism," a patriarchal solar religion with Judeo-Christian overtones. Its devotees draw upon "Brown Force" through prayers, hand signs, grips and chants, and pass through three initiatory stages: "Primitive," "Conservative/Mummy," and finally "New King." The titles "Sun King," "Corona," "Cacique" and "Inca" represent ranks within the gang's hierarchy. (Cacique is derived from the Taino culture, an Indian tribe native to Puerto Rico.)

Their colors are black for the darkness of night and gold for the sun, and their main emblem is a five-point crown. Near the beginning, the North Side used the three-point crown, and the number of its points didn't matter until the advent of

Compliments of Chicagohoodz: Chicago Street Gang Art & Culture

People and Folks, who gave each point a meaning, just like the five points of the star: love, honor, obedience, sacrifice and righteousness. Other symbols are a king's ("Master") head, and the lion.

Insane Unknowns

The Insane Unknowns (IUK) first appeared in the 1970s at Leavitt and Schiller in Wicker Park. The racial make-up of this gang has been mixed since its inception.

Started by pee-wees left behind when the Leavitt and Schiller Latin Kings moved to greener pastures, their colors first became black, then black and white—the same as their Lake View rivals, the Paulina Barry Community. This stark color scheme complements their imagery: a hooded "ghost" figure, occasionally wielding a shotgun, and a "U" hand sign reminiscent of the "devil's horns" from the heavy metal subculture.

The Kings, Spanish Lords and Unknowns were inseparably allied in the Wicker Park area; one famous joint mural was composed of a crown atop a heart, hoisted aloft by two ghosts. As a Latin King states, "At one time the Unknowns and Spanish Lords were close—so much so that if you messed with one, you messed with the other."

By the late 1970s and early 1980s, the Unknowns had made their way into Lake View, Bucktown, Roscoe Village, Galewood, Halsted and Wrightwood in Lincoln Park, and the "K-Town" within West Humboldt Park.

Above: I don't remember if this was on Spaulding or Christiana, but obviously Tank (RIP) was from Kedzie and Cortez. I have pictures of his funeral that I got from a cop I went to school with, a year or so after I took this picture in 1993.

Opposite page, left to right: I just stumbled upon "Snake Alley" in Humboldt Park, so named because it curves from Spaulding toward Division. When the wall would get buffed, they just painted in a different rival's emblem. The Lovers and Campbell Boys flip was taken in 1992. Other gangs would also come through with paint splashes. I kept an eye on this wall, and caught the Deuce/Cobra and Eagle/Jiver flip before it got splashed.

Compliments of Chicagohoodz: Chicago Street Gang Art & Culture

Opposite page:

Top, left to right: The card with misspelled "Unknowns" was printed in 1987 by a 14-year-old "Mr. Cortez," a.k.a. "Lil Kent" from Grand and Mobile. Mr. Cortez moved to Little Village in the early 1990s and became a Cullerton Deuce—also People at the time. By then known as "Kaos," he was murdered in 1996. Edwin "Weso" Suarez, the leader of Halsted and Wrightwood, was given 40 years for the murder of Simon City Royal Darryl "Bulldog" Griggs in 1985. Angel "G" was an Imperial Gangster also killed by the IUK. "R.I.H." = "Rot in Hell." Zale "Casper" Hoddenbach comes from a long line of IUKs. While serving seven years for aggravated battery, he became what many in the joint call a "Bible thumper" after an altercation with a rival gang member. Released in 2002, he found employment with CeaseFire, an organization dedicated to curtailing gang violence, and was featured in a 2008 *New York Times* article praising him as an "interrupter" of violence in the streets. By 2011, Casper was facing charges of sexual assault of a minor, after allegedly having sexual relationships with minors while working as a counselor at the Logan Square Chicago Boys and Girls Club. In 2014, Casper, then 45, was convicted of criminal sexual assault and criminal sexual abuse, and sentenced to 40 years, while awaiting trial for child pornography.

Third row, left to right: The crown shows allegiance to the Kings. The upside-down horned and winged heart, and crown display their rivalry with the Disciples and Gangsters, respectively; "LSK" = Latin Styler Killer; "Small Folks" is against all gangs under the umbrella of the Folk Nation. In 1985, Reynaldo "Scooby" Munoz killed Ivan Mena and wounded Bobby Garcia at a party they were all attending. For his actions, Scooby was sentenced to 40 years for the murder of Mena, and 20 years for the attempted murder of Garcia. The original fight that ended in murder was over beer.

Bottom right: "The cross is a traditional IUK symbol, as it was for many gangs back then. This was made by Clown. Ironically, he was later considered a traitor for joining the Royals."—Ghost

This page, top: This is a famous piece from Division and Keeler in K-Town, early to mid-1990s. The Insane Unknowns did a lot of good murals.

Top: These walls were behind the southern end of Wrightwood Park, just northeast of Ashland and Fullerton. Early to mid-1990s.

Bottom: As the yuppies were moving in, Sting from the Deuces got a job doing rehab on buildings in Lincoln Park. This highly detailed memorial was found by him in a basement off Halsted and Wrightwood. Jose "Capone" Arroyo was killed by Frank Fender from the Royals, kicking off a war in which SCR Bulldog would be killed by Weso, whose name also appears on the right. The gold may have been a splash, but it somehow works.

Compliments of Chicagohoodz: Chicago Street Gang Art & Culture

Eventually, gentrification, incarcerations, and the loss of members forced the Unknowns to go dormant for many years, having lost some of their former major strongholds in the 1980s and 1990s. Today, the Insane Unknowns are trying to make a comeback, and in the last several years have opened up new sections with the recent release from prison of several more prominent members.

Spanish Lords

The Spanish Lords have always been a relatively small street gang. They got their start in the mid-1970s around North and Claremont in Wicker Park, with most members attending Clemente High School. Their colors are black and maroon, and they are made up of mostly Hispanic members, with a handful of whites and blacks.

By 1980, the Spanish Lords began to move their operations north, into Logan Square and Bucktown, around the same time they aligned with the People. Traditional rivalries continue with all Folks, particularly the Latin Disciples and Spanish Cobras.

The Spanish Lords have been closely aligned with the Latin Kings since their inception. Proof of this allegiance can be seen with the crown next to their most common emblem—a cross with a heart in the center, and a staff with what some refer to as a "ruby" on top. The "FSLs" (Future Spanish Lords) card pays tribute to two fallen soldiers—one a Spanish Lord, the other a Latin King.

Above: Two Spanish Lords cards from the 2000s.

North and Claremont. The Lords were still holding that section down. About this time, I was driving with Bear from the Cobras, who had a teardrop under his right eye. These guys spotted that tattoo from across the street. I saw one head pop up, then another, then another. They started coming for my car, and I had to blow the red light and get out of there before my car got bricked or shot at.

Compliments of Chicagohoodz: Chicago Street Gang Art & Culture

289

Although the Spanish Lords are members of the People, for the last decade and a half they have been in a tit-for-tat war with the Insane Unknowns, who border them to the east. This war began over drug turf disputes and escalated in 1999, when Spanish Lords leader Roberto Cruz was shot and killed by Insane Unknown David Gecht, son of 1980s-era Satanic serial killer Robin Gecht of the "Chicago Rippers" cult, a.k.a. "Ripper Crew." For his participation in this murder, David Gecht received a 45-year sentence, which he will serve alongside his father within the Illinois Department of Corrections.

The Spanish Lords continue to operate in the Bucktown neighborhood of Chicago, and can frequently be seen in the vicinity of Armitage and Western, where they continue to engage rivals while holding down their 'hood.

The Warlords

Wicker Park has a complex street design between Damen, Milwaukee, and Ashland, and at one point the Ellen Boys, PVP, Kings, and Warlords all hung out around that congested little triangle of curving streets and dead ends. Across Division to the south were Gents; to the North across Milwaukee were Latin Disciples; to the east across Ashland were Greenview Boys and Jivers; and a branch of Vice Lords on Pierce. This area was the birthplace of the Insane Unknowns, the Spanish Lords, and was the Taylor Street Jousters' first North Side encampment. But the gang that defined Wicker Park was the Warlords.

The Almighty Warlords from Damen and Evergreen, more commonly known as the "Wicker Park Warlords," started in the mid-1970s. Their colors were black and orange, and they were about 95% Latino and 5% white or black.

Most of the Warlords' territory overlapped that of other neighborhood gangs, including the Latin Kings, Vice Lords, Insane Unknowns, and Spanish Lords. In order for them to stay mainstream, in the late 1970s they decided to align themselves with gangs in the UPK, better known as "Unknowns Players Kings," an alliance which diminished after they were all absorbed into the newly created People in 1979.

By 1979, the Warlords found themselves in a dispute of power amongst their own ranks, and by 1982 two factions emerged, led by Lord Eggie on one side, and Lord Crook on the other. The infighting for control of the Warlords' narcotics business brought the gang to its knees, as did the fact that both the Vice Lords and Latin Kings—both People—were now encroaching onto their turf.

Throughout the late 1980s, with a house divided, their ranks began to dwindle. By the early 1990s, after losing members to narcotics and other clubs, there were fewer than 20 Warlords left in the entire organization. By the mid-decade the organization was no more. Once the neighborhood of Nelson Algren, then home to one of Chicago's largest Puerto Rican communities, Wicker Park is now just another hipster-yuppie enclave, much like Williamsburg in New York City, and the Mission District in San Francisco.

Compliments of Chicagohoodz: Chicago Street Gang Art & Culture

Bottom: Before I really got to know Danny, a.k.a. Mr. Cortez a.k.a. Kaos. I didn't feel comfortable asking him to wear the sweater for the picture, so I put it on and had him take a photo of me in it.

Card 1 (orange):

Crook Fro
Almighty Warlords
Damen -n- Evergreen
Brother Wayso
Freckles Bobone
Ziggy Casper

Card 2 (yellow):

West		Hawkeye
Pops		Lil player
Tiko		Peabody
Psyco	UN-KNOWNS	Fly
	PLAYERS	
	KINGS	
Sinners	C-K G-K	Monticello
&	D-K E-K	&
Tokers		Thomas

Card 3 (orange):

Pee Wee War Lord's Benjamin

Tiche	Ceja	Fro
Orlando	Olie	Head
Willie	Goby	Prieto
Raymond	Noel	Polo
Peyito	Marco	Max
Pepe	Frankie	Ears

Card 4 (orange):

Almighty Warlords
Evergreen -N- Damen

Bucky Crook
Ziggy

Card 5 (tan):

SHY-LAD	OUR COMPLIMENTS	CAPONE
CANO	WE GIVE	LIL DAGO
BIG DAGO	FROM THEE	JOE-ZEP
YOUNG BLOOD	ALMIGHTY	CHINO
RENE		LIPS
NANDO	"Chi-Town"	LIL ROOSTER
ELVIS		JOSE
BIG B	War Lords	LIL MAN
LOUIE		CANE
LITO CAPONE		S-D-K

Card 6 (red):

LIL MAN	WE RETURN TO GIVE THEE	PLAYBOY
SNAKE	OUR COMPLIMENTS	BABY
	FROM THEE	LORD
CLYDE	Chi-Town	
DAGO	ALMIGHTY	SWAN
PLAYER	War Lords	CASPER
CAESAR	IN MEMORY OF	LIL CAPONE
	ACE - R.I.P.	

Card 7 (orange):

In memory of Fro
Mariano Custodio Jr.
Born: September 15, 1959
Died: February 4, 1976
Buried: Mount Carmel Cemetery
February 7, 1976

Third row: This South Side branch was started with the help of a guy named Pasqualie, who moved from Wicker Park to Taylor Street. The Chi-Town War Lords pretty much dominated the neighborhood during that period. This card pays respect to Ace, who was killed while awaiting trial for murder.

Compliments of Chicagohoodz: Chicago Street Gang Art & Culture

WARLORDS

WL

Playboys

During the 1980s, the Northwest Side became one of the last bastions of Chicagoland's white working-class population—and its gangs followed. There were Jousters and Playboys in Belmont Cragin; C-Notes further north in Dunning, Portage Park, Jefferson Park and Forest Glen; Freaks in Hermosa and Jefferson Park; Popes to the northeast in Irving Park and West Ridge; Royals generally to the east of Milwaukee; and Gaylords sprinkled to the west. When these organizations started falling under the Folks and People umbrellas, the Royals and Popes went one way, the Gaylords, Freaks, Jousters and Playboys went another—and the C-Notes were not part of either, so they fought all those mobs.

On the Northwest Side the majority of violence was a continuation of the old-school fighting ethos: fisticuffs, bottles and bricks, ball-batting, and flailing with a padlock and chain. It was about kicking somebody's ass and going about your business. As things started escalating, the deterrence mentality came in. In certain instances the intent was to kill, but it was more often saber-rattling.

On older Playboy cards from West Town, "Popes Die" appears, but when the Insane Popes transplanted themselves to the far Northwest Side, there weren't yet any Playboys in those areas. The two clubs didn't have much to do with each other apart from the occasional spat. The one place Playboys and Popes would have engaged in battle in the 1980s would have been the Axle Roller Rink.

"M-O" stands for Montrose and Octavia Park, a little park in the sub-

Top right: Already sharing the colors black and white, in the late 1980s the Playboys arranged a meeting with the Insane Unknowns to propose an official unification: "I was honored they respected us enough to want the unity, but didn't feel it was needed, as we were already united under People. We told them they were welcome in our 'hood, and could tag in it or with us. The concern I had was I didn't want any racist tags with ours. They assured me they weren't racist; that was more the Gaylords and Jousters. Afterwards we tagged 'IUK PB' for a while, and they made this card. I always just thought it was their way of showing respect. Cragin Park turned IUK after they shut down."—Insane Unknown

Bottom left: A 1980s "PVR" card from Montrose and Octavia Park.

urban town of Norridge, on Chicago's western border. In the late 1970s and early 1980s, as white flight continued to suburbia, clubs like the Playboys and Rice Boys tried to establish themselves there. Their joint card still bears the appellation "PVR" (Playboys-Ventures-Rice Boys), revived in homage to the now bygone Ventures. Members of this set could often be found frequenting the Axle and its neighboring arcade, as well as the local mall, the Harlem and Irving Plaza. The Royals and the Dakin and Neenah Popes would also on occasion frequent the rink and mall. This particular section was off the map by 1984.

Once home to ethnic enclaves of Germans, Italians, Irish and Polish, the Northwest Side has changed drastically and is now a melting pot, many communities having been diversified for years.

Footnote: Another locale for gang activity were the numerous forest preserves and wooded areas within the city. Every gang had their own: the C-Notes' woods were Forest Glen; LaBagh was the Popes; Bunker Hill was the Freaks. These areas were also sites of Satanic rituals: the Satanic Warriors were considered just another gang by the CN$; during the 1980s, they would tag "666" and inverted pentagrams. LaBagh Woods had "The Monks"—the homeless who lived in the cemetery and would chase you to keep you out.

Taylor Street Jousters

Initially composed of Italians, as well as Mexicans, the Jousters' symbol was a medieval helmet, with dual shades of blue—both baby and navy.

By the early 1970s, the Taylor Street fatherland was predominantly Mexican, and the Jousters had begun a northward migration, opening mainly white sections in Wicker Park, Lakeview and Logan Square. Throughout the decade, these North Side Jousters became standard-bearers of the PVJ and UFO white gang alliances. The 1980s would ultimately find them settling in Hanson Park, in Belmont Cragin on the Northwest Side.

There, the Hanson Park Jousters expanded both their ranks and their brand, now utilizing a Celtic cross with two emanations on each side, a solar wheel, as well as the more overt occasional Klansman. This, along with the swastikas, show that they considered themselves to be part of the white power movement that started with greaser clubs during the 1970s. What many fail to realize is that, since their inception, the Jousters have had members of Hispanic descent in their ranks.

Once a large gang with sets scattered around the North Side, by the mid-1990s all of the Jousters neighborhoods would become home to Hispanic gangs, as the Latin Pachucos, Latin Brothers and Imperial Gangsters began moving in. Hanson Park, their last holdout, is now controlled by the Pachucos.

Compliments of Chicagohoodz: Chicago Street Gang Art & Culture

297

Top: Hanson Park, early 1990s—the Jousters' last stronghold after all the other branches closed down. By the late 1990s, as the Latin Pachucos started getting big, they were gone. The Jousters and Pachucos for the most part got along. They both rode People, and perhaps the Jousters just finally accepted that their neighborhood was changing.

Middle: I found this not far from the Grand and Central police station on the side of an abandoned factory, a long mural that displays all of the Jousters' rivals: the Imperial Gangsters, Latin Disciples, and C-Notes. "HP" = Hanson Park.

Right: In the early morning of December 5, 1983, Simon City Royals John Thorson and Michael Clark (known on the streets as "G-Man" and "Rotten") were found murdered—Clark in Hanson Park, Thorson on a porch across the street. In an attempt to evade his attackers, Thorson ran onto the porch from the park. Unfortunately, the owner of the house was deaf, and failed to hear Thorson pounding on the door. Clark never made it out of the park. His body was found wearing a Royals T-shirt, having been both shot and stabbed. Both men's throats were slashed. The case remains unsolved. Due to the incident occurring in their 'hood, the Jousters took the street credit; however, some speculate the actual perpetrators were the Gaylords or the Chicago Police.

Compliments of Chicagohoodz: Chicago Street Gang Art & Culture

299

Stoned Freaks

"Freaks" were like hippies and have been around Chicago since the late 1960s. There were unorganized Freak sections scattered all over the Northwest Side: at Chopin Park, Eugene Field, Independence Park, Lamon and Cullom, Montrose and Cicero, and Cicero and Gunnison. The majority of them were perceived as partiers; some were gangbangers.

Part of the transitional "Gaylords, Freaks and Jousters" (a.k.a. GFJ or UFO III) entente in the early 1980s, they were on their way out until they were resurrected out of nowhere in the late 1980s by Tommy Damnitz, a.k.a. "Crazy-F" (for "Freak"). While the older Freaks were stoners who were more interested in getting high, Crazy-F had gone to the joint for shooting a Cobra in 1987; he formally christened the entire nation the "Stoned Freaks," picking up steam to recruit new members. Already considered de facto People on the street with the GFJ, when Crazy-F started bidding to get recognition, the Stoned Freaks got a "seat" in the joint in the 1990s.

The Stoned Freaks identify with red and black; their initials and colors lend themselves well to San Francisco 49ers attire. Their emblem is a skull with a top hat and cross. Like many gangs, the Stoned Freaks would pull hits in skull masks, and paint their faces on Halloween.

In the fall of 2016, Thomas "Crazy-F" Damnitz was found dead in Skokie, Illinois, at the age of 50 inside a burnt car. His death was ruled to be an accident.

Top: Kildare and Fullerton/Keeler and Armitage. Lil Ham became the leader of Keeler and Palmer, Lil Al the leader of Kelvyn Park. Many turned Jouster.

Middle: The "FL" (Freak Love) card features their signature skull and an inverted Latin Disciples heart. One cross disrespects Royals, the other celebrates Gaylords. A hand-drawn original from 1984.

Compliments of Chicagohoodz: Chicago Street Gang Art & Culture

Top: This Freak cross was done by a shorty named "Villain" (a.k.a. "the Lone Freak"), behind the Hastee Tastee in Gladstone Park, with the slashes on the wrong sides of the cross. The inverted "R" is for Royals. Both gangs went to Taft and got high together, before a Royal stabbed an older Freak at Bunker Hill. Before the wall was splashed by the JP C-Notes, circa 1988.

Bottom, left to right: The "FL" red card is from Milwaukee and Austin in Jefferson Park. Still just "Freaks," they weren't "Stoned" until the late 1980s. From then to the mid-1990s, the C-Notes were their main rivals. It is unknown why they would flip "Gangsters," as there weren't any nearby.

Latin Brothers

The Latin Brothers originated in Pilsen in the 1970s, and expanded to the corner of North and Latrobe in Austin on the West Side when their president "Mike" moved there in the early 1980s. They continued to expand to Belmont Cragin on the Northwest Side, which became their main headquarters in the late 1980s, as the neighborhood around North Avenue changed to African-American. The Latin Brothers were in close proximity to the Hanson Park Jousters, making it easy for them to have had a problem with each other—although both were People-affiliated and shared similar symbols. In addition to the knight's helmet, the Latin Brothers display a lance, and their colors are black and purple.

Thee Insane Miniature card was from the 18th Place and Ashland section; the surrounding area also consisted of Laflin Lovers and Latin Counts—the dominating gang in that section of Pilsen, and the Latin Brothers were directly related. (You will notice "Lil Lepke," named after Lepke from the Latin Counts.) Eventually, the Latin Brothers from that area would join them. The initials "S-D-K" stand for Satan Disciple Killer, one of their main rivals from the area. Like many compliment cards, it was made in a few different colors.

"Thee Almighty" card represents Senior Latin Brothers from Pilsen. "A-K" and "D-K" displays the rivalry of the Ambrose and Disciples.

Compliments of Chicagohoodz: Chicago Street Gang Art & Culture

Top: Giving respect where it's due, to the Latin Sisters; Belmont and Cicero.

Latin Counts

The Counts were established in 1959 by Joe Escamilla and members of a gang called the Texans. First called the Sons of Mexico, they changed their name to the "Latin Counts" and settled at 19th and Racine, and 18th and Loomis in Pilsen. They were known to hang around Dvorak Park, and were said to have the best baseball team in Pilsen—their color scheme of black and red inspired by the jersey of the Chicago White Sox American League win in 1959. These colors, along with their mascot of a combative knight's head, serve to project a very martial image for one of the few gangs representing People in Pilsen.

The Counts and Kings never had much of a relationship, although many Count cards from the 1970s will have "King Killer" on them. In the 1990s, they finally went to war, the Kings killing Caesar from the Cicero Latin Counts. The Counts threw up different crosses as styles evolved over the decades, but like several People gangs, they often feature five rays above the crossbar. In the 1980s the Counts expanded to Detroit, where they adopted a more Los Angeles style of dress.

Bishops

Around 1970, the younger brothers of some Counts started a club on 18th and Bishop, calling themselves the "Bishop Boys." The Counts didn't want them becoming a gang, but their association—and the ever-increasing presence of other gangs in the area—pushed them into street gang status, creating the "Bishop Count Nation."

This blood alliance between "throne and altar" lasted about 20 years, until a fight broke out over new territory in Cicero, which resulted in the shooting death of the pregnant girlfriend of one of the Latin Counts.

The brown-and-black card reflects their colors of black and copper, and depicts a budded "Apostles" or "Cathedral" cross, rather than the definitive Bishops' cross with "crutched" arms. As the Bishops were originally directly related to the Counts, they therefore shared the same enemies. On this card, you see "A-K" and "D-K," which stand for Ambrose and (Satan) Disciple Killer. It shows two Bishop figures hoisting crosses on either side of an upside-down crown. Before People and Folks, they and the Counts were in opposition to the Latin Kings, as well as the other gangs aforementioned. Since then, a lot has changed.

Compliments of Chicagohoodz: Chicago Street Gang Art & Culture

Top: The "INS" for "Insane" is informal. The inverted spear likely refers to the Ambrose's "Wild Side" section nearby. This alley wall had been covered up with layers of Bishops imagery.

Lower-right: This guy just happened to be in front of the same wall. The Bishops have a couple hand-signs: a "B," as well as their bishop's mitre emblem visible here. This wall may have been splashed, and thus covered up with the full-length Bishops wall, where they kept the same mitre.

Compliments of Chicagohoodz: Chicago Street Gang Art & Culture

Opposite: South Chicago on top of a factory by a railroad track. The Counts sure did make a point of letting you know where you were, with murals all over the neighborhood. You wouldn't know it by driving around there today. While the neighborhood still looks abandoned, it hardly has any graffiti in it anymore.

Above: Harvey's shoes—he was a Cicero Count. Decking out your shoes has been popular since at least the 1970s.

Lenny of Noble Knights holding two guns in center.

Compliments of Chicagohoodz: Chicago Street Gang Art & Culture

Villa Lobos

The Villa Lobos ("Village Wolves") were one of the few Puerto Rican gangs in Pilsen. They started around 1975 in the area of 21st Street between Loomis and Throop—right between the Ambrose's main branch, and the up-and-coming La Raza. Their emblems are a wolf's head (often donning a fedora, later adding a moon) and cross, and their colors are green and black.

Due to the Villa Lobos' association with the Bishops and Counts, they were forced to move further west to Cullerton and Ashland—known as "Wolf City," named that by the member "Wolf" himself.

Around the same time, they also started a branch in Little Village at 23rd and Ridgeway. The fighting with La Raza in Pilsen got to be too much and caused them to shut down there in the early 1980s, while in Little Village they continued with an alliance with the Latin Kings.

Note the abbreviations for the Satan Disciples, Kool Gang, and Party Boys—all rival clubs from Pilsen—and Two-Six from Little Village; the Satan Disciples had a branch there as well.

Noble Knights

The Noble Knights are a Cicero gang, although they originated on the North Side around Division and Noble in West Town. They consisted of Irish, German, Italian, Lithuanian, and Slovakian members, and were founded and presided over by "Krazy Pete."

In Cicero, they started in the Grant Works neighborhood around 1971, where they remained until around 2000. Like their predecessors the Arch Dukes, their main rivals were the Ridgeway Lords from western Little Village. As time passed and the Arch Dukes faded away, the Noble Knights called the Grant Works their home, and a new group began to move its way into the area: the Two-Two Boys.

To the east, the same neighborhood that hosted the Ridgeway Lords was now seeing a new gang emerge, the Two-Six. As time would pass, other gangs would make their way in and out of Cicero, like the Gaylords and Imperial Gangsters, while the Orquesta Albany opened up a section in Summit, Illinois, a few miles southwest. Looking at their cards, you can see the Noble Knights' opposition to these clubs.

The Noble Knights' emblem is a knight's helmet, and their colors are royal blue and black. The gang had a unique style to their lettering, perhaps because they had a few taggers amongst their ranks. As People, the Noble Knights designed the famous "Folks Busters" T-shirt; during the 1980s, even cops could be seen wearing it.

12th Street Players

The 12th Street Players are a predominantly white Cicero/Berwyn gang, born in the mid- to late 1970s out of the Cicero Greasers, where they occupied the same territory as the Park Boys. Like their allies to the east, the Noble Knights, their main rivals are the Two-Two Boys, Two-Six, and

Compliments of Chicagohoodz: Chicago Street Gang Art & Culture

Like the Insane Deuces, many of the Villa Lobos cards are variations on a theme in green.

There's one block that the Villa Lobos claim in Little Village and that's 23rd Street. They've been there for over 40 years, and side with the Kings because of their historical wars with the Two-Six. They might be small in Little Village, but there are branches outside the city.

anyone else associated with the Folks. Although further west from the opposition than the Knights, the shooting of a Player by Sir Vic started a big war with Two-Six—one Two-Six member recalling the Players as one of the "downest" suburban gangs they ever dealt with. The 12th Street Players' colors are black and white, and their emblem consists of the Playboy bunny, top hat, and cane.

As a founding member reminisces:

"I can remember the night we thought of the name and the colors. How Players and Knights only got along when it came to fighting Ridgeway Lords. The tension we had with the Arch Dukes over the similar colors of our sweaters. Players wore black and white sweaters (street colors) and all white with black cuts for parties. I'm proud that the Players still exist today and outlasted many of the clubs that were around in my days. I hear in the Illinois prisons that Players are a major factor in running the joint. I long over the gangbanging days, but will always remember that time of my life and the bond we had with each other. The beatings we gave to other gangbangers and the beatings we got will always last in my memory."

Opposite page, top: Off Roosevelt and Austin. In the early 1990s, the 12th Street Players went down the route of "wicky-sticks," a.k.a. PCP. Being "wet" on wicky will cripple you, or get you "stuck." You don't know where the ground is, and your sense of gravity is gone. This is why many gang presidents banned the use of it, along with any hard drugs, especially in public.

South Side Insane Popes

Legend has it that Insane Pope pontiff Larry Larkin went southbound in the

313

1970s, and converted a gang called the "LAs" (so named because all their streets started with "La": Latrobe, Lamon, Laclaire, etc.), whose colors were black and white. Like their North Side counterparts in the Folk Nation, the South Side Insane Popes were more about racism than gang alliance, and throughout their evolution made enemies with the Two-Six and Satan Disciples from Kelly and Curie High Schools, as well as the Latin Kings. The South Side Popes were the area's biggest white gang, opening sections in Clearing, Garfield Ridge, Archer Heights, Brighton Park, and McKinley Park. Many of the Insane Popes had parents who were city workers and police officers, which wasn't unusual for street gangs.

One such member was Michael "Lord Conan" Hamilton. A former Two-Six, Hamilton was recruited by the South Side Popes at 17, and assumed leadership three years later, around 1990. While greaser staples like denim, leather and chains were inherited by the heavy metal subculture, for these "Insane Greasers" long hair was non-negotiable, Lord Conan forcing "metalhead" recruits to shear their lengthy locks. Conan carried a reputation as one of the most legendary badasses of Chicago's streets, and after retirement went on to amass several championship bodybuilding titles. A well-respected leader, it wasn't until Conan's departure from gang life that he was drawn into the adult industry, and even then he left a strong section of Popes that still exist today. Mike Hamilton died in his late 40s of natural causes in 2018.

Like their North Side brethren, the South Side Popes use a cross, with the addition of a halo and sometimes—like the Counts—five slashes. The Popes and Latin Counts have a relationship dating back to the 1970s, when Buffalo took a bullet for a Count, saving his life.

The Saints

The Saints were ordained in the Back of the Yards during the mid-1960s by a guy named Rich, who was also known as "Rabbi." The early Saints were mostly Polish, with a couple of Mexicans. They borrowed the haloed stick-figure logo of British fictional character Simon Templar (*The Saint*), adding angel wings, a cross or cane, and—like NYC graffiti artist Stay High 149—a cigarette. The Saints' colors are baby blue and black.

By the early 1970s the Union Stock Yards had closed, and the neighborhood was almost entirely Mexican. As the neighborhood changed, so did the face of the Saints.

While the Back of the Yards' demographics altered, its gangs stayed; the Saints and the Latin Souls were two of the bigger ones who remained. The Saints planted their roots deep in Davis Square, to become entrenched for generations. If you go anywhere in the city, you won't see a 'hood as deep as the Saints. Their mean reputation was sealed when a 27-year-old Saint, Ernesto Godinez, shot an undercover ATF agent in the face in 2018.

The Uptown Rebels

The Uptown Rebels began in the 1970s, and gained notoriety by the early 1980s for their blatant display of white suprem-

Top: "Kool City" is around the tracks southeast of Cicero and Archer. The "Almighty Popes" splintered off in a schism over an open-air drug market here. Mike Hamilton was against the idea—he was after all of the greaser mindset. But once the money started coming in, Mike believed he was entitled to a cut. Ultimately, this faction was taken down by law enforcement, in the aftermath of the deaths of two innocent girls in a botched hit on the remnants of the Ridgeway Lords in 1995.

Top: Knowing the nature of the Saints' reputation, one is hesitant to stop in their neighborhood, which runs from 35th to 47th, from Ashland to Damen. When you drive around there, you know you are being watched.

Opposite page, top to bottom: The Saints have dominated their neighborhood in the Back of the Yards for the last 40-plus years—and they made a point of letting you know it, with walls like this throughout the area. The "R" is in reference to the La Raza directly southeast of them. "45" = 45th and Paulina. Note the number of rivals displayed along the bottom of the drawing. Although few gangs have more enemies than the Saints, the shared haloes might help their being at peace with the South Side Popes.

Compliments of Chicagohoodz: Chicago Street Gang Art & Culture

317

Looking east from the fire escape on my buddy Howard's high-rise apartment building on Wilson and Magnolia. It shows not only the cityscape of Uptown, but the Uptown Rebels' giant "U-R,"

acy. Their emblems and attire consisted of various Ku Klux Klan symbols, as well as red and gray Confederate-themed sweaters. When not hanging around Godfather's Pizza in Uptown, they were known to attend Klan rallies and monthly meetings in Kentucky, where they received the official patch they wore on their sweaters.

> "We had a go with the Latin Kings, but me and Tony Atlas of the Kings stopped that. We went to the El-Rukn headquarters, and helped found the People Nation, with the understanding we keep our white power stance. Three representatives each in the projects sat down with their leadership, drew up maps for our areas, and agreed to a non-attack rule on all People. Even if they was black, they got a pass.
>
> "Now I am friends with guys that I fought from the past. Things changed in the late 1980s—more shootings and less honor. We took pride in our black eyes and missing teeth. Never did shoot anyone. I knew of Rebels that did, but that usually wasn't the case. At that time, in that day and age, it was needed. Now I look at things differently; I have friends from all walks of life. Most of the guys I fought are friends now."
>
> —Jack, former Uptown Rebel

Compliments of Chicagohoodz: Chicago Street Gang Art & Culture

Opposite page: "Most gangs have two-inch sleeve chops. We had four-inch chops for officers and two-inch chops for soldiers—and of course for our patches, mainly Klan-oriented. Sweaters are forbidden to leave us; they are buried with a member."

Above: An interesting thing to consider when looking at Chicago neighborhoods is the people you grow up and hang out with. This mock photo of a couple of the Uptown Rebels beating up a black individual is supposed to emphasize what the Rebels represent. The kid is obviously in on the spoof.

The back of the old folks' home at 21st and Albany was a popular canvas and chill spot for the Latin Kings. You can see a car coming from either side, and you can see this wall from the train. The Master holds the sun, an important symbol in King lit. Note the five dots above "Albany." They've done numerous walls here—either after getting splashed or deciding to re-do them.

By the time Crazy Tony was released from prison, three generations had passed, but the legacy of casual gunplay he left on the streets had caught up with him. The original Morgan Deuces had given way to the Juniors, who were bypassed by the Littles, as gangs got more into drugs in the late 1960s and early 1970s. Some clubs, like the Jr. Esquires, retired their name as gang culture became less morally structured. In the wake of Crazy Tony freely waving a gun around, many gangs found it necessary to follow suit in using firepower to approach rivalries. In this photo, Lumbago, a big Morgan Deuce, stages a mock execution of Mr. Big, who is wearing a Latin Kings patch. Photo courtesy of Mr. Big.

chapter 6
"DEUCES"

Morgan Deuces

The Morgan Deuces were a racially mixed Pilsen club founded in the late 1950s at Taylor and Morgan by an original Latin Count named Teddy McGee, who said he got tired of the Counts running from fights. Their emblem was four suits of deuce cards in a spread, and their colors were gray and charcoal gray.

They became well known in Pilsen, especially after one of their members, "Crazy Tony" Gonzales, became notorious around the area for his dandyish style—and proclivity for shooting at people. He was one of the first gang members to be known as a gunner during the early 1960s, and was the subject of a 1963 episode of *Lee Marvin Presents: Lawbreaker*. Crazy Tony was the brother of David "Boogie" Gonzales, a former Rampant turned gang mediator, accidentally killed by the Latin Kings in a failed assassination attempt on "Mr. Big" from the Deuces (see Pilsen Rampants section in Chapter 1). Tony himself was killed in 1996, shot in the head in a car wash at 35th and Kedzie.

Another notable former member of the Morgan Deuces is New York City artist Jack Walls, a.k.a. "Hi-Fi."

"Tony was like the Morgan Deuce. When he got out of jail, it was a big deal. I actually got along with him; we were like friends. He got busted because he would be wearing a fucking coat in the summertime, because he had a rifle or shotgun… The Deuces were affiliated with the the Cullerton Boys, the Chancellors, the Spartans to a degree—but we eventually ended up going to war with them. If we had a party, they could come, and nothing was gonna happen. Or if you threw a dance at St. Joe's, all the gangs would come, but you had some that, whatever the reasons were, you just were friends with them. There was a kinship…The Deuces, a lot of them graduated high school and read books. With them, there was always more like a quest for knowledge. Some of the guys went to the military, and they came back. Most of them went to Catholic schools. They had this edge. I remember talking to Frankie; we would talk about Carlos Castañeda, Kahlil Gibran. We would smoke weed and read his poems and bug out. For a while we all got into that. So, there was this other element."
—Jack Walls/Hi-Fi

The Deuces in Bridgeport were started by two brothers from Pilsen named Pipeye and Shy-Lad. That particular set

turned 33rd and Morgan Latin King. Pipeye, the older of the two, went on to join the military, and Shy-Lad continued on to refer to themselves as the "Ex-Morgan Deuces."

The Senior Morgan Deuce card is courtesy of Mr. Big from the second generation. There were the original Morgan Deuces which started in 1959, then the Juniors, then the Littles started in 1967, who soon skipped the Juniors to become the Senior Morgan Deuces.

> "These guys were Cullerton Deuces. Gent's Cullerton. Johnny's Cullerton. They were the Cullerton branch, but they were from 18th Street, They just happened to live on Cullerton. Later in the 1980s, something went down. Everybody got old, and then these young jacks came up and sort of hijacked the name. There was some kids in that neighborhood in the early 1980s after I left. All of these kids who used to run around that I probably didn't even think about—once they grew up, they wanted to be Deuces. And so they went to the Deuces and got the name. The Cullerton Deuces are still there, but the Morgan Deuces, my people, we formally disbanded. It was like 'That's it.'"
>
> —Jack Walls/Hi-Fi

Compliments of Chicagohoodz: Chicago Street Gang Art & Culture

327

Opposite: Going off some original Morgan Deuce photos, I had a patch manufactured to complete the sweaters I had come across. Made before meeting Mr. Big, the official scroll would have stated "Death Before Dishonor." "That's a Deuce thing, that was our slogan. Johnny Santiago and Gent, they were Marines; they brought it back with them."—Jack Walls/Hi-Fi

Top: A 1964 group shot of the original Morgan Deuce branch of 18th Street. Note the upside-down crown in the background, an early example of the inversion of rivals' emblems. Photo courtesy of Ted McGee.

Very soon after I had met him, Kaos made this painting for a memorial celebration of Favian's life.

Compliments of Chicagohoodz: Chicago Street Gang Art & Culture

Rejecting the direction gang culture was taking, the club folded in the 1980s. The Morgan Deuces indirectly spawned two gangs on two opposite sides of the city: the Cullerton Deuces of Little Village, and the North Side Insane Deuces of Hamlin Park. These two initially unrelated gangs would run parallel courses, first as members of the People alliance, then of the Folks opposition—both transitioning due to disputes with the Latin Kings. The Cullerton Deuces and Insane Deuces ultimately united under the same banner.

Cullerton Deuces

"The Cullerton Deuces started because we didn't want to give them the name Morgan Deuces; we just wanted to quit. The main guys were Morgan Deuces from Cullerton, but we told them that we didn't want no more Morgan Deuces. This was the mid- to late 1980s. We told everyone we weren't Morgan Deuces anymore, but if you fuck with us, we'll fuck ya up—and those guys over there have nothin' to do with us. So, at first, the Cullerton Deuces used to hang around with the Kings..."
—Mr. Big, Morgan Deuce

The northeast area of Little Village around 21st and Washtenaw was the last holdout of the Morgan Deuces, and the birthplace of their offshoots the Cullerton Deuces. All too often, a kid is associated with the gang in their neighborhood, and in this particular area there isn't much else to offer. Within its three square blocks are

Top: Kaos' sweater while he still owned it. He kicked around the idea of calling himself "D-Kidd" even before he came up with Kaos. A name created to disrespect Disciples, he put it on his sweater.

Opposite top: A garage between Fairfield and Washtenaw just off 21st Street. Kaos was the Cullerton Deuces' resident artist and loved doing walls.

Compliments of Chicagohoodz: Chicago Street Gang Art & Culture

Lil Sal R.I.P.	Compliments of Thee :	Dave R.I.P.
	INSANE ♠ **DEUCES**	
"2" Short R.I.P.	of **CULLERTON**	Mona R.I.P.
Shanker R.I.P.	Demon R.I.P.	Munchies R.I.P.

This Cullerton Deuces drawing on notebook paper was made after they changed their affiliation to the Folks coalition. The dice on top represent 21st Street. The cracked and inverted Satan Disciples pitchfork and Latin King Master represent their closest rivals, and underneath is a display of other gangs they are in opposition to. From the left: the Saints, Latin Counts, Two-Two Boys, Ambrose, Bishops and Imperial Gangsters.

Compliments of Chicagohoodz: Chicago Street Gang Art & Culture

railroad viaducts, industry, and apartment buildings—no parks or school for that neighborhood to call its own. The only beacon of hope is the Chicago Boys and Girls Club on Cermak.

The Cullerton Deuces shared the same school district with People gangs, going to Farragut High with the Kents, Villa Lobos—and the Latin Kings to their west, with whom they would be tight allies throughout the 1980s. To their other three sides was Satan Disciples territory.

The Cullerton Deuces' original colors were white and gray, keeping the gray in homage to their lineage from the Morgan Deuces. Their few cards were created by Danny "Ramos" (a.k.a. "Kaos"), a Deuce of Mexican and Italian descent who was originally an Insane Unknown ("Lil Kent" and "Mr. Cortez") from the North Side.

Kaos held on to the traditional gang values before drive-bys and drug spots, and in respect to fighting "heads up." He looked down on the use of drugs, yet understood that in order to survive as a gang you had to roll with the changes, especially in that neighborhood. All of their cards were made in the early 1990s in respect to fallen members.

By then the relationship with the Latin Kings had deteriorated, as younger Kings started representing in Deuce 'hood. After Kaos beat a King to death in self-defense, the Cullerton Deuces became Folks, as probationers of the Insane Deuces of the North Side—eventually becoming one of their factions. No longer an independent gang, they changed their colors to those of the Insane Deuces, green and black.

Some in the joint had been killing Folks for so long they resisted all of this, one high on his deck turning 12th Street Player.

The green card, while still giving respect to the deceased, was made after Cullerton became incorporated with the Insane.

Danny hated drugs. He drank; that was his vice. He was a mean drunk too. But he was a brother to me. He had a son from a girl in the neighborhood. She told him he had some kind of medical condition. Danny worked for a living; he drove a truck. He was an honest worker. He didn't want drugs being sold in the neighborhood. But he ended up starting to hustle, because he wanted to make some money in order to help his son. So he started bagging. He even wore a mask when handling the cocaine, because he didn't want to take a chance of breathing it in. That's the last I remember of him. I got a phone call from him on my pager the night he was killed. I called up and didn't get an answer. Three days later I found out that he was killed. The people in that neighborhood are used to hearing pops and a car screeching off. They heard the shots and then nothing. He was coming home from work late. He lived in a garden apartment. He came down the stairs and somebody was waiting for him by his door.

Danny "Kaos" Ramos RIP was killed in 1996.

Insane Deuces

The Insane Deuces (I2D) originated in the Lathrop Homes in 1971, in response to bullying by the Simon City Royals (SCR). Inspired by a weed-dealing Morgan Deuce with a girlfriend in the Lathrop "Projects," they dubbed themselves the "North Side Deuces," selecting the

Top to bottom:

Although not in the photo, Kaos did this wall after Cullerton turned Insane Deuce (note "I-D"). The cross is dedicated to Monica, one of two girls Kaos liked to memorialize in his pieces: one died in a house fire, the other at the hands of her boyfriend or husband in Texas. Photo courtesy of Sting.

Danny's final great wall, the last big emblem he ever did. Although there were some leftover whites like "Casper," the Puerto Rican and Mexican flags most reflected the neighborhood. Already aligned with the Insane Deuces, Danny would incorporate white and gray into his work out of respect for Cullerton's roots.

spade symbol and the colors of black and Kelly green. At the time they consisted of white, Hispanic, and black members. The "N.S.D." (North Side Deuces), "Y.D." (Young Deuces) and "Almighty Projects" cards are circa mid-1970s. Circulation of the former was very limited due to the misspelling of the word Deuces.

Planting their flag in Hamlin Park (Damen and Wellington) early on, the branch is central in both geography and governance, with many satellite sections springing up out of its neighboring cliques. With dual capitals, at its summit the Insane Deuce nation stretched from the Projects at Diversey and Hoyne, to Damen and Melrose; and from Western Avenue to the Ravenswood tracks—the border with their other biggest rival of the time, Paulina Barry Community (PBC). Throughout North Side high schools during the 1970s and 1980s, one could hear the chant: "What's that love that roams the halls? Deuce! Deuce! What's that love that's busting loose? Deuce! Deuce!"

Hoyne and Wellington is the location of George Schneider Elementary School, the main breeding ground for the Project Deuces. Members could often be found in the school playground, or hanging out across the street in Hamlin Park. Many gangs across the city made neighborhood schoolyards into their home bases, and the Deuces were no different. When they weren't using baseball bats to play fast pitch in the school yard, they were using them to crack heads in the projects a block away.

The "Almighty Jahn Deuces" card pays tribute to another breeding ground, Friedrich Ludwig Jahn Elementary School at Belmont and Wolcott, a buffer zone at the border with the PBC. All Deuces that lived west of Damen Avenue attended Schneider; all those that lived east of Damen went to Jahn. For the past five decades, these two schools have bred hundreds of Deuces. In the 1970s, Jahn produced many members for the Wolcott and Wellington branch. Due to the influx of yuppies into the area by the early 1990s, Wolcott and Wellington was no longer active.

By the early 1980s they had become both "Insane," and members of the People alliance—the latter via associations with the Latin Kings and Insane Unknowns. Several Deuces with kinfolk that were Kings would invite them to hang out in the Projects, while the Unknowns were joined with the Deuces in opposition to the Royals and PBC. The Deuces' war with the Royals was a very deadly one, both sides suffering multiple casualties. Many of the Kelly green cards from the mid-1980s show opposition to the Folks, as well as the C-Notes from Schurz High.

"Lil Dago" on the "Pee Wee Hamlin Park" card was a well-known Deuce during the early 1980s. By mid-decade, he had fallen out of favor after implicating another member, "Jap," in the murder of "Smurf," a Southport and Fullerton Royal. Jap would be convicted for both the murder, and the attempted murder of Smurf's brother-in-law. Years later, Lil Dago would be gunned down and killed by one of his own over the rights to distribute drugs in a neighborhood bar.

The "Thee Insane" and "Thee Young" Hamlin Park cards were both printed in 1987, but did not hit circulation until the mid-2000s. They were picked up from the print shop by Sting, and due to his incarceration no one saw them until

Compliments of Chicagohoodz: Chicago Street Gang Art & Culture

Top: The Deuces with the Ghetto Brothers Organization and Unknowns. The GBOs were on the way out, and as relations with the Kings went south, Sting offered them a section to create a GBO branch, but the remaining members decided to turn Deuce instead. Photo courtesy of Sting.

Bottom: "49th" is Canaryville, started by Hamlin Park—which explains why they have both North and South Side emblems flipped. Left to right: Gangsters crown, Two-Two Boys shield, Kings "Master," Ambrose helmet, Disciples fork, Bishops mitre and a Counts cross.

Compliments of Chicagohoodz: Chicago Street Gang Art & Culture

339

he got out. Michael "Ice Mike" Rivera is currently serving an 85-year sentence, after being convicted of shooting a 16-year-old African-American teenager in the back of the head.

The "B-O" (Belmont and Oakley) card from 1984 shows the Deuces' allegiance to the People long before they turned Folks. It is alleged that in November of that year, the Royals and PBC in a joint effort rolled up in a car and opened fire, killing one John "Psycho" Combs, a member of Hamlin Park, as he ran from this intersection.

The "Compliments of Sir Sticks" card shows their opposition to the Simon City Royals, Paulina Barry Community and United Latino Organization. Sir Sticks is currently serving a 60-year sentence for rape.

Fellger Park on the corner of Belmont and Damen is more of a play-lot than park; the Deuces could often be found congregating in its vicinity. One of the more notable was John "Munchkin" Nattinger, whose nickname is misspelled on the "Almighty Fellger Park" card. Munchkin is currently serving a 60-year bid for allegedly killing the nephew of Rabbit from the Insane Spanish Cobras. Rabbit's nephew was a "neutron" (non-gang member), but was mistaken for a member of the Latin Kings. At the time of the killing, Rabbit was the number-two man for the Cobras, and this murder raised tensions between the two gangs. Prior to this conviction, Munchkin had already served time on two separate occasions for three counts of attempted murder. Ironically, he would be a key player in the negotiations of the Deuces flipping Folks with the help of the Cobras.

Sting was a Hispanic who grew up around the Lawndale Gaylords, as they were on the way out. Because the 'hood was hot, his mother moved him east to Hamlin Park, where he joined the multiracial Deuces. For stabbing an Italian Playboy multiple times in the head, at age 18 Sting was sent to Stateville. When released, he became leader of Hamlin Park himself.

"You see a lot of these cards from different corners, or sections in the neighborhood but the same names like the Fellger Park card. Lil Flash was Hamlin Park. Sticks was Projects. Munchkin Hamlin Park, Shorty Hamlin Park, Wee Gee and Ozzy Projects, Weasel Projects, and the rest Hamlin Park. But we were so deep back then, you'd find 30 guys here, and 20 here, 10 guys there, etc., any time. They always had respect for the women. It was cool being a Deuce back then."
—Sting

The "Insane 2 Deuces" card represent members from Fellger Park, Clybourn and Hoyne, Leavitt and School, and Hamlin Park:

"There's Lil Dago and there's Lil Flash, the one that killed him. Who'd think two guys on the same card would end up trying to kill each other ten years later? Lil Flash is doing time in Iowa. Shorty and Ozzy moved on with their lives. Speedy got locked up for, I wanna say, bank robbery. Lil One—that's Meko from Hamlin Park—got a 24-year sentence, had to do 12. The story is he was on a roll one

341

Top: "A-Town" = Aurora, Illinois; "E-Town" = Elgin, Illinois. In a basement of an Aurora Deuce's house. Aurora was a strong section and pulled a lot of weight for the nation; Elgin was large as well. The Insane Deuces became bigger in the suburbs than in the city at one point. Photo courtesy of Sting.

Bottom left: The card from "Sir" Droopy shows strong opposition to the PBCs by inverting their skull emblem. Droopy was considered by many Deuces a weekend warrior—i.e., his heart wasn't really into gangbanging, and normally only showed up when there was a party. The card itself turned out to be highly collectible. "Droopy was a vacationer—only came for a couple of years. He wasn't a forever kind of Deuce, but this card became very popular for us. The card was made in 1987, but the top hat was never our symbol."—Sting

night, went over by the Kings, shot a King, went by the Disciples, shot a Disciple, went by the PBCs, and in the process of doing all this, he accidentally shot one of the guys in the car. And when they went to the hospital for this, all the victims from the other shootings were there and they pointed him out. Beaver got involved with drugs— he's done. Fly, a Middle Eastern gentleman, retired and became a good DJ. Lil Dago's dead. Lil Man went on the run to Mexico, came back, did his time, and moved out of state. Burnout speaks for itself. Pee Wee and Sly came and went."

—Sting

After years of rising tensions in the Lathrop Homes, by the late 1980s the Deuces were at war with the Kings over the Projects.

"It wasn't over drugs. It was over 'hood. When they started bringing other Kings around, before you know it, it became a King 'hood, then it became a problem. More Kings came in from other sections, and before you know it they were there. There was no getting rid of them. Then there was a war."

—Sting

Soon thereafter, the Deuces decided they'd had enough and made the decision to flip Folks themselves, as a member of the Spanish Cobras newly minted "Insane" coalition, a.k.a. the "Black and Green Machine." When the time came for the various Folks organizations to vote on letting the Deuces in, the Royals were one of two gangs that voted against it. Their rivalry continues to this day.

Kilbourn and Diversey started in the late 1980s, while the Deuces were still a part of the People alliance. They shared the corner and the neighborhood with the Freaks from nearby Kelvyn Park. The set was started as the Deuces began to expand their empire outside their Hamlin Park stronghold. The displacement of Section 8 tenants from the Lathrop Homes assisted the Deuces in stretching their boundaries even further, as families began to be housed in Portage Park.

The Deuces have always been involved in the drug trade, but in the 1990s, with satellite branches fully established in suburbs such as Villa Park, Addison, Carpentersville, and Aurora, some of them looked to expand their network even further.

In the mid-2000s, the Edwards Brothers, Flash and Lil Flash, sick and tired of getting raided in their old stomping grounds, took some of their drug proceeds and bought in to some drinking establishments in the town of Ottumwa, Iowa. Unfortunately for them, no sooner did they get there than word got out of who they were, and before long, law enforcement began to infiltrate their operation. Nearly two hundred officers crashed through their doors and arrested members of the Edwards family and associates who had also relocated. In total, eight individuals would be convicted for narcotics trafficking and arms dealing.

Compliments of Chicagohoodz: Chicago Street Gang Art & Culture

Thee Insane Deuces ♠2 Of Villa Park Deuces Wild	STING MAD CASANOVA RICO ROMEO MOOCH JUNIOR BIG MAN CUBAN KID JD HUGO LIL' J SLAUGHTER MOOKIE

Wedged between the Chicago River and Damen Avenue, where Clybourn cuts through, are the Julia C. Lathrop Homes, also known as the "Projects." This cluster of public housing at the northwest border of Lincoln Park has been home to the Barons, then the Insane Deuces, then the Latin Kings. This was one of Chicago's first housing developments, and remained the most diverse CHA complex in the city, making the Deuces a very unique gang for a city so segregated. From "Diversity" to the north, Leavitt cuts through and curves east to meet Hoyne, which circles back and spits you back out on Diversey. This trap came to be known as the "horseshoe." Deuces loved having that road to catch rivals like the Disciples and Simon City Royals…and it was the first area in this complex where the Kings moved in.

CHRISTIANA PARTY PEOPLE

chapter 7
PARTY CREWS: "WE DON'T DIE; WE JUST GET HIGH"

THE TWO WAVES OF CHICAGO "PARTY crews" that emerged in the 1970s, and then again in the mid-1980s, were equivalent to the neighborhood street gangs or social athletic clubs of the 1950s through late 1960s. An old guy from that era will tell you that, apart from light-hearted juvenile delinquency and petty theft, his club weren't "criminals." They had girls, a sports team, parties and dances, and would occasionally fight, but that was it.

The party crews' purpose was, as the name suggests, to party. These festive organizations involved both boys and girls, and were found from the North Side to the South Side, from the inner city to the suburbs. During the 1970s, the first wave of party crews offered an alternative to gangs. The K-Town Party People (KPP) are a great example of a first wave party crew.

Former members of Little Village gangs the Bros and Ridgeway Lords started KPP because they were sick of gangbanging, but got respect from the local gangs because of their previous status and notoriety. KPP was originally a very powerful group, and were in control of Pietroski Park for years, even while Two-Six were coming up and trying to take it from them (Two-Six was still a small gang at the time). The original KPP then started the Orange Crush softball team or social athletic club. KPP lasted until the early to mid-1990s; by then, Two-Six had gotten bigger and the K-Town Party People had to quit or join them.

Party crews have been printing compliment cards since the early 1970s. The party culture followed the hippie culture of the late 1960s. For some the party cul-

Compliments of Chicagohoodz: Chicago Street Gang Art & Culture

Top: I was lucky to find this wall at least ten years after the K-Town Party People (KPP) had retired, at the back of Piotrowski Park, which the KPP originally claimed and controlled. Piotrowski Park was central to all the gangs in K-Town, from the Ridgeway Lords to Two-Six.

Top to bottom:

The Party Society from the Taylor Street area used blue and white. On this garage they painted Old English in the same way as street gangs, but underneath their triangle, or pyramid emblem, "OTBK" (One of The Boys Killer) is distinguished by the party crew tagging style. These two crews were not in proximity. While party crews may be neighborhood-based, they would still go to parties in other areas.

When sweaters were on their way out and fat laces got popular, people started jacking each other for gym shoes and starter jackets. The Nike Boys came about in the era of the post-hip-hop party crews in the late 1980s, after the Adidas Boys were established in 1987. Their rivalry was about as serious as any gang war.

Compliments of Chicagohoodz: Chicago Street Gang Art & Culture

349

Opposite page, top to bottom:

Popular sports or designer gear made it easy for crews to display their nation with corporate logos—you didn't even have to come up with a design.

Nike Boys displaying their love. They took away their sweaters, so gangs and crews then had to resort to fat shoelaces. Nike and Adidas Boys happened in the late 1980s—between laces fading away, but before starter jackets. Guess Boys came up in Gage Park. They became a gang too—even more so than Nike or Adidas—before finally fading in the early 2000s.

Compliments of Chicagohoodz: Chicago Street Gang Art & Culture

Card 1 (olive/gold)

CHICA CRAZY NENA MIDGET

(PARTY PEOPLE)
COMPLIMENTS OF THE
Krazy Ladies of 24th St.

PATTY SUGAR ADELA

Card 2 (black)

Michael Six Pack Compliments of Rich Pepe
THEE
Ace Boney **Original** Lil Duce / Lil Man
Party People
Dave Guero of Floyd / Dice / Rocky
17 St.

Card 3 (yellow)

Krazy Maria Barbie La Mary Land

Compliments of Thee
Almighty
Wild Bunch
of 2-3

Peewee Shortie Nini

Card 4 (blue-gray)

Raven Scooter

Bob ✝ Richie
Partiers
Big Head of Kenny
74 th.

Card 5 (pink/tan)

TRICKY SPOOK

COMPLIMENTS OF THEE
Rascals
of 43rd
"T" PARTY - BOYS GRIFF

QUICK MERC

Card 6 (light blue-gray)

Meuca Guera

Compliments
of thee
South Side Boogie
Penguin ✳ Lil One
Party People

Lil Bambi Lil Cheeta Chica

Card 7 (red)

Bertho Red Lici

Lil Crazy *Party Angels* Masy / Tina

Jaws Chankla Cula

Compliments of Chicagohoodz: Chicago Street Gang Art & Culture

Opposite page, left, second from top: The Wild Bunch card is marble chip, which at the time made it pretty expensive to print. In other words, these girls considered themselves high-class partiers. Above, middle row, right: The Imperial Tokers of Avers and Berteau were around in the late 1970s/early 1980s.

ture was all about sex, drugs, and rock & roll. For others it was all about the weed. One of their favorite sayings was "A friend with weed is a friend indeed"—or in the case of Randy Mealer, "Partier": "Have smoke, will toke!"

"We don't die; we only get high": Some crews used this saying to inform others that they were partiers and not a gang. In the late 1970s and early 1980s, gang violence was going through the roof. Letting those who participated in gangbanging know that they were not a gang sometimes saved party crews from some street dangers going on around them—but not always. What most teenagers failed to realize is that the number of drug-related deaths during the same time period also increased from previous years. Heroin use in the 1970s killed a great number of the youth of Chicago, and the introduction of crack in the 1980s left a devastating effect that ruined many families.

Party crews also had to deal with rivalry—not only with other crews, but gangs as well. Like gangs, many party crews were neighborhood-based—for example, the Nasty Boys from Back of the Yards, or the Guess Boys from Gage Park. In the eyes of many gang members, a person represents the neighborhood they come from, by gang: "I saw that guy in Saints' 'hood..." And like gangs, sooner or later animosity would grow between the crews, and the gangs as well. The neighborhood gang would keep an eye on them to make sure they weren't going to get too powerful.

As the local party crew gained popularity—and even power—the neighborhood gang couldn't let them exist without their say-so. While some remained strictly partiers, most would end up having to either join the dominant gang, or turn into one themselves—examples include the Stoned Freaks on the North Side; the Sin City Boys, originally from Little Village; their Cicero rivals, the Latin Angels; and the Party People of 17th Street in Pilsen.

Although they began as a party crew on 17th and Racine/Carpenter, the Party People would go on to transform themselves into a full-blown street gang. Once they started making sweaters and compliment cards with "Almighty," "Insane," etc., and flipping the opposition, it put them into the gang category. The Party People can still be found today, holding down the 'hood in the Pilsen neighborhood of Chicago.

Others allied themselves with specific gangs, like the Leland Avenue Party People. This particular crew was closely aligned with the Dunham Park Gaylords. Note their cross, Klansman, and five-pointed stars—all utilized by the GLs.

Some, like the Three-Six Party People, would have members join gangs—in their case the Simon City Royals. Although their card has the word "family" on it, they had no affiliation with the C-Notes street gang, who utilized this moniker during the 1980s and early 1990s. (Many gangs and crews considered themselves family, and were to countless members.) This prominent crew of the 1980s could often be found partying on the banks of the Chicago River, which bordered the eastern side of Horner Park. "666" is not necessarily in reference to being Satanic worshipers, but more their taste in music, which at the time would have been heavy

In Cicero, the Sin City Boys went to war with the Gents and Latin Angels (who use the Los Angeles Dodgers logo). Because they're Folks, they also diss the Counts, Bishops, Kings, and Noble Knights (who during their last reign adopted similar symbolism as other modern gangs—using dots became more of a thing, rather than slashes). It is uncertain why they brought the club and heart into their lit. This big vacant lot which faced Cicero Avenue was a convenient canvas for them. Their colors were blue and white.

metal. Members of this group attended Lane, Roosevelt, and Gordon Tech high schools. By 1990, the crew was no longer in existence, having had most of their members move on in life.

Other examples can be seen on the two cards from the Central Park Party People, and the Royal Capris street gang. Notice the names "Weasel" and "Mechanic" on both; these two individuals are one and the same. Both clubs were "white power organizations" during the 1970s.

In the early 1980s, New York's hip-hop scene made its way to Chicago. Breakdancing, DJ-ing and graffiti writing became popular, and gave neighborhood kids an alternative to gangs. Breakdancing crews began to pop up all over Chicago (e.g., Crazy Crew, Down to Rock, Floor Masters, ABC Breakers). By the mid-1980s, breakdancing began to lose popularity, and a new form of party crew evolved, incorporating a lot of members of the old breakdancing crews—just as the dance music was changing from hip-hop to house, deep house and hip house, then freestyle and heartthrob starting coming around. Radio stations like WBMX and B96, and DJs like Joe "Naw-T-Boy" Nardi and Farley "Jackmaster" Funk, were big with party crews in the 1980s and early 1990s.

Crews like the Funk Boys in Back of the Yards, and Krazy Getdown Boys (KGB) in Marquette Park still had somewhat of a post-hip-hop theme in their titles, but they developed their own style of tagging. The party crew style was somewhat similar to the gang style, but was very distinct, with bends to the lettering and curled vertical lines. As some of these crews started getting

Compliments of Chicagohoodz: Chicago Street Gang Art & Culture

The OTBz (One of The Boys) were a Latino party crew who used red and white. Here they flip the Party Society's emblem. Around it the Insane Majestics have tagged as well; they may have placed the K. The Z may be an attempt to flip the Party Society pyramid again.

closer and closer to gangbanging, you could see their graffiti begin to appear in Old English. The Funk Boys would ended up getting recruited by La Raza, Souls or City Knights, due to the neighborhood they were from. KGB flipped to gangbanging, and still exist today.

A person in tune with Chicago street culture could now distinguish three different styles of graffiti: street gang, graffiti writer and party crew. For example, Latin Image Crew were comprised of kids from Satan Disciples' 'hood in Pilsen, where in passing from a car or moving "L" train, you might see a graffiti writer's piece done by Mr. Fess, then a Satan Disciples emblem—then somewhere in the middle of all this would be a "LIC" tag, staking their own claim in Chicago's urban youth landscape.

Unlike citywide graffiti crews, party crew graffiti was territorial and meant to claim their 'hood. But even graffiti writers flipped rival crews, would throw up a "K" and fight, and party crews did war with each other—one example being OTBz (One of The Boys) in Back of the Yards, who flipped and cracked the Party Society from Taylor Street's triangular symbol. (If the OTBz ever did start banging, they probably had to join La Raza.) Many Back of the Yards crews adopted the gang style of graffiti, OTBz using Old English in later years.

On the Southwest Side people liked their khakis, but there wasn't a big difference in dress between gangs and party crews. In the era of big hair and pegged jeans, musical taste might still have been defined by race—but even a Gaylord might endorse Iron Maiden from the waist up, but rock Cavaricci or Girbaud from the waist down. Photos of the

Compliments of Chicagohoodz: Chicago Street Gang Art & Culture

Initially named the "Aryan Lords," the Chicago Party Boys entered the scene in the mid-1980s. They were Royal/Pope sympathizers, and could often be found dealing weed in the company of the Stone Party Gods—both headquartered in Ravenswood/Lincoln Square, blocks away from Welles Park.

The Party Gents were from 26th and Millard in Little Village. They weren't about gangbanging, but would go at it with the Two-Six Boys and didn't get along with the Villa Lobos. Their colors were black and maroon.

Compliments of Chicagohoodz: Chicago Street Gang Art & Culture

The Party Boys may have still existed in the 1990s, but if so they were on their way out. They did have a few sections throughout Pilsen, but the set by Damen was their last. Some may have turned Satan Disciple, only because they became the dominant gang in the area, but most just retired.

Hanson Park Jousters from the late 1980s and early 1990s are a great example of the introduction of starter jackets, a gang representation which crossed ethnic lines and was adopted by everybody.

On the North Side, party crews certainly did like their rock & roll, and it shows in the Stooge Brothers cards. Besides their love for music and beer, the Stooge Brothers of Lawrence and Lavergne show their affection for one another, and pay tribute to their Irish heritage. The card also has both male and female members on it. Both of their cards are circa the early 1980s, and were printed by Michael "Rocker" Polk and Robert "Sarge" Finn, prior to them both becoming Belden and Knox Gaylords. Mr. Polk went on to author the memoirs *Lords of Lawndale* and *Lords of Kilbourn*.

Often what music one listened to depended on the company one kept. When chasing tail with the boys, it was the Scorpions, Metallica, Judas Priest, Slayer and AC/DC, at Alpine Valley or Poplar Creek. When you were with the girls, it was freestyle, Hi-NRG and heartthrob: the Cover Girls, Cynthia, Bad Boy Bill, Lil Suzy, "Diamond Girl" by Nice & Wild, and dance clubs like Medusa's, 13 Colonies, McGreevy's and Illusions. One might see Julian "Jumpin" Perez at a battle of the DJs one day, and Anthrax at Rosemont Horizon the next.

While many North Side party crews were into sex, drugs, and rock & roll, South Siders like the Party Angels, Party Girls and Coquettes were into sex, drugs, and disco. Their cards show that although the boys were partying it down, the girls were not too far behind. Notice how the majority of the girls on these cards were of Hispanic descent.

The Party Players started in 1972 on Luther Street by 24th and Rockwell in Little Village. The president was killed by the Saints in the Back of the Yards; that put a big hurt on them, but a couple held on to 48th and Wolcott. They then expanded to around 63rd and Kedzie in Marquette Park.

The Orange Crush card is from the 1970s. This South Side party crew originated in that decade, and is still partying to this day—except the parties they are throwing today are all for a good cause. Today, Orange Crush is a not-for-profit organization based in the Little Village community that raises money for underprivileged kids to attend school. The "Orange Crush Social Athletic Club," as it is now referred to, hands out several scholarships a year to inner-city youth to help them achieve a higher education. Who ever said that the party had to finish? All they had to do was change the reason to throw it.

Even the suburbs were not spared from the party craze of the 1970s and 1980s. The Clyde Park Drinkers made their home in the southern suburb of Berwyn during the late '70s/early '80s. Like their city counterparts, the suburban party crews were not immune to being forced to either align with, or join gangs. The Unknown Assassins (UA) from the western suburb of Melrose Park aligned themselves with the Folks in the 1980s, as a result of their close relationship to the Royals in Northlake and Franklin Park, Illinois. Their card with the Party Savages is circa 1980.

Compliments of Chicagohoodz: Chicago Street Gang Art & Culture

Card 1 (tan):
Vita - Tita Lil Devil - Dimples
Compliments From
Thee Almighty
Party Girls
of 31st
Baby Dee - Lady Love Muneca - Patty

Card 2 (pink):
LADY CAPONE CRAZY DEE
NINA BITA
Compliments of
THEE PARTY GIRLS
TITA VITA
PREACHER LITA

Card 3 (faded):
ALMA GR
Compliments Of
Thee Party Girls
Of 18th Street
NORMIE TERRY DEBBI

Card 4 (white):
☆ Clyde Park ☆
☆ Gino Drinkers Sal ☆
☆ Vince Kevin Dwayne Dom ☆
☆ Joey Tony Scott Frank ☆
☆ Alex Tom Ed Bill ☆

Card 5 (cream/red):
Nesto Toker Stevan Roy
Marcos Noel Compliments Sam Robert
Rankie Rudy of Joe Speedy
Lando Mario Thee Israel Nasty
Layer's Almighty Lover's
 Party Players
 of 48th Street
 Pepe Luckie

363

Card 6 (green):
† Insane †
Party ★ Master's
Nation
K G K K K 18 K
Cisco Loco Chico
Snake Lil Leo
Ajax JJ Ace

Card 7 (black):
Loco Cisco Chico
Compliments of Thee Almighty
Party Masters
OF HOYNE & CULLERTON
Party Masters
Lee Capone Flaco Snake

Card 8 (orange):
 China Man
Cisco Benny
 Compliments of thee
Blue West Side Vato
Ace PARTY Sam
 MASTER'S
TJ Roach of 18th. St. Chico

All these cards are related to the original Party People of 17th, 19th starting almost at the same time. Phil started the Damen Party People spinoff, then turned Ambrose, then Disciple—then was killed by his own boys.

Compliments of Chicagohoodz: Chicago Street Gang Art & Culture

Because most were lovers and not fighters, those that did not join were forced to close shop. The Imperial Tokers of Avers and Berteau were around in the late 1970s/early 1980s. The Simon City Royals were only blocks away at Montrose and Hamlin, and some believe that one of the reasons this party crew went away was that the Royals suspected they were encroaching on their territory. On the South Side, the Ambrose were notorious for forcing such acts—and that just goes to show that the party wasn't always a party when gangs were involved. •

Footnote: There is one neighborhood—Hegewisch—that ended up with about two gangs, but was dominated by party crews. The crews that survived or stayed ended up being "war crews" (the Lynch Mob, et al.). One member explained, "The only difference between us and street gangs is we don't have to follow their rules," e.g., having to deal with "violations" as initiations or punishments.

Miscellaneous crews throughout the South Side adopted the moniker "Party People."

Party Knights, on Halsted by the viaduct under I-55. Everything about this wall is done street gang style, including all the lettering. The Party Knights were well on their way to having a full-blown emblem and cross, then they up and faded away.

Key to Gang Abbreviations

2-2	= Two-Two Boys		GBO	= Ghetto Boys Organization
4CH	= 4 Corner Hustlers		GL	= Gaylords
A	= Ambrose		HD	= Hells Devils
AD	= Arch Dukes		HG	= Harrison Gents
AS	= Albany and School Royals		I2D	= Insane Deuces
B	= Bishop		ID	= Insane Deuces
BCN	= Bishop/Count Nation		IG	= Imperial Gangsters
BD	= Black Disciples		IP	= Insane Popes
BG	= Black Gangsters		IUK	= Insane Unknowns
BGD	= Black Gangster Disciples		JP	= Jefferson Park C-Notes
BPS	= Black P-Stones		K	= Killer
BZN	= Brazer Nation		K	= Latin Kings
C	= Count		KP	= Kilbourn Park Gaylords
CD	= Cullerton Deuces		LA	= Lawndale and Altgeld Gaylords
CN$	= C-Note$		LB	= Latin Brothers
CPW	= Central Park and Wilson Royals		LC	= Latin Counts
CW	= Christiana and Wellington Royals, Chi-West		LD	= Latin Disciples
			LE	= Latin Eagles
D	= Disciples (Black, Gangster, Latin or Satan)		LJ	= Latin Jivers
			LK	= Latin Kings
DP	= Dunham Park Gaylords		LL	= Latin Lovers
DW	= Drake and Wolfram Royals		LRZ	= La Raza
FC	= Farwell and Clark Royals		MC	= Moffat and Campbell Gaylords
FL	= Freak Love		MK	= Milwaukee Kings
FS	= Future/Familia Stones		MLD	= Maniac Latin Disciples
G	= Gangster			

Compliments of Chicagohoodz: Chicago Street Gang Art & Culture

N	=	Nation
NK	=	Noble Knights
OA	=	Orquesta Albany
OL	=	Ohio and Leavitt C-Notes
Outfit	=	Chicago Italian organized crime
PB	=	Playboys
PBC	=	Paulina Barry Community
PC	=	Paulina and Cornelia Royals
PP	=	Party People
PRS	=	Puerto Rican Stones
PST	=	Palmer Street Gaylords
PVG	=	Playboys-Ventures-Gaylords
PVJ	=	Playboys-Ventures-Jousters
PVP	=	Playboys-Ventures-Pulaski Park
PVR	=	Playboys-Ventures-Rice Boys
R	=	Simon City Royals
RB	=	Racine Boys, Rice Boys
RC	=	Royal Cavaliers
RL	=	Ridgeway Lords
SA	=	Seeley and Ainslie Gaylords
SC	=	Spanish Cobras
SCR	=	Simon City Royals
SD	=	Satan Disciples
SF	=	Stoned Freaks, or Southport and Fullerton Royals
SK	=	Stone Kents
SL	=	Spanish Lords
SM	=	Sunnyside and Magnolia
SP	=	Sayre Park
TJ	=	Taylor Street Jousters
TJO	=	Thorndale Jarvis Organization/ Thorndale Jag Offs
TPN	=	12th Street Players Nation
TS	=	Two-Six
UFO	=	United Fighting Organization
UK	=	Unknowns
ULO	=	United Latino Organization
UR	=	Uptown Rebels
VL	=	Vice Lords, Villa Lobos
WL	=	Warlords
WP	=	White Power
WPO	=	White Power Organization
YBO	=	Yates Boys Organization
YLO	=	Young Latin Organization

Map of Gang Territories

GANG BRANCHES (also known as sets or sections) can be transient; they are especially fragile when newly established. For many gangs their strength lies in a leader, or a few aggressive soldiers. All it takes is one big arrest, or the death of a powerful figure, to weaken the section, and to be overtaken or disintegrate. Gentrification also has a huge effect and possesses the ultimate power to reshape an area.

As money and real estate carry so much weight, numerous gangs became involved in buying property. Neighborhoods like Rockwell and Potomac or Beach and Spaulding might have generations of members involved in the gang, making that particular neighborhood deeply entrenched.

The basic reference maps contained herein are not intended to be exhaustive, but to provide the reader with a general orientation for most of the primary gang territories and neighborhoods discussed in this book. They are essentially historical, and may or may not reflect current gang locations. Please refer to www.chicagohoodz.net for more detailed and up-to-date information.

Logan Square / Humboldt Park / West Town

1. Beach & Spaulding Kings
2. Kedzie & Cortland Kings
3. Armitage & Kedzie Kings
4. Armitage & Albany Kings
5. Albany & Cortland Kings
6. Cortland & Whipple Kings
7. Whipple & Wabansia Kings
8. Sacramento & Walton Kings
9. Talman & Wabansia Latin Disciples
10. Rockwell & Potomac ("Twilight Zone") Latin Disciples
11. Francisco & Wabansia YLODs
12. Springfield & Lemoyne Cobras
13. Springfield & Hirsch Cobras
14. Artesian & Lemoyne Cobras
15. Campbell & Potomac Cobras
16. Division & Maplewood Cobras
17. K-Town Unknowns
18. Iowa & Springfield Unknowns
19. Cameron Elementary School
20. North & Kedvale PVG
21. Keeler & Armitage Freaks
22. Palmer & Keeler Freaks
23. Almira Simon's Park
24. Spaulding & Armitage Gangsters
25. Palmer & Drake Gangsters
26. Yates Elementary School (YBO)
27. Palmer Street Gaylords
28. Maniac Latin Hoods
29. Maplewood & Charleston Chi-West
30. Oakley & Maclean/Holstein Park Spanish Lords
31. Moffat & Campbell Gaylords
32. North & Claremont Spanish Lords
33. Leavitt & Schiller Unknowns
34. North & Damen Jousters
35. Wabansia & Wolcott Jousters
36. Honore & Wabansia Ventures
37. Honore & Bloomingdale Jousters
38. Hermitage & Wabansia Ventures
39. Pierce & Paulina Jivers
40. Wicker Park Warlords
41. Bosworth & Blackhawk Jivers
42. Greenview Boys
43. Greenview & Potomac Jivers
44. Division & Wolcott Kings
45. Thomas & Winchester Playboys
46. Honore & Thomas Ventures
47. Ashland & Cortez Gents
48. Greenview & Pearson Ashland Vikings
49. Huron & Noble Milwaukee Kings
50. Huron & Elizabeth Satan Disciples
51. Grand & Noble Gaylords
52. Huron & Wood Jivers
53. Wood & Chicago Popes
54. Iowa & Winchester Ventures

Compliments of Chicagohoodz: Chicago Street Gang Art & Culture

Pilsen

55. Hoyne & Iowa Playboys
56. Erie & Leavitt C-Notes
57. Ohio & Leavitt C-Notes
58. Smith Park (C-Notes)
59. Chicago & Western Chi-West
60. Chopin Elementary School
61. Crystal & Washtnaw Jivers
62. Roberto Clemente High School
63. Armitage & Kostner Eagles
64. Grand & Division Gangsters
65. Insane Campbell Boys
66. Maniac Campbell Boys

1. 18th & Oakley Satan Disciples
2. 21st & Oakley Satan Disciples
3. 23rd & Oakley Satan Disciples
4. Two-One
5. 18th & Wood Bishops
6. 21st & Paulina Ambrose
7. 22nd & Paulina Ambrose
8. Laflin Lovers (defunct)
9. Latin Brothers (defunct)
10. Benito Juarez High School
11. Villa Lobos, "Wolf City" (defunct)
12. 18th & Laflin Counts
13. 18th & Bishop Counts
14. 18th & Loomis Counts
15. Cullerton & Loomis La Raza
16. 18th & Throop Ambrose, then La Raza
17. 17th & Racine Party People
18. 17th & Carpenter Party People
19. 19th & Carpenter Party People
20. Morgan Boys
21. 18th & Morgan Ambrose
22. 18th & Desplaines Bishops
23. Racine Boys
24. 19th & Racine Counts

Little Village

TWO-SIX

1. 24th & Karlov
2. 25th & Kildare
3. 26th & Karlov
4. 27th & Keeler
5. 27th & Tripp ("Wild Side")
6. 26th & Avers
7. 27th & Avers
8. 28th & Kostner ("Sykko Realm")
9. 28th & Kolin ("Ghetto Side")
10. 28th & Kildare
11. 28th & Keeler
12. 30th & Karlov ("Gangsta Side")
13. 30th & Harding
14. 31st & Avers
15. 30th & Hamlin ("Homicide Town")
16. 23rd & Hamlin
17. 30th & Lawndale

LATIN KINGS

18. 21st & Albany
19. 21st & California
20. 21st & Fairfield
21. 22nd & Sawyer
22. 23rd & Central Park
23. 23rd & Homan
24. 23rd & Spaulding
25. 23rd & Whipple
26. 24th & Drake "Chi Town 24"
27. 24th & St. Louis ("Coulter 24")
28. 24th & Trumbull
29. 24th & Christiana
30. 24th & Sawyer
31. 24th & Troy
32. 24th & Marshall ("Boulevard")
33. 25th & Lawndale
34. 25th & Millard ("Napalm City")
35. 25th & St. Louis
36. 25th & Trumbull
37. 25th & Spaulding ("Spanish Harlem")
38. 25th & Sacramento ("Slug City")
39. 25th & California ("Cal Two-Fives")
40. 26th & Lawndale
41. 27th & Lawndale
42. 27th & Drake ("Murda Town")
43. 27th & Homan
44. McCormick Elementary School
45. 28th & Lawndale ("Wild Side")
46. 30th & Millard
47. 30th & Trumbull
48. 30th & Sawyer ("Redrum City")
49. 30th & Troy ("Ruthless Side")
50. 31st & Drake ("Drake Side")
51. Farragut High School
52. Villa Lobos
53. Two-Two Boys
54. Cullerton Deuces
55. 24th & Washtenaw Satan Disciples
56. Pietrowski Park
57. Ridgeway Lords (defunct)

Compliments of Chicagohoodz: Chicago Street Gang Art & Culture

Northwest Side

1. Central Park & Wilson Royals
2. Lawndale & Agatite Royals
3. Albany & School Royals
4. Christiana & Wellington Royals
5. Drake & Wolfram Royals
6. Milwaukee & Avers Royals
7. Koz Park Royals
8. California & Fletcher Royals
9. Avers & School Royals
10. Kedzie & Barry Latin Disciples
11. Central Park & Schubert Cobras
12. Kedzie & Wrightwood Gangsters
13. Palmer & Drake Gangsters
14. Armitage & Spaulding Gangsters
15. Charles Darwin School
16. Fullerton & Albany Orquesta Albany
17. Fullerton & Rockwell Lovers
18. Kolmar Park Popes
19. Independence Park Popes
20. Lawrence & Rockwell Popes
21. Cicero & Gunnison C-Notes
22. Central & Giddings C-Notes
23. Normandy & Belden C-Notes
24. Lawndale & Altgeld Gaylords
25. St. Louis & Altgeld Gaylords
26. Kildare & Fullerton Gaylords
27. Belden & Knox Gaylords
28. Sayre Park Gaylords
29. Long & Oakdale Gaylords
30. Kilbourn Park Gaylords
31. Reinberg School Gaylords
32. Central & Berteau Gaylords
33. Montrose & Narragansett Gaylords
34. Dunham Park Gaylords
35. Gunnison & Mason Gaylords
36. Cleveland Park Gaylords
37. Diversey & Rockwell Gaylords
38. Logan & California Kings
39. Grand & Mobile Unknowns
40. Diversey & California Spanish Lords
41. Cicero & Diversey Playboys
42. Hanson Park Jousters
43. Belden & Lorel Jousters
44. Prosser Career Academy High School
45. Sawyer & Belden Jousters
46. Sawyer & Altgeld Jousters
47. Fullerton & St. Louis Jousters
48. Kelvyn Park Freaks
49. Grace & Kedvale Freaks
50. Latin Brothers
51. Lawrence & Kedzie Kings
52. Kilbourn & Diversey Deuces
53. Hells Devils
54. Lane Tech High School
55. Carl Schurz High School
56. Steinmetz College Prep.
57. Cragin Park Playboys

375